FEB 1 '82 SEA

A11703 557222

D1095472

COP 1

770.28
 Photography, Venice '79 ; [scientific
 editing of the book, Daniela Palazzoli,
 Vittorio Sgarbi, Italo Zannier ;
 translations, Sara Corcos, Rodney
 Stringer]. New York : Rizzoli, 1979.
 404 p. : ill. (some col.) ; 25 cm.
 "Published to mark the occasion of
 Photography/Venezia '79 arranged by the
 Municipality of Venice and UNESCO, with the
 artistic organization of the International
 Center of Photography, New York."
 Includes bibliographical references and
 index.
 ISBN 0-8478-0250-7 RCN 0-8478-0250-7
 1. Photography, Artistic--Exhibitions.

General Research Corp. 1980 (cont'd)

Photography: Venice '79

8544

This book is published to mark the occasion of «Photography/Venezia '79» arranged by the Municipality of Venice and UNESCO, with the artistic organization of the International Center of Photography, New York.

Photography Venice '79

Rizzoli
NEW YORK

770.28
Ph

Scientific editing of the book

Daniela Palazzoli
Vittorio Sgarbi
Italo Zannier

Translations
Sara Corcos
Rodney Stringer

Published in the United States of America in
1979 by:

RIZZOLI INTERNATIONAL PUBLICATIONS, INC.
712 Fifth Avenue/ New York 10019

© 1979 by Gruppo Editoriale Electa, Milan,
Italy

All rights reserved.
No parts of this book may be reproduced in
any manner whatsoever without permission of
Rizzoli International Publications, Inc.

Library of Congress Catalog Card Number:
79-64760
ISBN: 0-8478-0250-7

Printed in Italy

While reading a magazine in an ophthalmological clinic recently I came across the latest novelty in photography. Lord Snowdon is engaged in a campaign for a polaroid for the blind.

Photography has always been tempted by the comparison with blindness. In *The Wild Duck* by Ibsen the little blind girl sacrifices her life to her photographer-father's inventive vanity. She will no longer see the beautiful geographic engravings in English books. In *Death Kit*, the novel by Susan Sontag, an ambiguous relationship is established between the guilt feelings of the man, who deals with optical equipment, and the secure innocence of the blind woman. The reality of visual objectivity is no truer than the reality guessed at in the darkness. Photography would not have given rise to metaphors of this kind had it not been for its non-selective totality.

Photography in fact has very little hope of escaping faithful reflection — albeit with a memory! — of what it has before it. It is significant that the beginning of a long period of photographic history, from which we have only recently emerged, was marked by an emblematic photograph of a blind woman by Paul Strand. In all these years, photography has been *objective* and has justified any deviations from its self-imposed law only in the supposedly moralistic, though actually utilitarian field of industrial and advertising photography. And how has this disarming ideology crept into our acceptance of photography as objective reality, as an indisputable necessity? Why does nobody make daguerreotypes any more? We have the wherewithal, and today it would be much easier to produce them than it was in the past. Is it because no more than one print can be produced? Or because we would be leaving the path of industry and going off towards private research? And yet, the inner torment of photography today, its continual self-disputing, self-renewal and self-questioning on moral obligations, which differ from those of a hypothetical social need linked to industry and to the photographic industry, suggest that radical turning points lie ahead. Meanwhile we entrust our certainty of living, our health, to symbolic representation that has nothing to do with what is commonly visible: to radiography, to the incomprehensible alphabet of scintillography. Only a network of magic certainties, of convictions dictated by experience and by relationships lived, can persuade us that we ourselves, our story and those of unknown ancestors, are contained in those abstract signs. In *Zauberberg*, Thomas Mann demonstrated that one can grow fond even of those obscure accounts of a real life. Oppressed by the logic of industry, photography has tried to hide its magic relationships with the existent, with Benjamin's *hic et nunc*. It has rediscovered this connection today not only on a metaphysical scale, but in the widening of its historical and geographical horizon. Until not long ago the history of photography concerned only a few areas of capitalist development. Very much less was known about photography in Czechoslovakia or in Hungary, in Italy or in Cuba, than is known today.

William Carrick, the great photographer from St. Petersburg, and one of the great men of his century, was, for instance, quite unknown. The decisive influence of the LEF upon Russian photography was, for the whole of the European avant-garde, scarcely felt. In capitalist countries the links between a certain avant-garde and the *Arbeiterfotograf* movement slipped by unnoticed; and an analysis of Fascist photography was lacking. In the age of the polaroid, when photography has become so fluid and varied as to lose a safe identity — doomed, like many other of today's disciplines, to be dispersed in the interdisciplinary immensity — we discover that photography has tried to give itself a centre, while denying its own peripheral constitution. Thus Henry Fox Talbot attempted with patents to deny his own revolutionary discovery that negatives were endlessly reproducible. This means that an exhibition of photography today cannot easily aspire to a centrality which would not be

granted to it. It can only, photographically, find what we trust will be a revealing and effective view of a continuity which has to be taken into account.

Because of this, all the exhibitions in Venice, organized by the Municipality and by UNESCO, with essential guidance and collaboration from the International Center of Photography of New York, directed by Cornell Capa, cannot, and do not wish, despite the ambitiousness of the programme, to render a complete and universal account of photography, but merely to testify to the achievements of some recognized masters, and to present some trends in photography today.
"Photography / Venezia '79" is an unprecedentedly ambitious programme, which might be the model for future such festivals that will document the importance of photography for all cultures and civilizations.

Carlo Bertelli

Contents

UNESCO thanks the curators and
photographers for granting generous
permission to print texts and
photographs.

The Municipality of Venice thanks
public and private lenders for their
kind assistance.

Lewis W. Hine

Lewis W. Hine

Born at Oshkosh, Wisconsin in 1874, Lewis
Wickes Hine died at Hastings-on-Hudson
(N.Y.) in 1940.
He began his working life as a labourer, but
pursued his interest in art at the same time. In
1898 he enrolled at the University of Chicago
and, a few years later, at Columbia and New
York Universities, where he read sociology
and graduated in 1905. Until 1908 he taught
at the Ethical Culture School of New York.
A self-taught photographer, he chiefly
recorded the life of European immigrants on
Ellis Island in 1905. His first illustrated article
was published in 1908, when he began
working for the journal *Charity and the
Commons*. That year he published a report on
miners in *The Pittsburgh Survey*.
Appointed by the Federal Committee on Child
Labor, he conducted a photographic study of
this problem, publishing the resulting
photographs in *The Survey* and thus
contributing towards the promulgation a law
for the protection of child labor.
During World War I he was a photographer in
Europe and particularly in the Balkans.
His coverage of the construction of New
York's Empire State Building, which he
followed from start to finish, is famous. He
later published a selection of these
photographs in *Men at Work* (1932).

8

Bibliography

Weller, *Neglected Neighbours in the National
Capital*, New York, 1909.
Van Kleeck, *A Seasonal Industry*, New York,
1917.
L. Hine, *Men at work*, Dover Publications,
New York, 1932.
B. Newhall, ''Lewis Hine,'' in *Magazine of Art*,
31, Nov. 1938.
E. McCausland, ''Hine's Photo-Documents,''
in *Photo-Notes*, Sept. 1940.
J. Gutman, *Lewis W. Hine and the American
Social Conscience*, New York, 1967.
J. Gutman, *Lewis Wickes Hine*, New York,
1974.
W. e N. Rosenblum, A. Trachtenberg, *America
and Lewis Hine-Photographs 1904-1940*,
Millerton, Aperture, New York, 1977.

Lewis Wickes Hine began his distinguished photographic career at the
beginning of the twentieth century in an atmosphere of urban ferment and
progressive social programs. He used his camera with consummate artistry
to create thousands of pictures of immigrants, child workers, tenement
dwellers, and skilled craftsmen. His photographs were not made as
self-expression or as aesthetic objects because Hine believed that art should
have a social purpose. Nevertheless, they are more then merely a historical
record. Hine's images provide penetrating insights into the social and
psychological realities of the time.

Hine arrived in New York City in 1901 from Oshkosh, Wisconsin, to join the
faculty of the Ethical Culture School. He had previously worked mainly at
unskilled jobs, starting as a helper in an upholstery factory when he was
eighteen years old. Recognizing his potential, Frank A. Manny, the newly
appointed principal of ECS invited Hine to teach nature studies and
geography. Sometime later, probably in 1903, Manny gave Hine a school
camera and suggested that he use it to teach and record. Record he did,
producing over one thousand images of educational life at ECS. Hine used
the camera in an unprecedented way in teaching: he set up a camera club,
took students on field trips, organized what may have been the first
academically credited high school photography class, and wrote frequently
and well on the value of photography in education.

Hine began photographing at Ellis Island in 1904 in response to Manny's
wish to instill respect among ECS students for the ''new pilgrims.'' His
interest in the immigrant may have been awakened by his exposure to
discussions about the new working man current among educators and
intellectuals in Chicago and New York. As subject, the immigrant presented a
difficult technical problem for Hine, but his response to the individual's
emotional state was unequivocal. He looked at face and gesture for
expressions of bewilderment, fear, or fragile hope, emotions that became
alive and poignant in Hine's images. It is apparent from titles such as
Madonna of Ellis Island that Hine had in mind conventional Renaissance
compositions when he arranged his subjects in frieze-like or pyramidal
groups. Also, the time required to arrange the pose and set up camera and
flash powder apparatus made the unexpected and often accidental
juxtapositions of small camera photography impossible for him.

Hine left no diary of the Ellis Island project and much that we would like to
know about the frequency of his visits or how his colleagues and pupils at
ECS reacted to his work will always be a mystery. He returned there time
and again between 1904 and 1909, perhaps in 1910, and definitely in 1926.
During his student days in Chicago, Hine had been attracted to the circle of
reformers who were actively engaged in transforming nineteenth-century
concepts of charity into modern social reform programs. He continued his
association with this group in New York where he received a degree in
pedagogy from New York University in 1905 and studied at Columbia
University.

Hine began to envisage a career that would combine educational activity with
a greater scope for the photographic image. While still at ECS, in 1906, he
provided photographic material for *Charities and The Commons*, for several
of the social welfare organizations that occupied the same New York building
and for the NCLC (National Child Labor Committee). In the fall of 1907 Paul
Underwood Kellogg asked him to participate in the *Pittsburgh Survey*, a
documentation in depth of an American working-class city. Shortly afterward,

Hine left ECS to become a social photographer, salaried by the NCLC and on the staff of *The Survey*. He also started the Hine Photo Company in 1908, operating from his home in Yonkers. Although he had left the placid world of middle-class academia for one of tension and constant travel, it was a step he never regretted.

To publicize its efforts to regulate child work, to enforce factory inspection, and to mandate school attendance, the NCLC published pamphlets, leaflets, broadsides, fund-raising brochures, and a periodical journal, *The Child Labor Bulletin*, which later became *The American Child*. But it was not until it began to make extensive use of photography that its literature became really effective and its educational programs began to convince on the basis of irrefutable evidence.

In addition, Hine convinced the NCLC of the need for truthful but imaginative displays of its visual material at meetings and conferences. Under his inventive direction, the NCLC visual material took on added power; he silhouetted and enlarged images and created montage effects, using limited text and large, easy-to-read captions. Movable posters and panel displays were prepared for use at the annual conferences, at regional meetings, and at the two large, West Coast expositions of 1915.

Hine's understanding of how to use the photographic image in the NCLC campaign was unusual for his time. Although the projected stereopticon slide had already been employed by Charles Weller in his social work lectures, Hine expanded its effectiveness by preparing a stock of three hundred slides for the NCLC. These were at first loaned and later rented in packages sets of fifty to seventy-five slides with accompanying text. Hine himself delivered fifteen such lectures around the nation in 1914 and 1915.

When we ask how Hine was able to project the living quality of his subjects so that they still seem vital and affecting, we are faced with the artistic character of his accomplishment. True to his perception of photography as an expressive medium, he isolated his subjects and simplified backgrounds whenever possible. He selected moments when a child's expression played counterpoint to grim surroundings, enhancing the sense of lost potential. His tact and resourcefulness enabled him to approach children and adults with complete ease, and his careful investigations of their lives and work situations informed the images with singular compassion.

Few artists of the period were as concerned with the meaning of childhood as Hine was when he wrote:
"For years I have followed the procession of child workers winding through a thousand industrial communities, from the canneries of Maine to the fields of Texas. I have heard their tragic stories, watched their cramped lives and seen the fruitless struggles in the industrial game where the odds are all against them."
After ten years with the NCLC, the organization inexplicably reduced Hine's salary. He had supplied its evidence in both word and image, but his investigative reports were no longer considered necessary, and the agency wished to pay him less for the straight photography they now proposed he do. Hine left the NCLC in 1918 although he later provided them with occasional free-lance work. He retained some of his prints, but the entire collection of more than five thousand negatives and prints belonged to the NCLC and remained with them until 1974, when it was acquired by the University of Maryland Library.

Hine may have welcomed the opportunity to explore new ground and face new challenges. Since the excitement and action associated with social work programs had shifted to Europe, he applied for a position with the American Red Cross Special Survey Mission to the Balkans. He arrived in Paris in June 1918 and was almost continually on the move for several months, through Italy and Greece to Serbia, and back up to northern France and Belgium.

After a year abroad, during which he helped Colonel Folks select pictures for *The Human Costs of the War*, Hine headed home, preferring to work for the ARC in the States rather than continue with a Mission to Germany. For a short time he settled into his old role, arranging exhibition for the Red Cross Museum and photographing rural ARC programs. One remarks a subtle change in his commitment, however — a shift away from the fervent sense of mission that had informed the earlier NCLC work. Undoubtedly this change reflected the reduced concern with social justice in the nation as a whole.

Hine's new project, which he embarked on in 1920, involved portraits of working people. He now called himself an interpretive (rather than a social) photographer, a reorientation that suggests a greater awareness of the expressive aspects of photography. This direction went back to ideas he had expressed in his earliest articles and in photographs such as "The Old Printer." Interpretive photography required outlets other than those offered by *The Survey*, although Hine still supplied the magazine with material. Influenced perhaps by the examples of Stieglitz and Strand (his former student at ECS), Hine began to seek exhibition space and throughout the twenties, found such facilities for his work in banks, women's clubs, and in the Art Director's and New York Advertising Clubs. In 1931 the Yonkers Museum gave him "the biggest showing... of my quarter century of work."

For the work portraits, as he called his new project, Hine sought out craftsmen and workers who exemplified the skill necessary to run an advanced technological society. Their compositions sometimes appear studied and deliberate, but it should be remembered that Hine was forced to grapple with the aesthetics of a heroicizing vision at a period when few artists were concerned with underscoring the relation of man to machine. Although he had de-emphasized the investigative role of his own photography, Hine still believed that photographic art had a social objective. He believed that it could be used to offset some misconceptions about industry... Our material assets, fabrics, photographs, motors, airplanes... don't just happen as the product of impersonal machines, under the direction perhaps of a few human robots... Many are just plain ignorant of the sweat and service that go into all these products of the machine.

Before events of the early thirties, when he was commissioned to photograph the construction of the Empire State Building, Hine subsisted on income from *Survey Graphic* and from the largely uninspired free-lance photography he provided for commercial enterprises and social work agencies. He was employed occasionally by the NCLC and the ARC, but by the end of the decade his great optimism had almost vanished, and his self-esteem was at low ebb. It is ironic that he should have found financial backing and just the right commission in the midst of a catastrophic depression that demonstrated the inability of industry to support a skilled working class. However, Hine's conception of the skill and courage required

to run and industrial society was exactly attuned to the Empire State project.

He climbed the structure as it went up and set up camera and tripod to capture riveters and joiners framed in the geometry of beams and hoists. His early interest in the silhouette received full expression as he used both men and structural elements against the sky. But he also tied the men to the city below, suggesting not only the adventurousness of their calling but their common portion with the rest of humanity. Their fearlessness so affected Hine that he allowed himself to be swung out from the mooring mast to make dizzying shots.

Unfortunately, the thirties, which began on such a high note, became a period of continual frustration for Hine. By and large, his great compassion and skill were frittered away on inconsequential projects after 1932. Nearly all of his efforts to keep himself occupied with purposeful work were abortive. His quirky optimism and his humor were still apparent, especially in letters to the faithful Kelloggs, but one senses beneath them a bewilderment and strain, as for the first time, Hine faced obscurity and real poverty.

Berenice Abbott and Elizabeth McCausland rescued Hine in 1938 and brought him into the Photo League. There his work was respected and he was given a project to lead, appropriately called ''Men at Work.'' Abbott and especially McCausland publicized his work and arranged for a large retrospective exhibition at the Riverside Museum in January 1939. However, few assignments resulted from McCausland's publicity, and his grant applications were fruitless. Nineteen thirty-nine ended with the death of Hine's wife, Sara, on Christmas Day. In November 1940, after another year of dismaying inactivity, Lewis W. Hine died.

Today we realize that Hine was a great artist as well as an impassioned humanist. His images are in the mainstream of social art, a tradition that includes Goya and Daumier. His photographs move us and will continue to do so because his compassion and understanding found a formal resolution, one that, like all great art, is unique and inexhaustible in its power.

11

This exhibition has assembled a systematic collection of the most emblematic images in Hine's photographic output from 1904 to 1940.
It was first arranged by Naomi and Walter Rosenblum for the Museum of Brooklyn in 1977.

Naomi Rosenblum

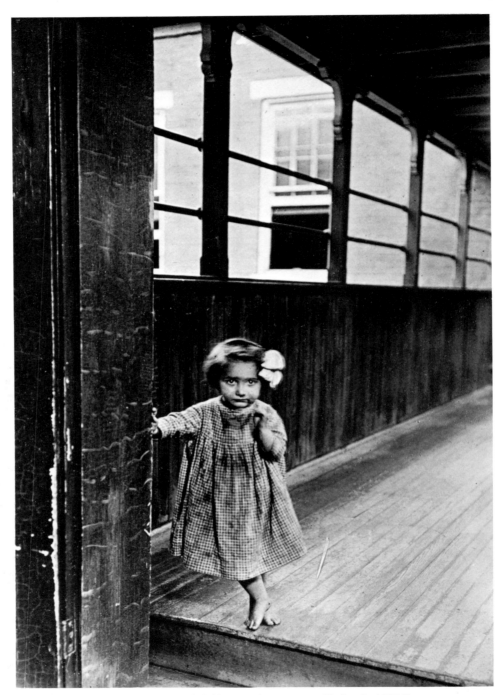

Little Orphan Annie. Child in an orphanage near Pittsburgh, 1907-8

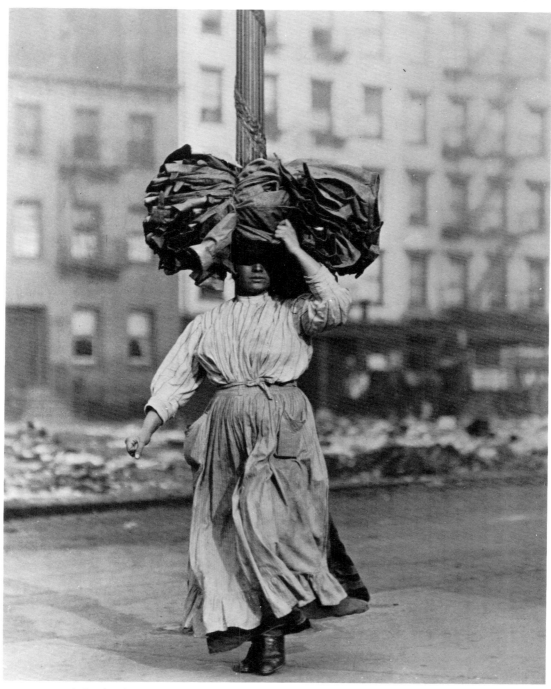

Italian immigrant woman carrying home materials. Lower East Side, New York, c. 1910

14

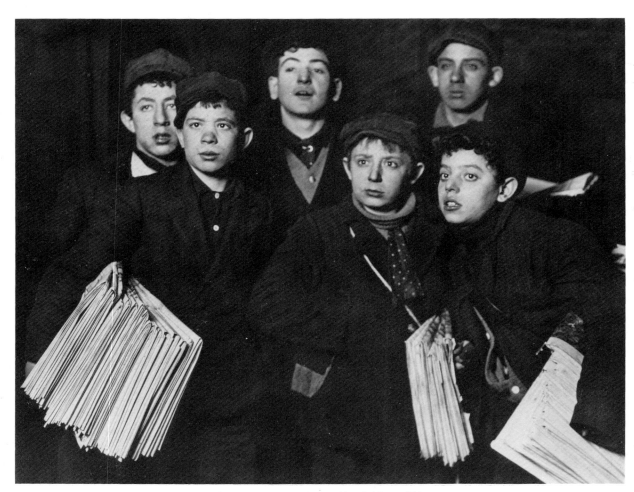

Group of ''newsies'', Brooklyn Bridge, 1908

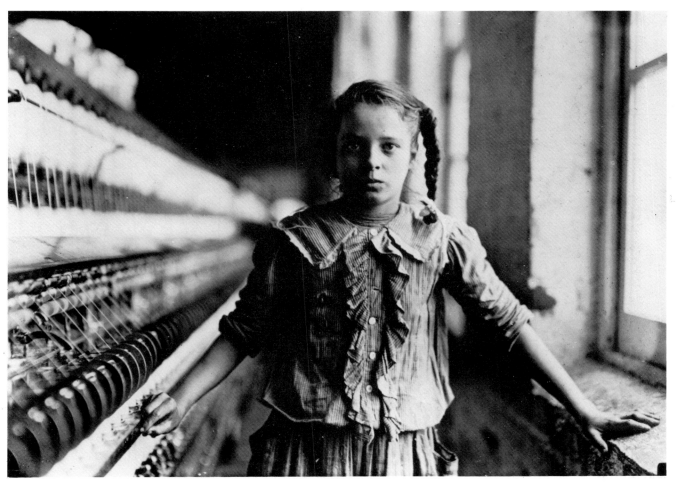

Ten year old spinner in a North Carolina cotton mill, 1908

16

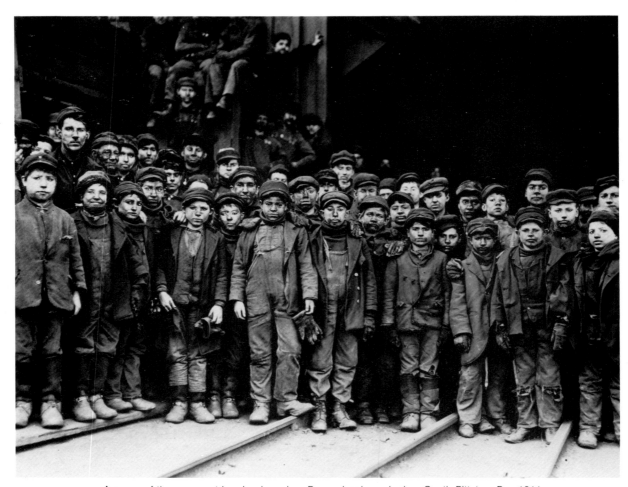

A group of the youngest breaker boys in a Pennsylvania coal mine, South Pittston, Pa., 1911

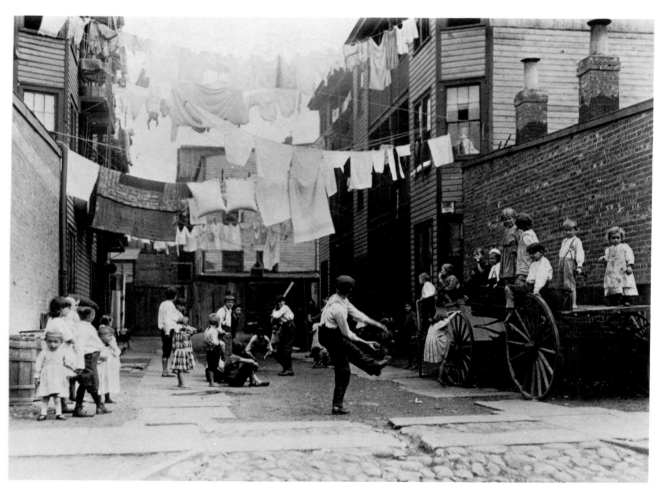

An early type of playground for tenement children, 1910

18

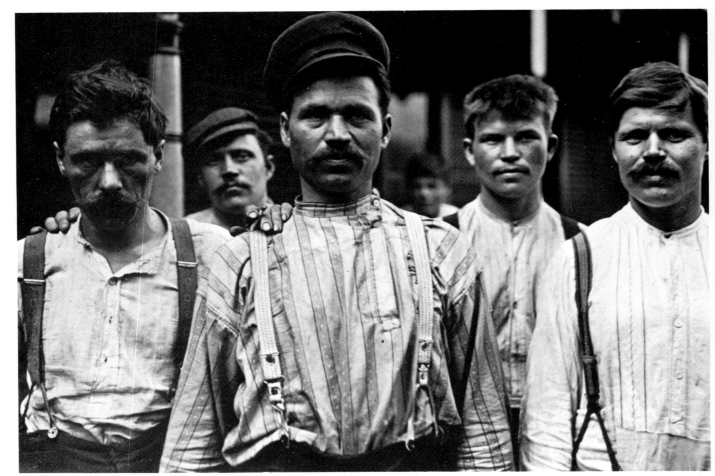

Steelworkers at the Russian boardinghouse, Homestead, Pennsylvania, 1907-8

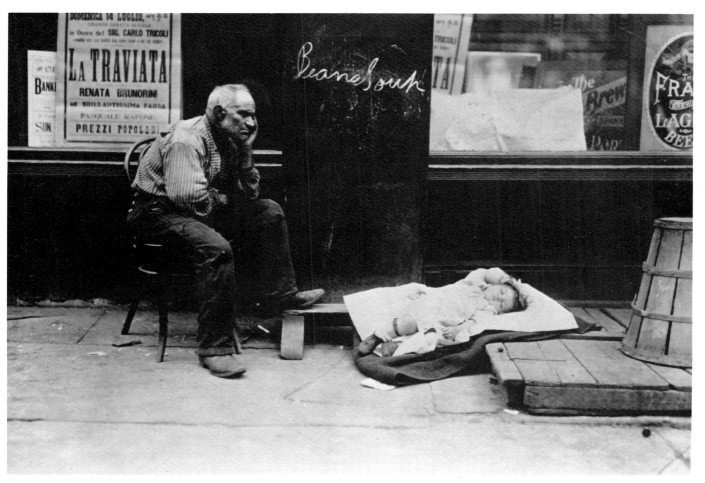

Summer on the East Side, New York, c. 1910

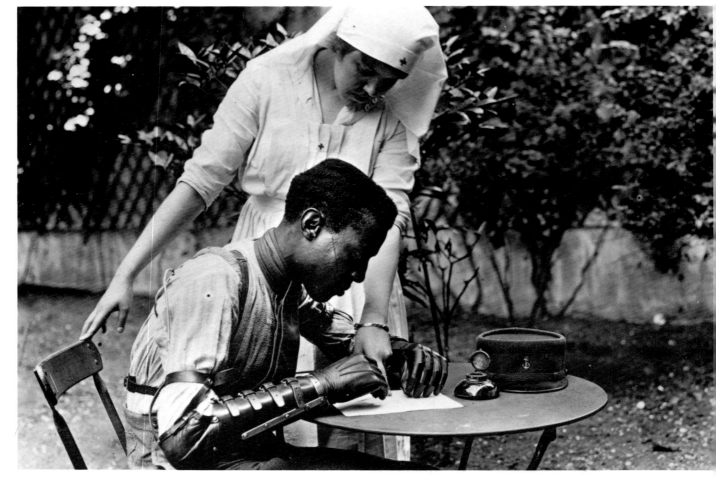

Man with artificial arm. Nurse and patient learning to write. France, c. 1919

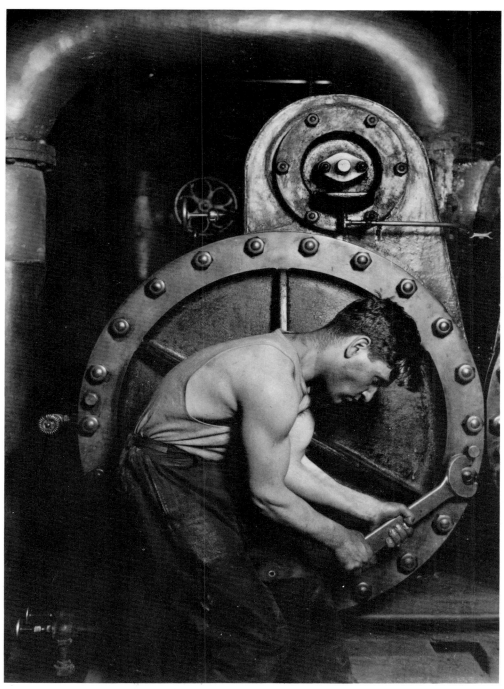

Powerhouse mechanic, c. 1920

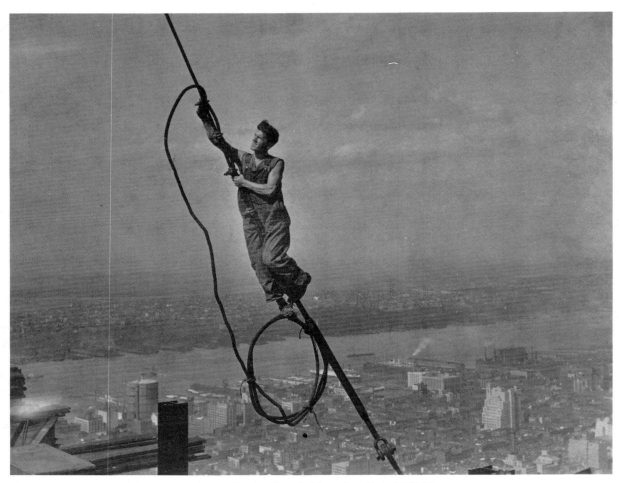

Icarus, Empire State Building, New York, 1930-31

Francesco Paolo Michetti

Francesco Paolo Michetti

Francesco Paolo Michetti, the fiftieth anniversary of whose death falls this year (on 5 March), was born at Tocco Casauria, in Abruzzo, on 2 October 1851.

In all probability, it was during that first trip to Paris (1871), that Michetti got interested in photography. He was attracted especially by the expressive scope afforded by a particular photographic format, the ''carte de visite'', which, on a single plate, could furnish different images of the same subject.

Of fundamental importance in the period around 1874 was Michetti's encounter with the painting of Mariano Fortuny. He was particularly attracted by the evocation of a Spanish world which cannot have appeared very remote to him, as a native of the Abruzzi, where the distances between poverty and wealth were unbridgeable.

With his *Corpus Domini* (1877) Michetti managed to select and to distil the best of Fortuny's production: the use of colour-tone which seems also to have benefited from photography which had in the meantime become a habitual pursuit. The camera's mechanical eye in fact automatically leaves out the contour line and the drawing.

The year 1883, with *Il Voto*, marked the beginning of a more committed painting, of a social kind.

And yet, careful inspection shows that the pastoral wild world of the Abruzzi is the poetic hub around which Michetti's photography and his painting rotate. Only the expressive medium changes.

Works like *La Figlia di Jorio* (which in 1895 won the first prize at the Venice Biennale) and the illustrations for *La Bibbia di Amsterdam* and *L'Offerta* (1896) still fit to the quick of contemporary figurative movements, into the ''official'' lines of painting.

His photographs of the same period — as demonstrated especially by his extensive, outstanding reports on cripples at Casalbordino (1895-1900) and on tunny fish slaughter (c. 1907) — move spontaneously away from the courtly expression of painting, towards a more direct and immediate idiom which can convey more closely Michetti's human as well as poetic involvement in the social issues of his time.

Michetti's crisis as a painter reached its lowest point in the large paintings hung at the Paris Exposition of 1900, *Le Serpi* and *Gli Storpi*. He seems to forgo a purely pictorial rendering in favour of a return to the contour line and drawing as the expression of movement. After this date he became convinced that art was only the imitation of nature and, disappointed with his own capacity for mimesis, he laid down his brushes for ever to devote himself to photography only.

24

From its earliest days photography was a subject of the keenest interest to painters.

Photography became increasingly a substitute for reality. With the intriguing prospects of its own specifics and its unexpected cuts, it influenced the Impressionists. Its fruition, denied or kept quiet during the period of nineteenth century realism, is now seen as the provocative expression of a new approach to art which takes into account all the vehicles of communication, and especially mass media. The road from Ingres and the Impressionists, through historical and nineteenth century genre painting, and the creative experiments of the avantgarde movements, right up to cases like Warhol or Rauschenberg, has been a long one.

The Italian Francesco Paolo Michetti takes us back into the narrow nineteenth century scene, from a typical original use in which photography was treated as a substitute for the real, to a broader-minded idea of dialogue between the two idioms, between painting and photography as the expression of creativity.

''The long development of relations between art and photography in Michetti's work, in the emblematic succession of these phases, up to his last efforts at art nouveau painting which have nothing in common with his earlier pictorial realism, rises to the height of a symbol, for it is enclosed in the course of a single existence, of the innermost drama of a special moment in modern art, a drama which broke out in no small measure as a result of photography itself.''

His earliest photographic work was devoted almost exclusively to portraits. In the years 1871-83 Michetti had still to identify the intrinsic expressive and linguistic values of photography. And yet, when one looks at the portraiture he did at about that time, one is at once struck by his great, innate capacity to enter into the psychology of his characters and to seize upon the salient points in their personalities, identified among the mobile features of expression more immediately linked to the fleeting sentiments and emotions of a vanishing moment in time, that of the exposure.

The cold, almost crystalline light which swathes and shows up the wrinkled face of aunt Luisa, is gathered into the look on her face, which expresses both the wisdom and the tiredness of her age, but also the proud and noble vitality of this weary, but not bent old woman. The self-portrait of the photographer as a young man is ambivalent, almost emblematic. The quiet light that bathes his forehead is contradicted by the puckering of his raised eyebrows. The shadow across the thoughtful eyes seems to suggest a door opening on the mind but at the same time those eyes are enquiring, almost arrogant, intent on staring at and provoking a hypothetical antagonist.

Clearly Michetti the photographer got this very marked habit from the other Michetti, the painter. Indeed, a chronological reconstruction of his biographical data indicates that these early efforts may be seen as the most direct and immediate way of approaching his models for the purposes of pictorial expression. This way of relating to reality, which is studied and mediated through the photograph, especially if one looks at the relations between art and photography within the narrow circle of portraiture, was particularly recurrent in the nineteenth century. Degas, Hill, Millais and Lembach, to mention just a few of the better-known artists, relied extensively on photography for their portraits. This was quite in keeping with the

Bibliography

G. D'Annunzio, "Nota su Francesco Paolo Michetti", in *Convito*, book VIII, Rome 1896 July-December, p. 583-592.
A. Cecioni, *Scritti e ricordi*, with preface by G. Uzielli, Florence, 1905.
D. Martelli, *Scritti d'arte*, edited by A. Boschetto, Florence, 1952.
Coke Van Deren, *The painter and the photograph*, The University of New Mexico Press, 1964.
R. Delogu, *Mostra di disegni, incisioni e pastelli di F. P. Michetti*, (catalogue), Francavilla a Mare, 1966.
C. Bertelli, "Le fotografie di F. P.Michetti", extract from *Musei e Gallerie d'Italia*, no. 36, September-December, 1968.
A. Scharf, *Art and photography*, London, 1968.
Michetti e la fotografia, journal of Gabinetto Fotografico Nazionale, edited by M. Miraglia, Rome, 1971.
Aspetti dell'arte a Roma dal 1870 al 1914, (catalogue), edited by D. Durbé, A. M. Damigella, Galleria d'Arte Moderna, Rome, 1972.
M. Miraglia, "Michetti pittore e fotografo", in *Qui arte contemporanea*, 1972.
Combattimento per un'immagine - fotografi e pittori, amici dell'arte contemporanea, Galleria Civica d'Arte Moderna (catalogue), edited by D. Palazzoli and L. Carluccio, Turin, 1973.
M. Miraglia, *Francesco Paolo Michetti fotografo*, Turin, 1975.
Francesco Paolo Michetti, travelling photographic exhibition organized by "Il Diaframma Fotografia Italiana", Milan, 16 March, 1976.
Francesco Paolo Michetti, entre pintura y fotografia, exhibition sponsored by the Italian Ministry of Foreing Affairs, organized by the Galleria d'Arte Moderna di Roma (G. Piantoni), catalogue edited by M. Miraglia, Buenos Aires, Lima, Sao Paulo, 1977.

The exhibition, organized by Marina Miraglia and Daniela Palazzoli, concentrates on the relations between photography and painting. A number of drawings and paintings by this important painter are compared with about fifty of the numerous photographs which he took in order to study and analyse the reality to be transposed into his paintings. Such an intensive dialectic also warrants a re-evaluation of Michetti's photography as an autonomous expressive form.

nineteenth century conception of photography, which was regarded as a copy, as a merely passive registration of reality with none of the possible interference or subjective action that were considered the prerogative of painting.

Even before Talbot and Daguerre discovered the chemical agents capable of fixing the image provided by the "camera obscura", the experiments conducted by painters like Canaletto and Guardi had already shown that the optical image makes a selection of reality which is perfectly similar to the kind effected in Europe in the Quattrocento.

This initial stage was common to all the nineteenth century artists who made use of photography. In Michetti's work it was quickly replaced by an absolutely new and much more stimulating approach to photography.

In 1880, with the advent of silver bromide gelatine, the improved rapidity of sensitive emulsions, and smaller cameras, the way lay open to instantaneous photography.
For the first time photography was disconnected from any reference to the compositive canons of art. Through its own specifics it displayed different and alternative ways of relating to reality. So the photographic image was no longer seen as a "composition" but as the subjective presentation of different "situations". The certainty of perspective representation, conceived as the sole possible and absolute truth, made way for the doubt that different and multiple factors might be able to explain "the stimulus which strikes the eye and our perception of the scene".

In the snapshot and in photo-reporting Michetti discovered photography's capacity to break down the total flow of every-day existence into the reality of countless fragments, fixed as ever-present. In these images, through festivals, public holidays and pilgrimages, certain images of nature, of trees, lilies and knotted roots, Michetti, much more than in painting, created the visual image of a late-nineteenth century Abruzzi. It is a far-off image, and yet so close.

Marina Miraglia

26

Photo collage of F. P. Michetti's study for ''Gli storpi'' by Gabinetto Fotografico Nazionale, Rome

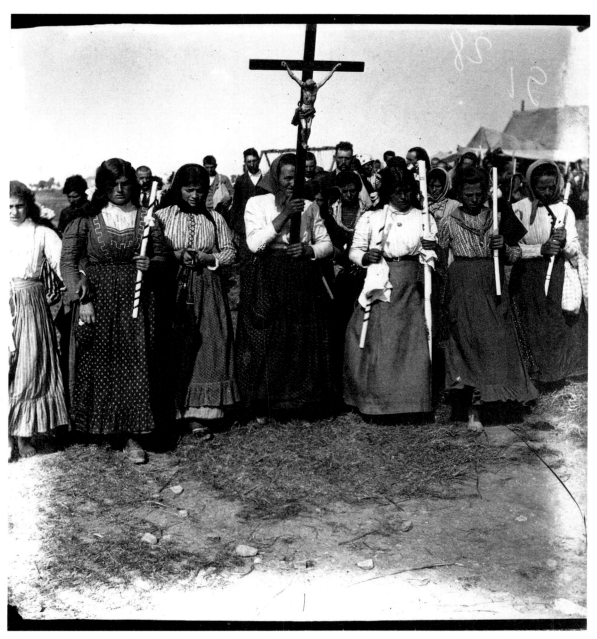

Start of the procession at Casalbordino, 1895-1900

27

28

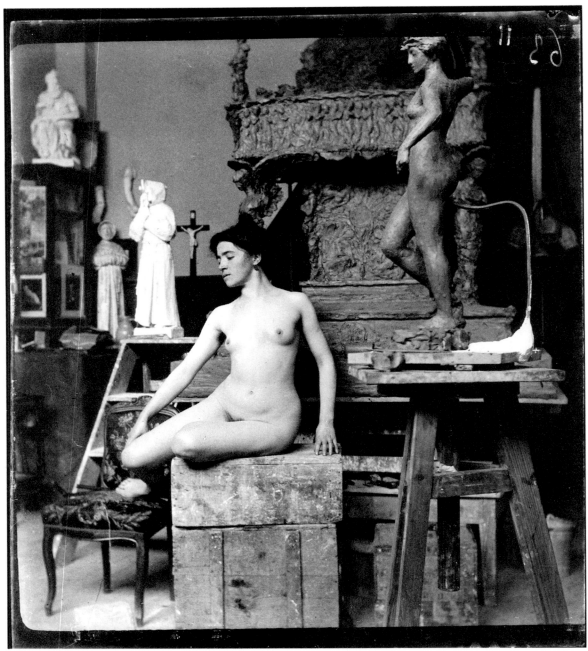

Study of nude

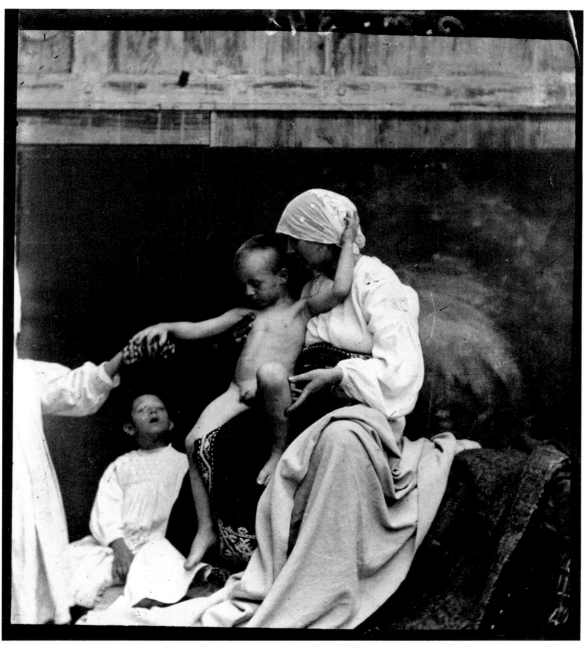

Annunziata and Sandro Michetti posing for ''The Offering'', 1896

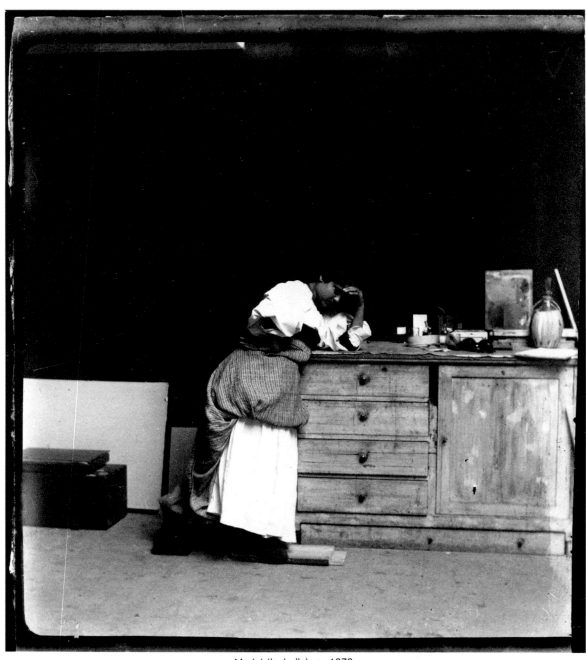

30

Model (Isabella), c. 1878

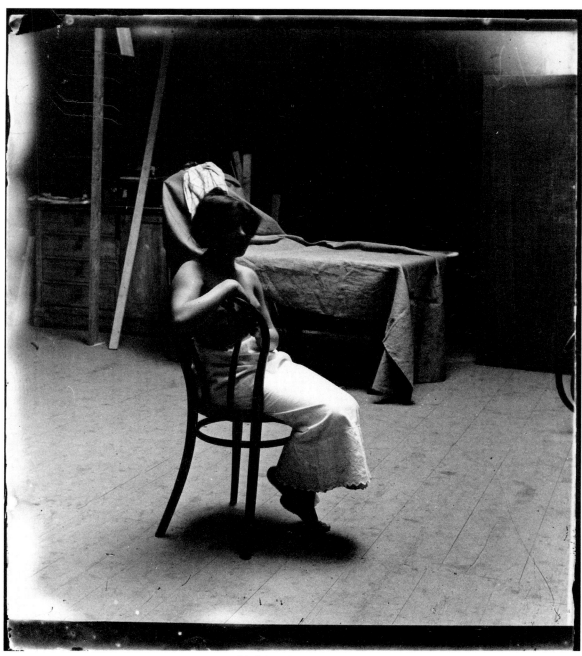

Model posing, c. 1896

32

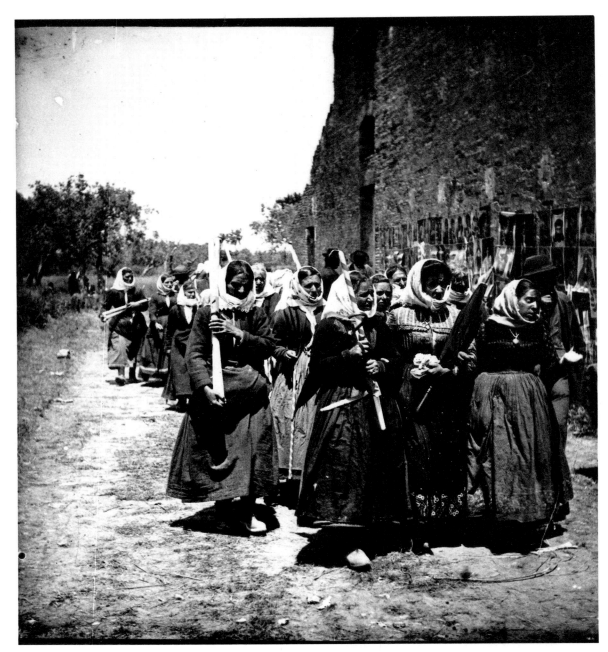

Pilgrims with tapers

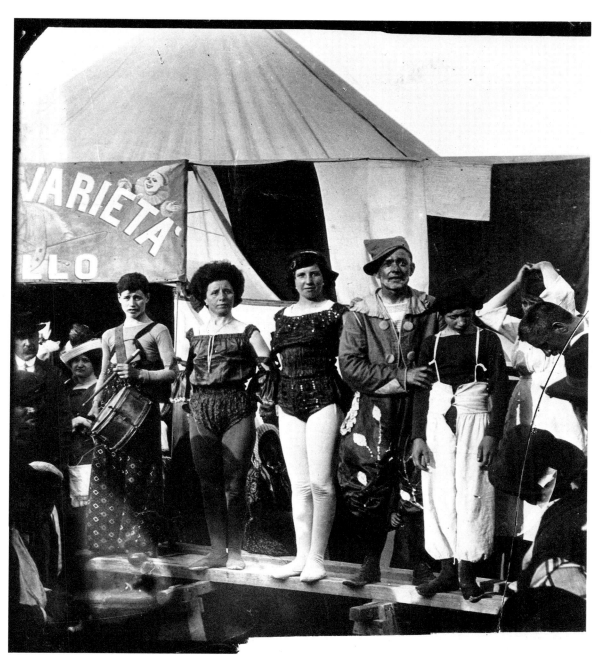

Acrobats, c. 1895-1900

33

34

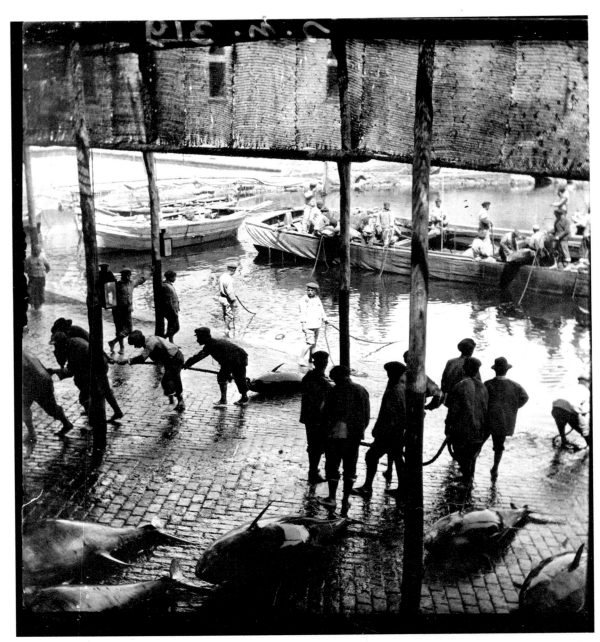

Tuna fishing at Acireale, c. 1907

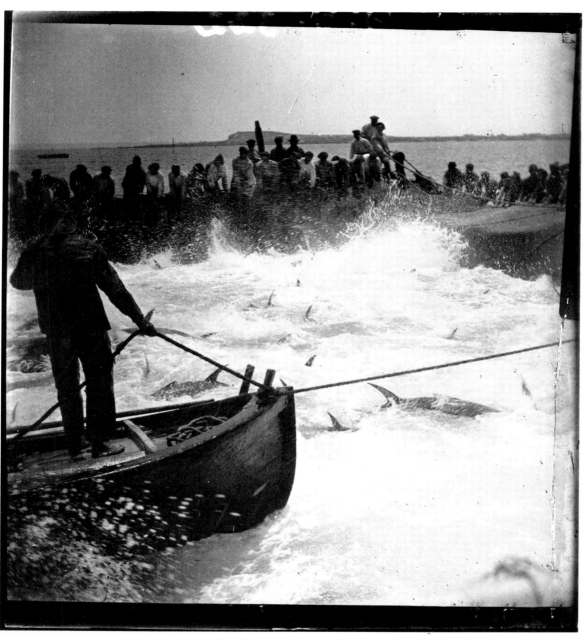

Tuna fishing at Acireale, c. 1907

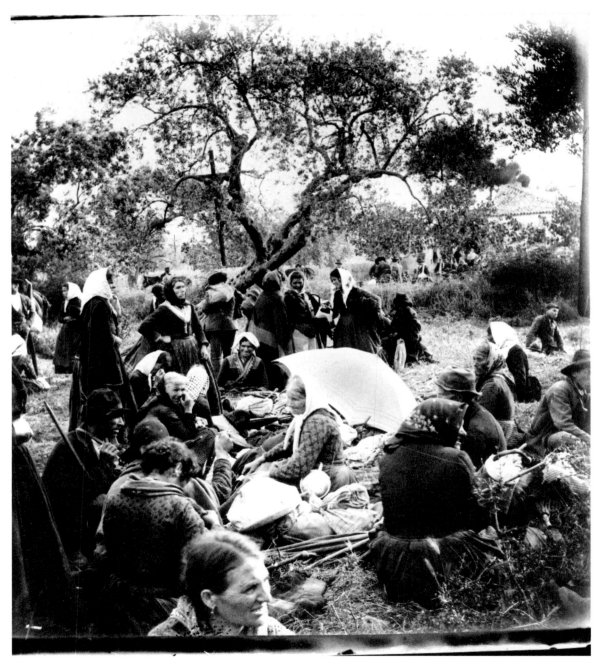

Pilgrims resting

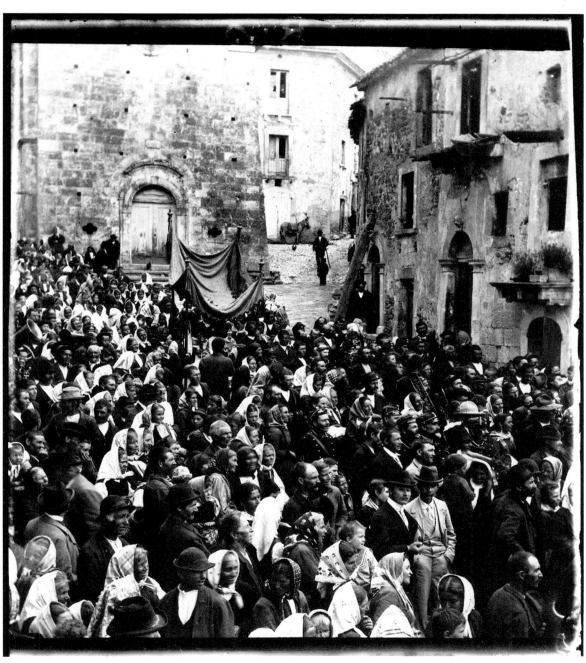

Procession

38

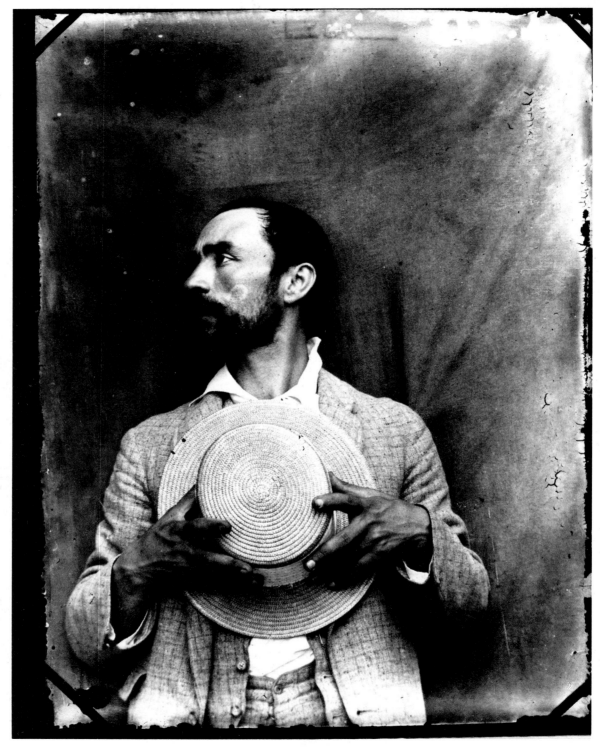

Self-portrait, c. 1875

Eugène Atget

Eugène Atget

Born at Libourne, near Bordeaux, in 1856, Jean-Eugène-Auguste Atget died in Paris in 1927.

In his youth he was a sailor, an actor and a painter, and only turned to photography at the age of forty.

In Paris he worked with an old wooden 18x24 cm box-camera mounted on a tripod, and sold the systematically printed pictures based on his own strict documentary standards, chiefly to his painter friends (Utrillo, Braque, Derain, Vlaminck, etc.) who would often copy parts of them. Among his other clients were several Paris shop-keepers whose windows and stores he photographed, whilst for some public institutions like the "Musée des monuments historiques", he sold groups of pictures of "Old Paris" or of "Picturesque Paris".

In 1921 he was spotted by Man Ray, who extolled his work in avant-garde circles and especially among the Dadaists. Later the American Berenice Abbott, a pupil of Ray's, took up Atget and inherited his archive. She subsequently exhibited the Parisian master's work for the first time in New York.

40

Bibliography

B. Abbott, "E. Atget," in *Creative Art*, no. 5, New York, 1929.
C. Recht, *Atget*, Paris and Leipzig, 1930.
P. MacOrlan, *Atget, Photographe de Paris*, Paris, 1930.
W. Benjamin, "Kleine Geschichte der Photographie," in *Literarische Welt*, Sept. 18, Sept. 25 and Oct. 2, 1931.
M. White, "Eugène Atget," in *Image*, Apr. 5, 1956.
B. Newhall, *Master of Photography*, New York, 1958.
B. Abbott, *Eugène Atget*, Prague, 1963.
B. Abbott, *The World of Atget*, New York, 1964.
R. E. Martinez, "Zeitgemässer Eugène Atget," in *Camera*, Lucerne, Dec. 1966.
E. Christ, *Les Métamorphoses de Paris*, Paris, 1967.
E. Christ, *Les Métamorphoses de la Banlieue Parisienne*, Paris, 1969.
E. Atget, *Lichtbilder*, Munich, 1975.
G. Freund, *Fotografia e società*, Turin, 1976.
J. Leroy, *Atget, magicien du vieux Paris en son époque*, Paris, 1976.
AA.VV., "Eugène Atget," in *Camera*, Lucerne, March 1978.
AA.VV., *Eugène Atget - Das alte Paris*, (cat.) Bonn, 1978.

Exactly fifty-two years ago, on 6 August 1927, at Bagneux cemetery in the suburbs of Paris, some half a dozen people stood around the mortal remains of a great French photographer unappreciated in his time. Eugène Atget was dead.

The "world of photography" had not interrupted its palavers, rivalries and games to consecrate a murmur of regret, an oration or a thought to him. But little by little the critics and history were to discover him, and for one reason or another, to turn him into a legend. Future generations were to look upon him as one of their masters. One will not be doing a disservice to the memory of Atget by disengaging him from his hagiography and trying to place him more impartially in the perspective of his time and of our own.

Jean Eugène Auguste Atget was born on 12 February 1857 at Libourne, in the Gironde. About his childhood and youth almost nothing is known apart from a few half-truths and some idle gossip. He is generally believed to have lost his parents at an early age. There is not in fact any record of their decease in the local registry. But it is known from the same source that the family left Libourne in 1859. Since it is not known where his parents then took up residence, Atget's subsequent movements are lost in conjecture. It is thought that the presumed orphan was brought up by one of his uncles, who was employed by the French railways; that this uncle put him into a small seminary, or possibly an orphanage, near Paris, where he acquired a good secondary education (confirmed by the style of his letters).

After that one loses track of Atget again. But according to André Calmette, his closest friend, the young Eugène embarked as a ship's-boy and made several voyages which he was fond of recalling and had occasionally talked about.

The thick fog that envelops the chronology of Atget's life and activities lifts in 1879, when, at the age of twenty-two, he entered the Conservatoire Nationa d'Art Dramatique. He left two years later, but without honours. His début in the capital was to have no future, for he performed in only one play. However, he managed to find employment in the district and suburban theatres, and then to get himself into repertory touring companies. However, his situation as an insignificant actor and understudy, and the worrying pursuit of employment filled him with bitterness.

Fortunately his meeting with Valentine Delafosse, an actress with more experience of the stage than he, besides being a charming, nice and plump woman, as Atget liked women to be, brightened his dull life as a bachelor and gave him confidence in his profession. Indeed his new companion fought tirelessly to procure parts for him which were entrusted to him less and less. And so, town after town, theatre after theatre and play after play, Atget managed to appear on stage even if only to pronounce a single line. But this state of affairs was to end in 1896, at La Rochelle, where Valentine, who was on tour for the next three years, failed to get him kept on again in the company.

In 1897 Atget returned to Paris and turned to a different artistic career. He hoped to earn his living and, maybe, to make a name for himself as a painter But he was poorly equipped for painting, judging by the few canvases that he left. After a year he had still not sold a single picture. He was forced to surrender to the fact that his vocation as an artist was but a mirage.

It seems fairly likely that Atget began photography in 1898. But history puts his beginnings in that profession at the year 1899, when he moved into the apartment at 17 bis, rue Campagne Première, in the heart of Montparnasse. His material situation was so modest that his work conditions were sorry indeed. He possessed neither studio nor shop as his honourable art

photographer colleagues did. He had no permanent location as did his similars who worked in fairs or in the streets. He was quite simply a strolling photographer. And the strolling was doubled because in addition to his work of taking pictures he had to prospect for customers and deliver orders. It was a hard task, but Atget balked at nothing — neither the long distances covered always on foot, under the burden of his equipment, an old 18x24 cm camera and an assorted kit of rapid rectilinear lenses, a gigantic wooden tripod and a box of 12 glass plates; nor all the paraphernalia which is the lot of those who have to work outdoors.

It will never be known just when or how Atget learnt photography. But there is a strong likelihood that he taught himself, which would explain his incomplete knowledge of photographic optics and chemistry. In this regard the top, unprinted corners of his plates (dark corners sometimes joining to form the shape of a bridge), an effect due to the exaggerated off-centering of the rectilinear lens from its camera, are too visible in his pictures to merit further insistence here. Similarly, as certain curious frames suggest, they are due more to maladroitness than to a deliberate intention. As for the chemistry, his plates are for the most part too dense, sometimes underdeveloped and nearly always scratched. They were on the other hand never retouched.
Curiously enough, his prints (by contact) on P.O.P. paper were of a remarkable chromatic quality in their range of sepias, reddish-browns and purplish-blues. But if the modern prints taken from the original plates lose the "aura" that surrounds those printed by Atget himself, they are on the other hand more "elaborate", and richly detailed in all parts of the image.

When Atget was taking his first steps in his new career, artistic photography, that is to say Pictorialism, reigned undisputed. But although its influence was considerable on the aesthetic plane, it had no effect whatever on Atget's output. The simple reason for this was that he always remained in ignorance of the evolution of photography in his time, just as he never understood the true artistic importance of photography, including his own. Proof of this is his obstinacy in qualifying his pictures as "documents for artists." In the early stages, Atget's clientèle consisted almost solely of painters, to whom he sold his "documents". These uninspired traditional artists hailed mostly from the academic schools.
Concerning Atget's relations with painters, one is more willing to stress the names of well-known artists, who were however improbable or very occasional purchasers, such as Braque, Kisling, Dali and Vlaminck, or even Picasso, whereas the painters who appreciated Atget's photographs and bought them for their own sake were Man Ray, Derain, Foujita, Dunoyer de Segonzac and Dignimont.
Let this be said to dispel a misconception and to draw the necessary distinction between painters who utilized or imitated Atget's pictures in one form or another, and those who purchased them for their own sake.

In due course Atget's clientèle grew and diversified as his own output increased in quantity and variety. His buyers were also official bodies such as the Bibliothèque Historique de la ville de Paris (which owns several thousand original prints bound and captioned by Atget), the Bibliothèque Nationale, the Bibliothèque du Musée des Arts Décoratifs, the Musée Carnavalet, publishing houses and various illustrated publications (5 of his photos appeared after 1909 in the book *La Voie Publique et son décor: colonnes, tours, portes, obélisques, fontaines, statues,* etc.), published in Paris by Renouard. Which explains why architects, stage designers and interior

decorators, and especially art craftsmen — wood-carvers, ironworkers, tapestry-workers, marble-workers, ornament-makers and ebony-workers — used Atget's services.

For that matter, did he not adopt the ambitious but meritorious style of: E. Atget. Author-Publisher of a *Photographic collection of Old Paris*, an opus which he attempted to achieve in the artisan form of albums containing a photographic print accompanied by a caption on each page. But he was unable to complete this project and eventually sold the 2621 plates (a large number of which were broken or spoilt) to the Caisse Nationale des Monuments Historiques for the then significant sum of ten thousand francs. must not be believed however that his work often earned him such amounts just as one must not lend one's ears to the legend of the old pedlar with his clownish air, reduced to selling his pictures outside the cafés of Montparnasse. As a matter of fact he earned his living modestly, to be sure, but sufficiently well to assure his own subsistence and that of his companion Atget was a complex figure and difficult to describe, so divergent are the versions of those who knew him or came into contact with him. Some regarded him as a poor fellow eaten up with false modesty, distrustful and taciturn. Others saw him as a well-bred, thoughtful man who could make conversation but did not easily let himself go. To tell the truth, Atget was always better than the various character patterns which people have tried to fit him into.

The same incomprehension has been shown with regard to his work, which has unjustly been classed as "populist", "picturesque" or "anecdotal", whereas Atget's documentary and plastic repertoire constitutes the most extraordinarily vivid Memorial of a city, in this case Paris, ever produced by one man alone. But although his photographs of ordinary people going about their daily tasks, his tradesmen and his itinerant craftsmen, his bars, shops and shop-fronts and his street women, account for much of his production, there is no reason to neglect the other and often more significant aspects of his oeuvre; be they the face of Paris in days gone by, or the urban landscape of a city in the process of transformation or disappearance.

To redress such misunderstandings and neglect is the object of this exhibition, produced with the resources (the original plates) of the Archives Photographiques de la Direction de l'Architecture, with the participation of the Direction générale des Musées and the collaboration of M. Pierre Gassman One might have expected to find a larger number of architectural photos, whereas the exhibit in fact consists of numerous known and lesser known "classics", and especially of a few unpublished masterpieces taken of places where one would not have expected Atget's photographic eye to have been caught or to have witnessed anything of note. Examples are a number of statues and vases in the Parc de Versailles, and especially a sculptural group in the large waterfall of Saint-Cloud which he framed in the manner of the nudes that he sometimes photographed in brothels. Likewise the statue taken in the Parc de Sceaux seems literally to be running away from the trees. Atget had a notorious penchant for trees; indeed they were an obsession with him. They are present wherever he could get them into the picture, and he very frequently photographed them for their own sake.

To say that Atget vindicated documentary photography is a truism. Nevertheless he innovated its rhetoric without actually being aware of the fact. And if his candid images, his images of truth, his picture-poems, go right to the bottom of, or beyond, his theme it is because of their metaphorical eloquence. Their charm, drollery and magic (it is to be noted that the famous reflections and fuzzy patches in Atget's photographs were

not intentional but due to his negligence or indifference at the time of taking the picture), cry out and move us in a thousand ways. And if they are not all of the same "gold", never mind that. Let's concentrate on those which conjure up the past which he had lived in or a past known to him only by its remains: nostalgic, tender and enchanted images that rediscover the lost past, a past which he manifestly missed.

R. F. Martinez

The Plates of the Archives des Monuments Historiques in Paris

In public and private collections the world over there are thousands and thousands of original "vintage-prints" done by Eugéne Atget and his wife in their apartment with original plates, more than 4,000 of which are now in the Archives des Monuments Historiques, Paris.

Why then make new prints today? The answer to this question comes from my own youth, when, using the same means of printing that Atget used, I was so often disappointed to compare my "poor" prints with the content of my negatives.
So I was dumbfounded when for the first time I was able to compare Atget's original plates with his prints in the collections. It seemed to me then that the science of photographic optics was clearly well ahead of chemistry, at any rate in so far as Atget used it. It so happened that one of the first plates that I was able to examine was that of a picture called "A l'Homme Armé", of which I was familiar with several relatively well-preserved prints. What I was able then to read and to see in the original plate was not just a fresh aspect of the image, but also a different aspect of Eugène Atget's work as a whole. The decision to make new prints does not seek in any way whatever to feed the flourishing "originals" market. It aims to show young photography enthusiasts the content of original plates, which we believe constitutes its totality, the only "original."

The choice of plates, from the 4,000 preserved in the Archives des Monuments Historiques, may appear arbitrary, but it is based upon two criteria:
1. - to choose precisely those plates of which no prints are known to exist, for the simple reason that Atget had discarded them, the proof print (if there were any) having shown him that he could not make a "saleable" print because of the process which he used;
2. - to choose those plates of which Atget's own prints, though known to us, do not in any way reveal their full beauty and richness.

These two choices automatically exclude the imitation of old processes — and still more the one employed by Atget himself — in order to make "old prints". The use of our contemporary technology conversely calls for severe discipline to avoid fanciful, "modern" interpretations.
I hope we have managed to stay within this picture and that this limited choice may be completed at a later date.

Pierre Gassmann

43

Selected by Romeo Martinez from over 4,000 original plates, the 50 photographs exhibited were printed by Pierre Gassmann. These collected images of Paris in the early years of the century are kept in the "Archives des monuments historiques" in Paris. (The Atget photographic fund belongs to the "Caisse Nationale des Monuments Historiques et des sites").

44

Fortifications and moats at the postern des Peupliers (Boulevard Kellermann), Paris

45

Sceaux Park, Paris

46

Flying buttress on the church of Saint-Séverin, Paris

Ossuary, tombs in the cemetery of Montfort l'Amoury

48

Cour du Dragon, Paris

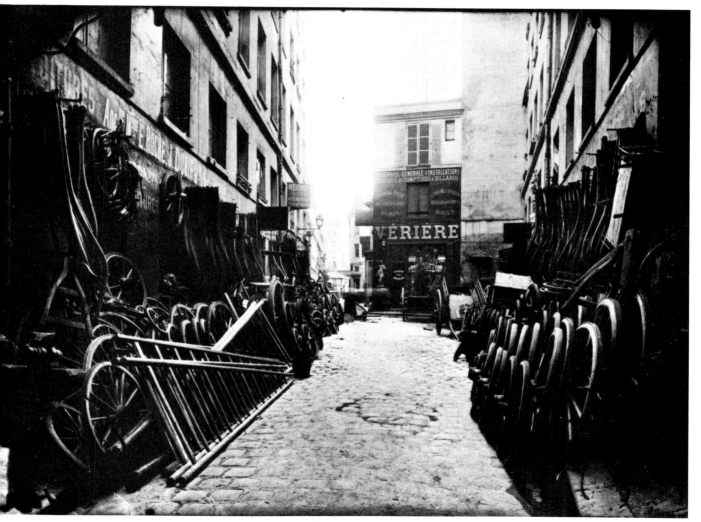

Cour Damoye, 12 Place de la Bastille, Paris

50

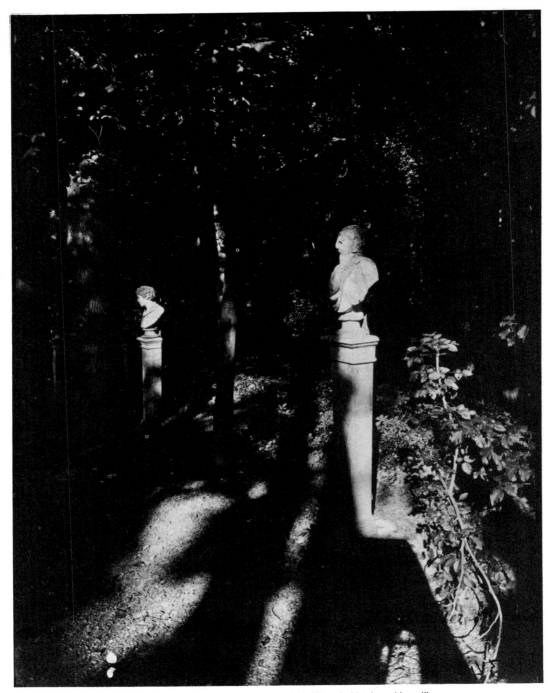

Parc Trianon, sculptures at the Amphithéâtre de Verdure, Versailles

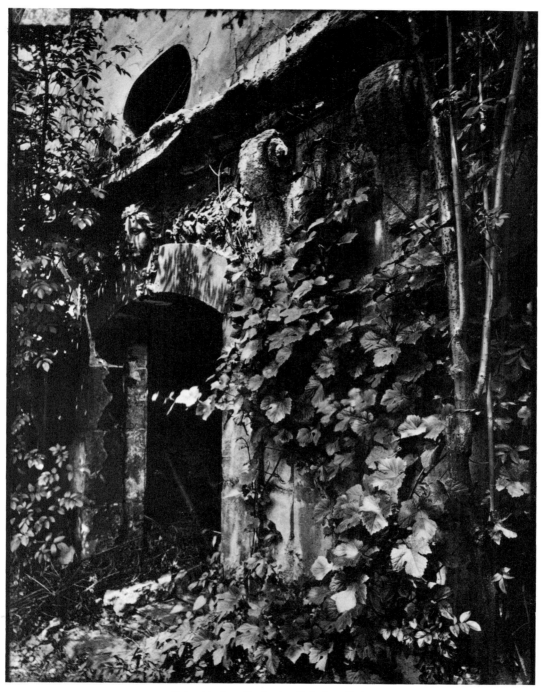

Ruined house, Ruelle des Gobelins, Paris

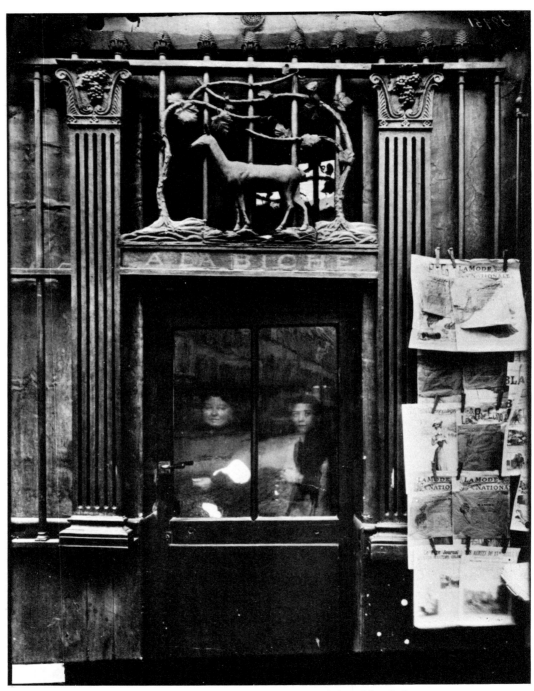

The "A la biche" tavern, 35 rue Geoffroy Saint-Hilaire, Paris

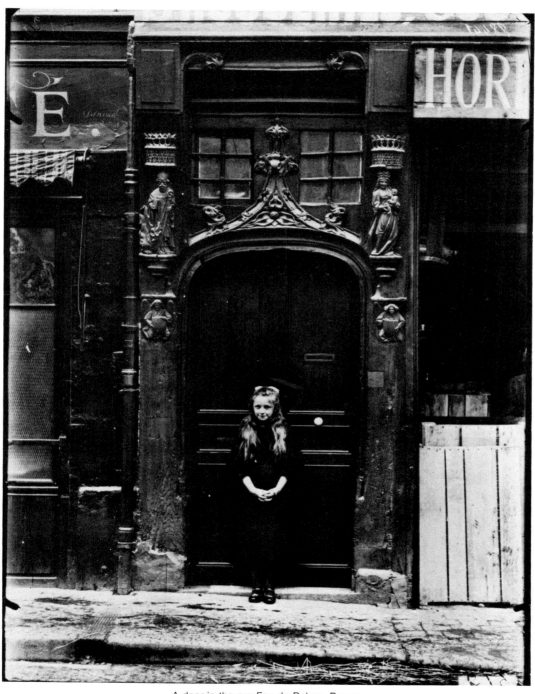

53

A door in the rue Eau de Robec, Rouen

The former Austrian Embassy, now the Hôtel Matignon, Paris

Count Primoli

Count Primoli

Count Giuseppe Primoli (1851-1927) was related to the Bonapartes on his mother's side and was educated in Paris, where he lived until 1870. With his brother Luigi he took up photography, in about 1880, and became a keen amateur. He amused himself by recording various facets of life in Rome and Paris in those years, as well as photographing during his numerous travels — to Venice, Milan, Genoa, Switzerland, Greece and Spain, the often inedited aspects of the places he visited.

In the social and intellectual life of his day he was an assiduous member of the literary circles centered around Théophile Gautier, Alexandre Dumas and Guy de Maupassant in France, and around Duse, D'Annunzio and Serao in Italy. Most of the photographic work he did in Paris has been lost, but some 12,500 of his plates are kept at the Fondazione Primoli in Rome, which Primoli himself established, together with the Museo Napoleonico.

The extant photographs from the thousands which count Giuseppe Primoli took at the turn of the century make up one of the most remarkable frescoes of that epoch. To this day our minds are filled with fantastic visions of a happy period in which only the great benefits of technical innovations could be seen, when a class of privileged people seemed to live in a state of everlasting euphory and innocence.

There were other photographers who, like him, devoted themselves as amateurs to seizing the features of the world around them. They were fascinated equally by the miracle of the camera, which recorded everything with a minimum of effort and skill, and of the social life which they were able to lead. Primoli is a case apart, not only in the quality of his photography but also in his peculiar social awareness. Since photography was closely connected with his everyday life, and his daily life being the almost constant subject of a diary with literary pretences — flanked for a number of years by a photograph album — it is of some importance to consider Primoli's social milieu.

Born into the minor nobility of central Italy, che cosmopolitan and worldly side of the Primoli family came from their kinship with the Bonapartes. It was through this connection that Primoli maintained his constant link with France, dividing his time between Rome and Paris, and was able to frequent the smartest and most stimulating salons and studios in "tout Paris". It is not therefore surprising that the archives of his photographs are richly endowed with pictures to do with fox-hunting, horse-racing and the first major international exhibitions, and also include such precious documents such as the portraits of Degas, Meissonier, Charles Gounod and Dumas fils, in unconventional, private poses. Also among his subjects are the various royal highnesses of Europe, from the German Emperor William II to the king of Italy Umberto I, the empress Eugenia and, naturally, the Bonapartes themselves together with the principal exponents of the Roman nobility, captured in some of the most representative records of the epoch.

In contrast to this context which, though extremely interesting, becomes almost predictable, a large part of count Primoli's time was also dedicated to capturing the other side of city life. His lens was pointed at dramatic and neglected problems such as urban development without the necessary infrastructures, the appalling poverty, and the mixture of a surviving country life squashed and degraded by all the new building.

Count Primoli was among the first to adopt the attitude of a photo-reporter. He dedicated himself wholeheartedly to picturing events which appealed to his imagination by their novelty or importance.

Two outstanding documents give a particularly good account of his social sensitivity: the picturing of one of the first public demonstrations, on 1 May 1891, and of prisoners embarking in the port of Naples in 1894. Observing all this material, one is amazed by the modernity of the count's photographic idiom. He himself stuck the sequences of his pictures on to boards — some of which are extant. He was not content to picture the event in itself, but pointed his camera at the context, trying simultaneously to capture both the action and the reactions of the crowd. At times he would single out some particularly enlightening situation. For instance, after showing us the platform where the speakers are speaking and the banners of the May Day demonstrators are unfolded, in another picture we are shown the listening, poorly dressed crowd. A poor man is walking away with a little girl asleep in his arms. This is all the more surprising when one thinks of the technical equipment available: plate cameras which could not be quickly reloaded. The photographer had to be prepared in advance to take his pictures.

This feeling for narrative development, caught in the multiplicity of its psychological and spatial folds — even the view often changed, with

Bibliography

. Negro, Gegé e Lulù Primoli fotografi di oma, Strenna dei Romanisti - Natale di oma 1856, Rome, 1956, p. 83-89.

.-N. Primoli, Pages inédites recueillies, résentées et annotées par Marcello Spaziani, ome, 1959.

etters by AA.VV., Con Gegé Primoli nella oma bizantina, Rome, 1962.

amberto Vitali, Un fotografo fin de siècle - Il onte Primoli, Turin, 1968.

aniela Palazzoli, Il Conte Giuseppe Primoli, Iilan, 1979.

he exhibition of photographs by count useppe Primoli, arranged by Daniela Ilazzoli, is the first major one of its kind to e dedicated to this amateur photographer ho was active at the end of the last century. omposed of about one hundred pictures, it constructs in the form of an album the iotographer's view of society life, with its x-hunting, horse-racing, grand weddings, urnaments, and portraits of celebrated ures from smart Rome and tout-Paris; and e social aspects — the contrast between h and poor, the first May Day emonstrations and the life of the urban oletariat — of the period from 1880 till the ginning of this century, as pictured by the otographer.

alternating eye-level and bird's-eye exposures for group views — did not preclude that "gran coup d'oeil" which even the De Goncourts, though not lovers of photography, felt in duty bound to recognize in count Primoli. This is in fact visible in the cuts and frames which are often played with great geometric purity, exploiting the background features against which the figures on the scene play their parts: windows, doors, staircases and corners of houses. Even the light at times helps to emphasize like a spotlight the significance of an exposure, as in the case of two beggars in a ray of light torn from the shadow outside the door of a church. But where Primoli most of all reveals his extraordinary gift as an "image-thief" is in his capacity to grab those opportunities which allowed him to visualize in snapshots of transfixed life the inedited, true features of his characters' psychology. We see, for example, Degas coming out of a public convenience, the king and queen in conversation, physiognomically characterized — the wags had nicknamed them "Curtatone and Montanara"; a famous actress, known as "Rèjane", preening herself, related to a female gossip who scrutinizes her passage and puts on airs herself.

In short, Primoli's concept of the portrait was an extremely modern one. His subjects were not posed, but dynamically situated so as to reveal their full personalities, as in the sequence entitled "Preparing for the portrait", in which he frames the empty armchair and then the sitter coming out from behind a curtain (instead of sitting on the chair); or again, in a portrait of a woman seated like a Madonna on an altar-piece, who, instead of the child you would expect to see in her lap, is holding a lively small dog, which creates a curious soft focus effect. This subtle irony, in which an understanding of human foibles is mingled with an insight into the universal tides that move individuals, grows tender, delicate and compassionate when addressed to children and to the wretched. Primoli himself did some boards titled "Bambini", where rich and poor children are depicted mainly for their psychological characterization. There is nothing similar to Lewis Caroll about this, but rather, an affectionate submission to their spontaneous way of posing. Primoli seems to have been more interested in learning from them the secret of authenticity than in taking their photograph. As for the disinherited and the wretched, there is no false pity, but rather the sympathetic understanding of a man observing the hardship and degradation which individuals can be forced to endure by certain social organizations and conditions of life. Naturally Primoli, like Lartigue and other amateurs at the turn of the century, was fascinated by the snapshot and its scope for capturing even fast movement. In particular, he was fascinated by the jump, that is to say, by the possibility of picturing a body in the moment in which it defies the force of gravity; and by the possibility of transforming, through photography, this brief instant of movement into an eternal suspension.

To sum up what I find most intriguing about Primoli's photographs, I would mention his sense of balance, so deeply felt that it seems to be second nature to him, between the sense of limit and the social rules. He knows, for example, the way in which a structure of forms is organized according to a point of view, or how a social order can create certain classifications and impose particular stereotypes in behaviour and dress in high as well as in low circles — and the constant desire to overcome them.

As, for instance, when he contrasts the vanishing point with an obstacle in the foreground, to force one's eyes to learn other paths; or when, beneath a pile of rags or a sumptuous toilette, he lets us discover the unexpected dignity and the peremptory truth of gestures and attitudes that strike through to the mind and to the heart regardless of any social stereotype.

Daniela Palazzoli

57

Women photographers posing

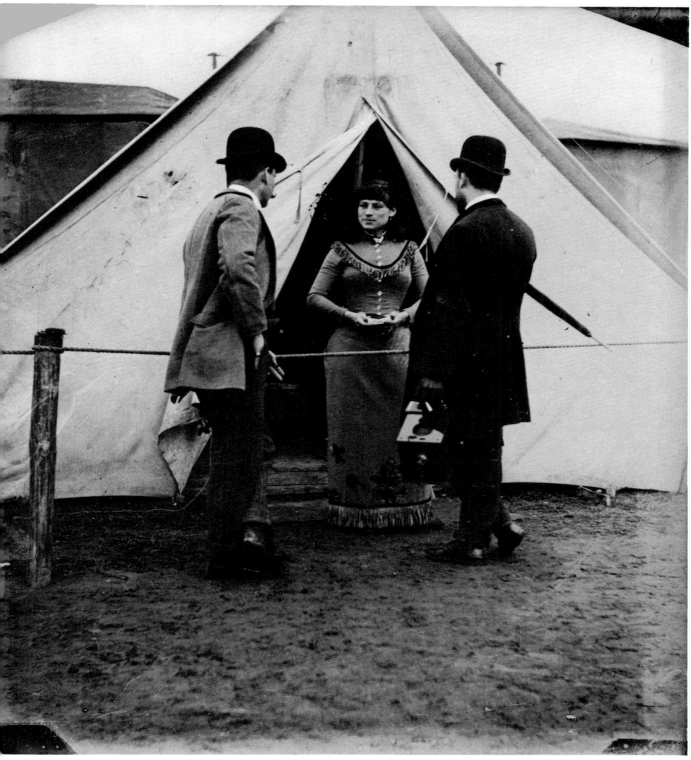

Annie Oakley of the Buffalo Bill company

The Roman campagna, c. 1885

60

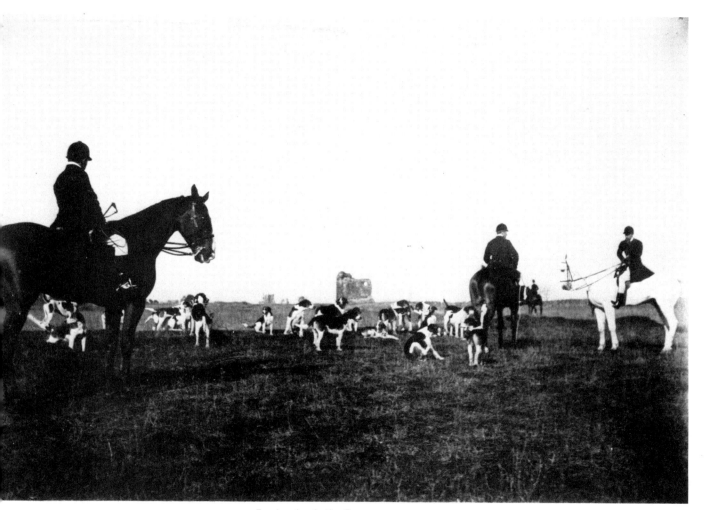

Fox hunting in the Roman campagna

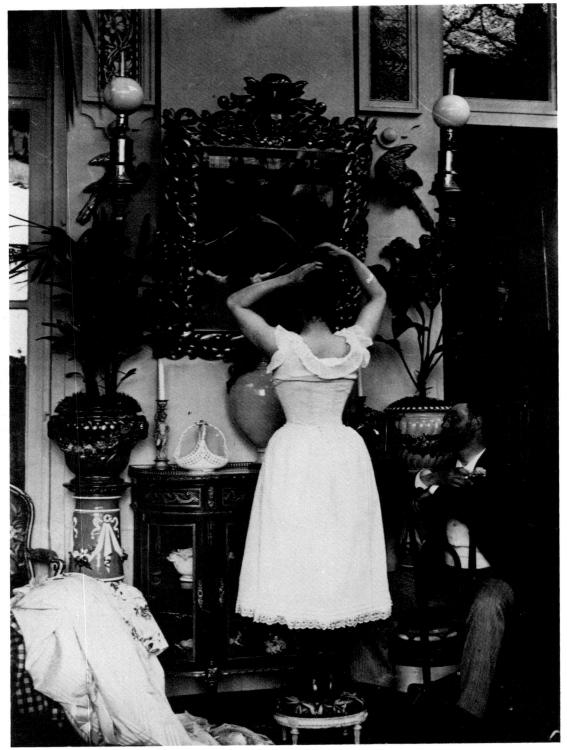

Nanà

Posters in Rome, c. 1880

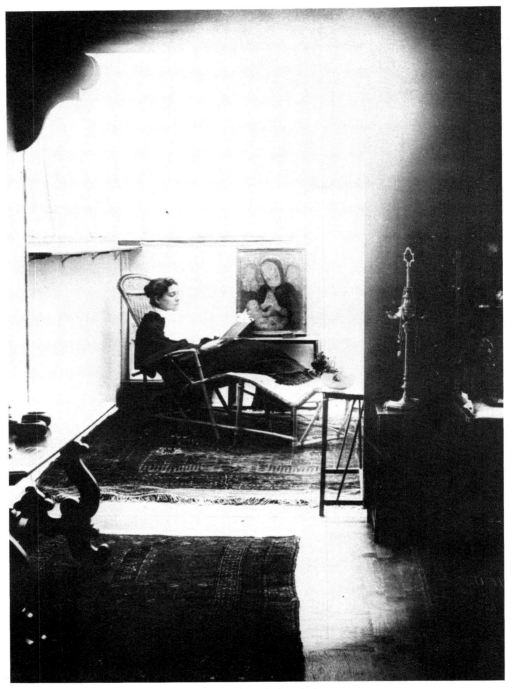

Eleonora Duse in her study

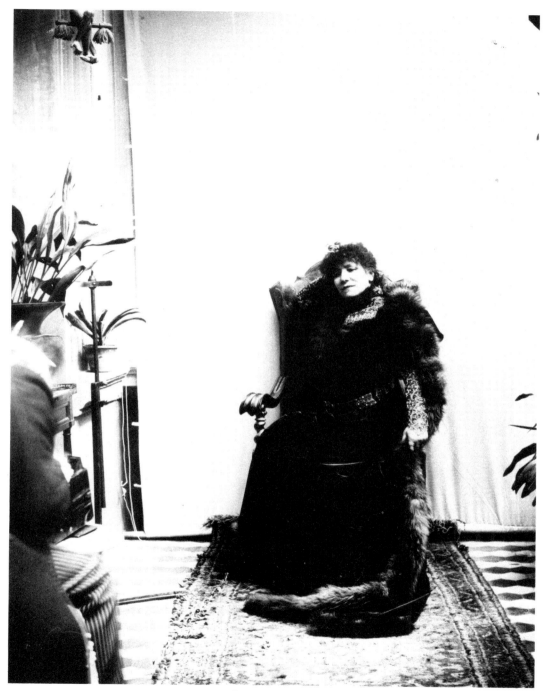

Sarah Bernhardt

66

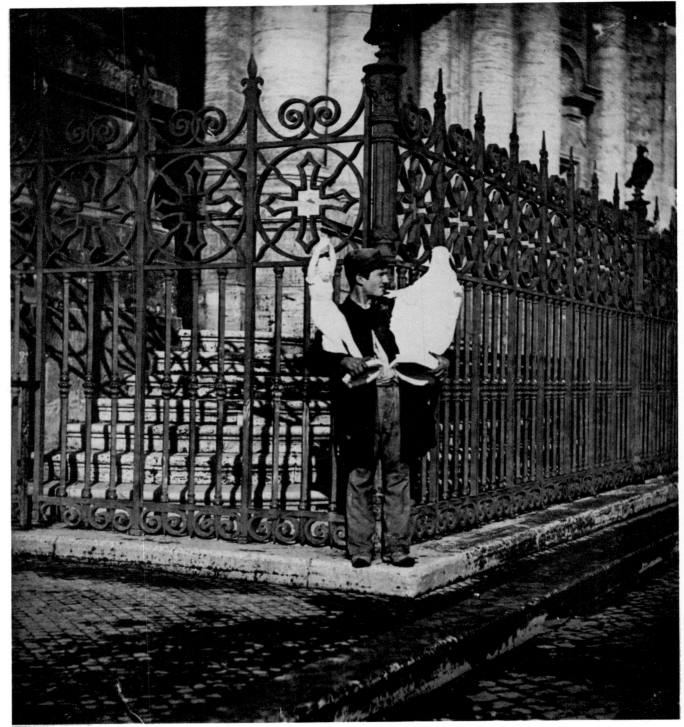

Seller of statuettes

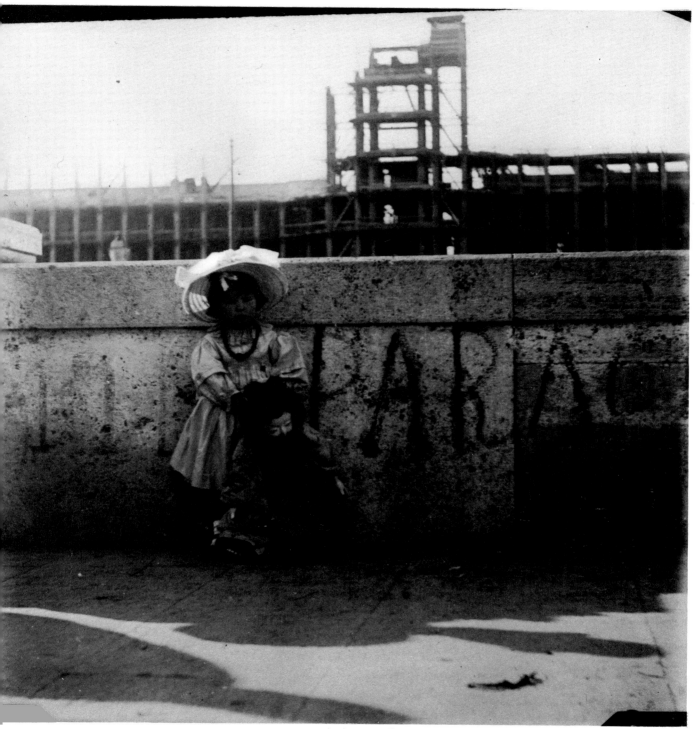

Girl with a Japanese doll

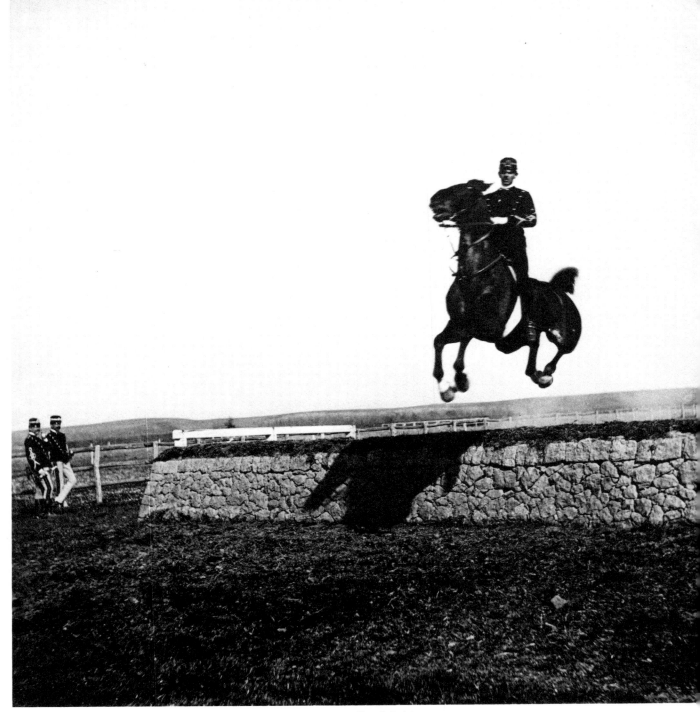

68

Horseman at Tor di Quinto

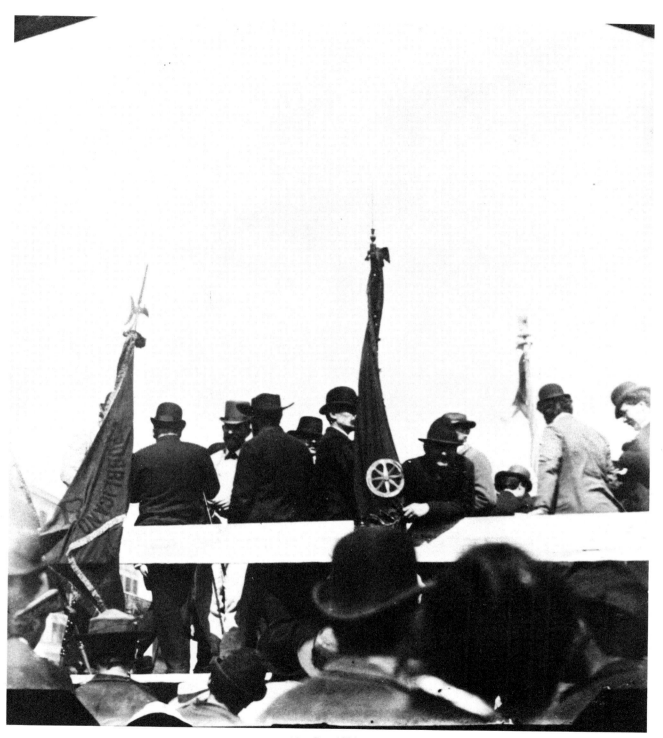

May Day 1891

70

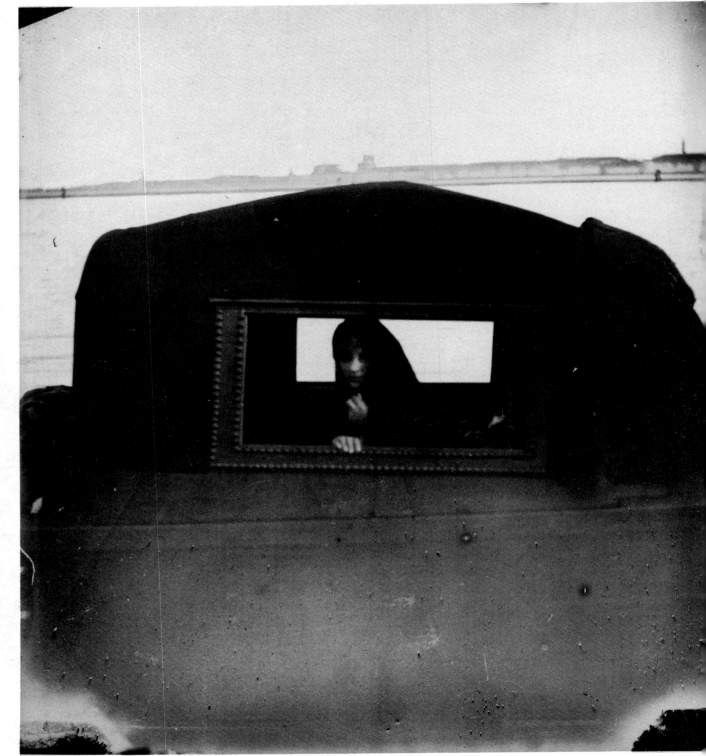

Venice, Widow in a Gondola

The Alfred Stieglitz Collection

The Alfred Stieglitz Collection

"... The only advice is to study the best pictures in all media — from painting to photography — and to study them again and again, analyze them, steep yourself in them until they become a part of your esthetic being. Then, if there be any trace of originality within you, you will intuitively adapt what you have thus made a part of yourself, and tinctured by your personality you will evolve that which is called style."

Alfred Stieglitz,
"Simplicity in Composition."
From *The Modern Way of Picture Making*,
Rochester, 1905

In the winter of 1902, General Luigi Palma de Cesnola, Director of The Metropolitan Museum of Art, was asked by Duke Abruzzi, a director of Turin's Esposizione Internazionale di Arte Decorativa Moderna, to arrange for an exhibit of important American photographs. General de Cesnola learned that the best person to advise him was Alfred Stieglitz, who was not only a talented photographer but also the most serious collector of photographs in the United States and possibly the world.

Stieglitz met with the General at the Museum and later recalled, "I told the General what my fight for photography had been [and] still was, and that I would let him have the collection needed for Turin if he guaranteed that when it came back it would be accepted by The Metropolitan Museum of Art *in toto* and hung there." Stieglitz recollected that de Cesnola gasped, "Why Mr. Stieglitz, you won't insist that a photograph can possibly be a work of art... you are a fanatic." Stieglitz replied that he was indeed a fanatic, "but that time will show that my fanaticism is not completely ill founded."

Stieglitz arranged for sixty prints by thirty-one persons to go to Turin, where they were awarded the King's Prize. In appreciation, Stieglitz wrote to the Duke that "after an eighteen years struggle I am glad to have accomplished my life's dream, to see American photography — sneered at not more than six years ago — now leading all the world." Stieglitz was not to see the complete realization of his agreement with de Cesnola for the General's unexpected death early in 1903 prevented the collection from being shown the Museum as had been promised.

A controversy erupted when the King's Prize was mistakenly awarded to The Camera Club of New York rather than Stieglitz's brainchild, the Photo-Secession. The ensuing correspondence revealed that forty-three of the sixty prints sent to Turin were from the personal collection of Stieglitz, which subsequently came to The Metropolitan Museum of Art as a gift in 1933 and as a bequest in 1949. Thus his desire to see the collection of photographs repose with master engravings, woodcuts, and lithographs, as he had contended they deserved to be, was fulfilled.

By 1911 Stieglitz had already begun to think about the disposition of his collection of photographs and The Metropolitan Museum of Art was first on his list as a home. Just before Christmas of 1911, Thomas W. Smillie, Honorary Custodian of the Section of Photographs, Smithsonian Institution, one of the first curators of photography in America, wrote to Stieglitz asking he could be of assistance in assembling a collection of pictorial photographs Stieglitz responded, "My collection is intended for the Metropolitan Art Museum [sic] some day," adding in his typically brusque manner, "I shall keep in mind your request." The collection which came to the Museum was the result of Stieglitz's activity as a collector between 1894 and 1911, when his acquisitions of photographs began to abate and his collecting of paintings commenced. Stieglitz's most active collecting of photographs coincided with his editorship of first *Camera Notes* (1897-1902) and later *Camera Work* (1902-17).

Between 1907, the year of his own remarkable photograph, *The Steerage*, and 1917, when he met Georgia O'Keeffe, Stieglitz entered a new phase in his own artistic life that was in many ways reflected among the photographs he had so resolutely assembled. The Collection of Alfred Stieglitz had, in the words of Georgia O'Keeffe, begun to collect him. More significantly, the photographs proved to represent a visual mode that he came to resent enormously, and against which he would produce in his own photographs of the 1920s what amounted to nothing less than a visual manifesto in repudiation of what many of the pre-war photographs he collected

represented esthetically.

Georgia O'Keeffe sagely perceived the discrepancy between Stieglitz's own esthetic and the one he expressed in work by others. She wrote that "the collection does not really represent Stieglitz's taste; I know that he did not want [by 1917] many things that were there, but he did not do anything about it [until his gifts to the Museum of 1922, 1928, and 1933]."

The scope and content of the Stieglitz collection is remarkable for it represents certain figures such as Kuehn, Puyo, and Demachy, who, if one were to judge from the appearance of Stieglitz's own photographs of the 1920s and 1930s, would not have had any appeal whatsoever because of their opposite visual premises. As could be expected, there are numerous works by photographers such as Clarence H. White and Edward Steichen, the co-founders of modernism in American photography, who today seem natural in such a collection. Stieglitz's collection was not, however, assembled with great rationality, but rather exhibits a recurring pattern of accidental, often spontaneous acquisition. Only in the case of the ten photographers represented in great depth was there a methodical attempt to be representative and historical. Seventeen photographers are represented by only a single print and any chronicle of Stieglitz's life as a collector must account for them as well as for the others to whom he committed himself more substantially.

In 1912 Stieglitz wrote to Heinrich Kuehn asking, "Isn't my work for the cause about finished? Useless to sacrifice time and money simply to repeat oneself — I don't believe in that and therefore I feel far too much the need for my own photography." By 1919, after the demise of *Camera Work* and the vigorous new interest in modern art, Stieglitz wrote his old friend R. Child Bayley of London regarding his collection of photographs. "It would make interesting history to write up how I came by all these famous masterpieces. They cost a fortune in actual direct cash outlay. My collection is undoubtedly unique." He went on to describe nostalgically the process of putting in order his "long neglected and messy personal affairs" particularly the five hundred to six hundred photographs, including "the collection of Steichens, Whites, Eugenes, Days, Puyos, Demachys, Kuehns, Hennebergs, Watzeks, Le Bègues, Brigmans, Käsebiers, Coburns, Seeleys, Hofmeisters, Keileys, Evans, etc., etc." The collection was cataloged on blue parcel post labels affixed to many of the prints and put into storage not long after these words were written. In 1922, Stieglitz again began thinking of the Museum, which resulted in gifts to the Museum of books and photographs in 1922, 1928, and 1933. In 1933 at the time of the gift of 418 photographs by others he had collected, Stieglitz wrote that "the collection represents the very best that was done in international pictorial photography upwards of seventy odd years. Over two hundred and fifty of the prints were exhibited at some time or other in the art galleries of Europe and in some of the American galleries. There are many priceless prints not existing in duplicate. The collection as it stands cost me about fifteen thousand dollars."

Stieglitz had a variety of personal relationships with photographers whose work he collected. Some work was acquired primarily because tnere had been an early friendship, such as with F. Holland Day, Joseph Keiley, Edward Steichen and J. Craig Annan. In many instances photographers sent work to him regularly as it was made and it formed simply the visual counterpart of a longstanding correspondence. This was particularly the case when the persons resided far from New York, as with Anne W. Brigman. Stieglitz apparently sometimes acquired photographs for reasons other than

their esthetic appeal to him. Käsebier's "first photograph" was a piece of memorabilia; other works demonstrated new processes or techniques being used by artistically oriented photographers, such as J. Craig Annan's photogravures.

Works of this kind were one of Stieglitz's first interests since they demonstrated the important interplay between processes of photography and the resulting image. Stieglitz also acquired works sent to him for reproduction in the various periodicals of which he was editor, including *American Amateur Photographer* (1893-97), *Camera Notes* (1897-1902), and *Camera Work* (1902-17). Stieglitz never accepted work for reproduction that he did not admire, but this does not necessarily mean he assumed the same emotional and philosophical commitment to every photographer or to every single work that was reproduced.

Then there was the core collection by a roster of names that first took public shape in 1899, changing gradually until 1902. By the time of the Photo-Secession, the roster had become crystallized and in 1919 Stieglitz could recite it from memory in a letter to Bayley. However, it should be noted that Stieglitz's collection does not include every Fellow or Associate of the Photo-Secession. After 1902 only a few new names were added to the roster, and one or two were even dropped.

Not every photograph Stieglitz acquired was on the same level of visual or historic strength, nor has every photographer come to be regarded as having realized the same consistency of accomplishment. In this regard Stieglitz's collection presents a spectrum of the range of work produced during the formative decades of artistic photography in Europe and America, without, however, including every photographer whose work might today be included in a survey of the period. Notably lacking are Peter Henry Emerson and Henry Peach Robinson. Many interesting figures such as Frank Sutcliffe in England; Achille Darnis in Paris; Robert R. von Stockert and Ludwig David Vienna; Franz Erhardt, Berlin; and Emma Farnsworth of the United States, famous then but little known today, are not included in Stieglitz's collection. Such a roster constitutes a coherent body of quality work that Stieglitz never collected even though he was certainly familiar with their photographs through the unavoidable reproductions in lavishly illustrated anthologies that included reproductions of his own work and which themselves established collegial context that itself could have supplied sufficient reason for Stieglitz to have acquired the work. Whether consciously or unconsciously, Stieglitz decided not to collect photographs by many workers who were held in very high regard then, and whose photographs look very strong today. It is evident that Stieglitz did not attempt to collect the photographs of every one of his talented contemporaries, but exercised his power to acquire in a discreet and highly personal manner. What then did the collection contribute to Stieglitz's understanding of photography in general or to his own creative work? Some of the more general answers are self-evident because collections of pictures by their nature teach certain lessons. Stieglitz was deeply influenced in his photographs before World War I by the work he collected. From the collection Stieglitz learned how to look at pictures, how to talk about them, how to exhibit them, and how to care for them. Between 1902 and 1910 Stieglitz traded his role as artist for one as curator and publisher. The collection was an incubative experience through which a part of his love and understanding of the medium of photography came to be, and through which a great portion of his influence on the emergence of American photography took material form outside of his own creative image-making. Perhaps the most revealing introduction to the collection is provided by

Stieglitz himself in a letter of transmittal, written in 1933, when he turned over to the Museum four hundred eighteen photographs. The letter, addressed to Olivia Paine, an associate of William M. Ivins, Jr., Curator of Prints, shows his growing ambivalence toward the collection and, in fact, how close he came to actually destroying it:

New York City, May 9, 1933
My dear Miss Paine
When you came to An American Place and asked me whether I'd be willing to send my collection of photographs to the Metropolitan Museum of Art instead of destroying it as I had decided to do even though I knew there was no such collection in the whole world and that it was a priceless one, I told you that the museum could have it without restrictions of any kind provided it would be called for within twenty-four hours.
The collection represents the very best that was done in international pictorial photography upwards of seventy odd years. Over two hundred and fifty of the prints were exhibited at some time or other in the art galleries of Europe and in some of the American art galleries. There are many priceless prints not existing in duplicate. The collection as it stands cost me approximately fifteen thousand dollars. This includes the cost of storage for years. In the collection sent you there are what might be termed some duplicates. In reality there are but few of such. What might seem duplicates to you are in reality different methods of printing from one and the same negative and as such become significant prints each with its own individuality. Frequently similar differences exist in photographic prints from one negative as appear in different pulls from one etching plate — differences in paper, differences in impression, etc. etc., giving particular value to each pull.
In case the museum accepts the collection I shall be only too glad at a future date to come to the museum when Mr. Ivins returns and go through the same with him and you and select what I think should go into the museum's files and which prints might be discarded. Still Mr. Ivins may decide to discard none, for all the prints sent were at one time or another of importance or I should not have incorporated them in the collection.
I might add here that a year or so ago Mr. Ivins expressed the wish that I should present the collection to the museum but at that time I did not know whether I could afford such a gift. To-day it is not a question of being able to afford to make such a gift but the question of how I can continue to physically take care of it for I am a poor man as far as finances are concerned and therefore I decided to destroy the collection so as to get rid of storage charges rather than to go out and try to place the prints piecemeal or in toto. I am telling you this so that you and your museum trustees can understand the facts as they exist. I might add that the collection contains about fifty Steichens and fifty Clarence Whites and fifty Frank Eugenes, all very rare examples of these internationally famous American artists in photography. There are furthermore the very rare French prints and Austrian prints, German prints and English prints together with other famous American prints.
The collection naturally does not include any of my own work since it is a collection I have made of the work of others. The museum has a collection of my own work.

Sincerely yours,
Alfred Stieglitz

Weston Naef
From *The Collection of Alfred Stieglitz*, New York, 1978

75

) photographs have been chosen from
red Stieglitz's own collection. These
otographs exhaustively illustrate the cultural
nate of the American Photo-Secessionist
vement. Arranged by Weston Naef, the
tures were first shown in 1978 at the
tropolitan Museum of Art in New York.

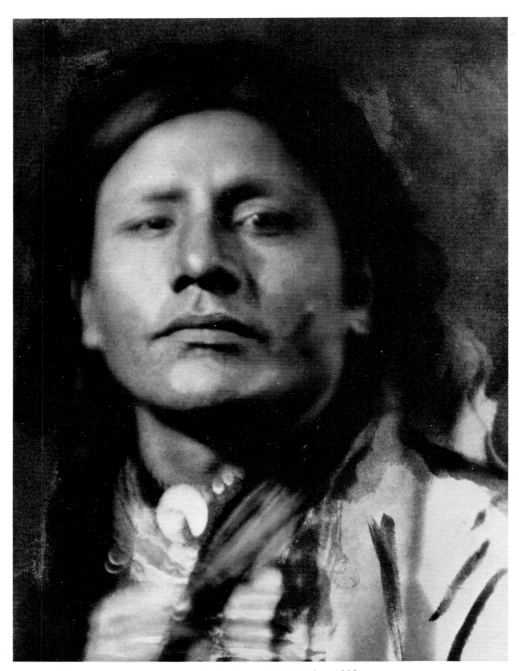

Joseph T. Keiley, A Sioux Chief, c. 1898

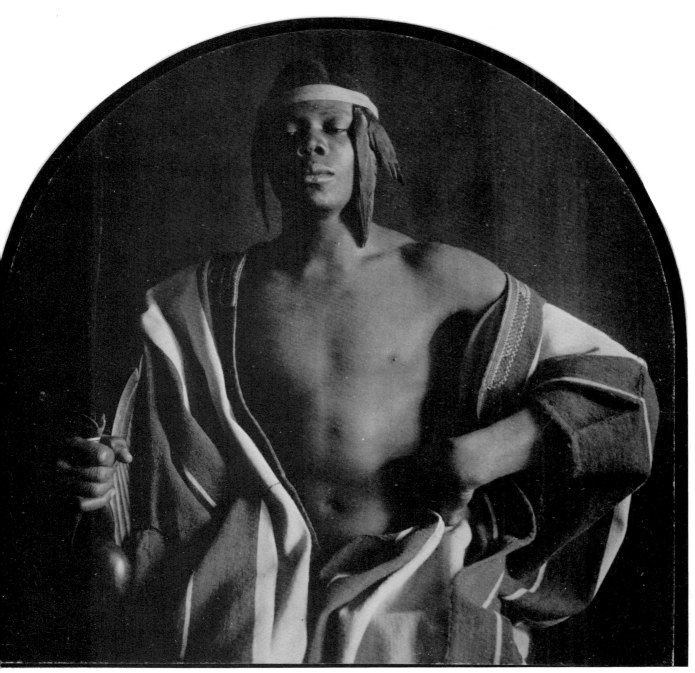

F. Holland Day, An Ethiopian Chief, c. 1896

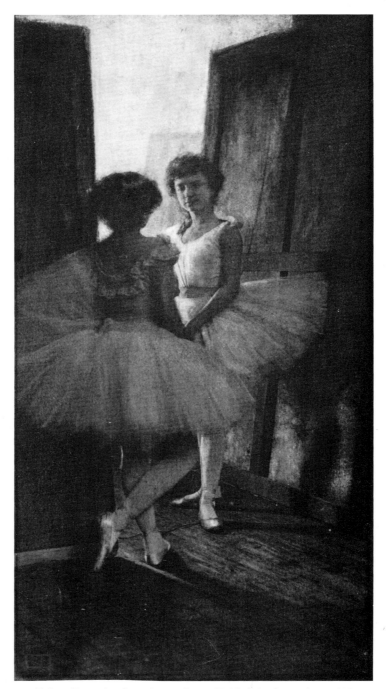

Robert Demachy, Dans les coulisses (Behind the Scenes), c. 1897

William B. Dyer, L'Allegro, 1902

Alvin Langdon Coburn, The Rudder, Liverpool, 1905

Archibald Cochrane, The Viaduct, 1910 or before

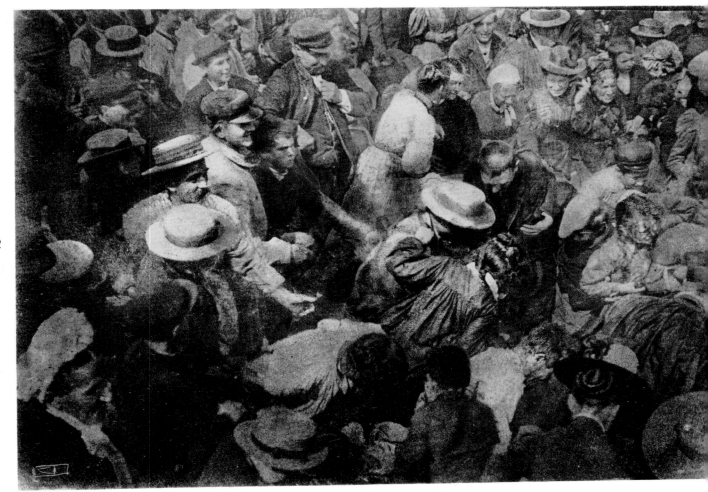

Robert Demachy, The Crowd, 1910

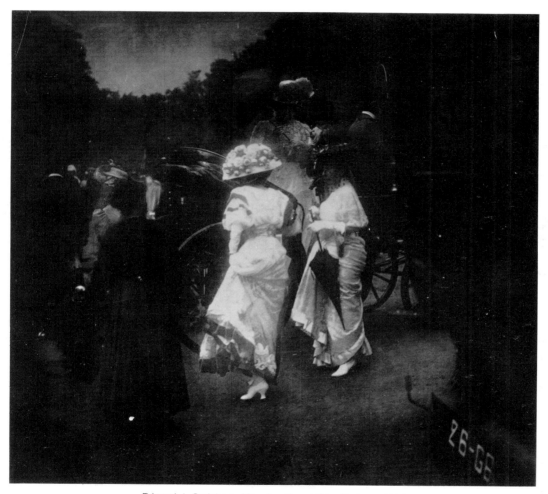

Edward J. Steichen, After the Grand Prix, Paris, c. 1911

84

Ansel Adams, Americana, 1933

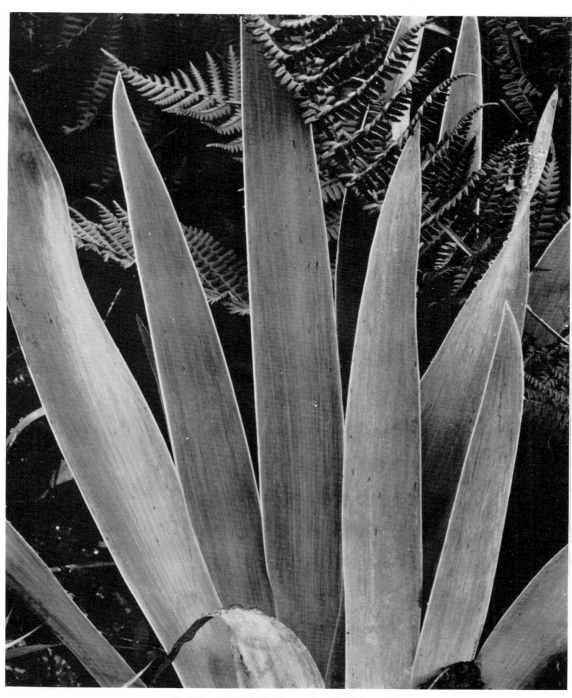

Paul Strand, Wild Iris, Center Lovell, Maine, 1927

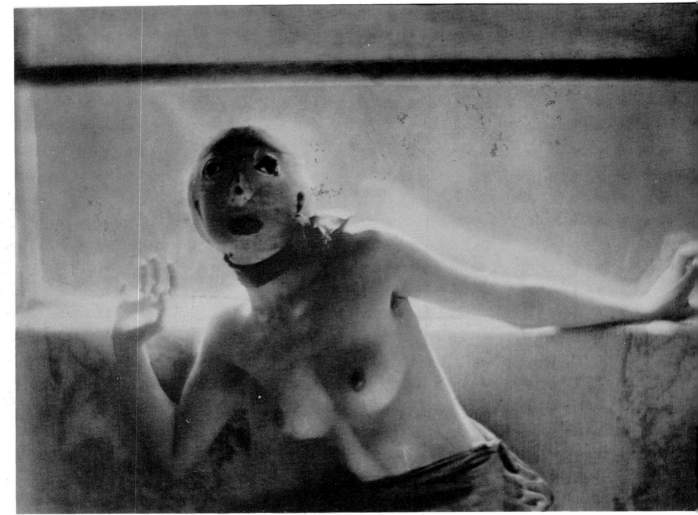

Baron Adolf de Meyer, Dance Study, c. 1912

Alfred Stieglitz

Alfred Stieglitz

Born in 1864 at Hoboken, New Jersey, of a German family, he died in New York in 1946. From 1871 to 1882 he studied in New York and in Berlin, where he studied engineering at the University. He first turned to photography in 1883.
In 1887 he travelled to Italy, where he did one of his first reports in Venice. In Europe he mixed with Emerson and Vogel. On his return to New York in 1890 he organized debates and promoted photographic clubs and journals.
In 1897 he founded Camera Notes, the organ of the Camera Club in New York. In that magazine he presented the American group "Photo Secession" in 1902. The same year an anthology of his collection was shown in Turin, through the good offices of the Duca degli Abruzzi.
In 1903 the first of what was to run into fifty issues of the legendary journal Camera Work, came out; publication ceased in 1917.
In 1905 Stieglitz inaugurated the "291" Gallery in New York. Here the works of avant-garde, including European, photographers and painters, whom Stieglitz was the first to introduce to the USA, were exhibited.
In his clique modern American photography was formed and found the stimuli and the tools for a dedicated discussion of the specific in photographic language. Stieglitz also did a number of reports on the port and city of New York, besides visual research and experiments on the form of natural elements.
In 1941 he donated to the Museum of Modern Art in New York a sizeable collection of his photographs. In 1945, one year before his death, the Philadelphia Museum of Art showed for the first time Stieglitz's collection of paintings and photographs.

When at age 26 Alfred Stieglitz returned to New York after nine years of schooling and picture-taking in Berlin, he was distressed to find Americans so insensitive to the great strides being made in photography in Europe. Wit two ex-roommates from Germany, he founded the Heliochrome Company — a commercial venture suggested by Stieglitz's businessman father. The photographer's main pursuit, however, was raising the level of respect for photography, particularly American, through exhibitions of the highest qualit

In 1891 Stieglitz joined the New York Society of Amateur Photographers, an two years later became editor of their magazine, American Amateur Photographer. In 1896 the Society merged with the New York Camera Club and as Vice-President of that organization Stieglitz initiated Camera Notes — a small journal that eventually expanded to 200 pages of the finest text and photogravures. The photogravure process, invented in Vienna by Karl Klíč in 1879, used polished copper plates to which a fine resin dust had been caused to adhere. Carbon tissue printed under a diapositive was transferred to the grained copper plate, and by washing with warm water soluble portion of the carbon image were removed. The plate was etched in perchloride of iron in successive baths, of varying strengths. After cleaning the gelatin off the plate, it was etched in different depths in proportion to the tones of the picture. One photogravure cost as much as the printing of a whole edition o the same picture by one of the other reproduction processes popular at the time, such as collotype or Woodburytype. Each photogravure was printed b hand, and tipped into the magazines.

In 1902 Stieglitz was asked by the National Arts Club to curate a photography exhibition, an event marking the first informal association of the Photo-Secessionists. The photographers Stieglitz selected included Alvin Langdon Coburn, Frank Eugene, Gertrude Käsebier, Edward Steichen, Clarence White, and himself, among other. They shared a passion and committment to photography, largely rooted in the advancement of photographs as pictorial expression, promotion of the photographic community, and the organization of man-exhibitions.

By 1902 Stieglitz had won over 150 medals around the world for his photographs, yet his love for photography did not increase his tolerance for the bickering among the more reactionary and conservative members of the Camera Club. He withdrew as Vice-President. With the assistance of his close friend Edward Steichen, who designed the cover, Stieglitz turned his energies to editing a new magazine, Camera Work. The first issue (January 1903) was devoted to Gertrude Käsebier, whose photographs were reproduced as photogravures on Japanese tissue. In all, 50 issues of Camera Work would be published between the years 1903-17, presenting the finest papers and designed to exacting standards Stieglitz's own work, well as many others including photographs of the Photo-Secessionists and Paul Strand. Each issue was printed in an edition of 1,000 copies with photogravures, mezzotint photogravures, duogravures, four-color halftones, and collotypes hand-tipped into the magazines. From the beginning Camera Work included articles on photographic criticism and techniques, as well as writings in philosophy, literature, reviews and discussions of the latest developments in painting and sculpture. Among the many contributors to Camera Work during its fourteen year history, in addition to Stieglitz, were George Bernard Shaw, Oscar Wilde, H. G. Wells, and Gertrude Stein.
In November, 1905, Stieglitz's 291 Gallery opened on Fifth Avenue, with a major exhibition of works by the Photo-Secessionists. The name referred to its location, at approximately 23rd Street, in the vicinity of the Flatiron

Building. The building no longer exists. Gradually the emphasis of the gallery would shift in the direction of painting and sculpture, although Stieglitz continued to show photographs along with the most advanced art of the time. Between 1905-17, the years 291 was open to the public, Edward Steichen had four one-man shows, the Baron de Meyer exhibited three times, Paul Strand exhibited once, and Stieglitz had a single exhibition of his own photographs from February 24-March 15, 1913. By the end of the first year, Edward Steichen had returned to Paris. His role in introducing Stieglitz (and America) to Rodin's drawings and the art of Matisse, Picasso and Cézanne would be incalculable. Steichen also alerted Stieglitz to the paintings of John Marin and Alfred Maurer, and brought him into the circle of Gertrude and Leo Stein. In 1912 Stieglitz was the first to publish Ms. Stein's writing, essays on Matisse and Picasso, in *Camera Work*.

In 1907 Stieglitz returned to Europe, his first trip since his student days. On shipboard he was repelled by the "nouveaux riches" and walked to the extreme bow of the ship to make an exposure which would become his most famous photograph, "The Steerage": "The scene fascinated me; A round straw hat; the funnel leaning left, the stairway leaning right; the white drawbridge, its railing made of chain; white suspenders crossed on the back of the man below; circular iron machinery; a mast that cut into the sky, completing the triangle. I stood spellbound for a while. I saw shapes related to one another — a picture of shapes, and underlying it, a new vision that held me: simple people, the feeling of ship, ocean, sky, a sense of release that I was away from the mob called 'rich'. Rembrandt came into my mind and I wondered would he have felt as I did."

"Some months later," Stieglitz wrote, "after 'The Steerage' was printed, I felt satisfied, something I have not been very often. Upon seeing it when published, I remarked: If all my photographs were lost and I were represented only by 'The Steerage' that would be quite all right."

The photogravures — portraits, landscapes and industrial scenes — are significant on many levels. Stieglitz's earliest images reflect the influences of pictorialism, and a romantic approach to photography which elevated it to "art". Most remarkable was Stieglitz's extraordinary technical expertise, which included, at the turn-of-the-century, the photographing of moving objects and landscapes in all kinds of adverse weather conditions.

By the early 1920's Stieglitz had begun to photograph his "Equivalents", the 4"x5" cloud series which next to "The Steerage" he felt were the equal of any images made to date. Clouds became a metaphor for Stieglitz's philosophy of life, and an opportunity to make images devoid of subject matter — as beautiful in their abstraction as music itself. Between the years 1922-34, he would make approximately 300 of these cloud pictures, occasionally duplicating images, but never making more than four or five prints of each. Most are unique.

In 1915, at a time when 291 was faltering financially and the demands of WWI seemed more pressing to many than art, Paul Haviland, Agnes Meyer, and Marius de Zayas approached Stieglitz with an idea for a new magazine. They selected the name of Stieglitz's gallery, and in March 1915, the first issue of *291* appeared — Alfred Stieglitz, publisher, Marius de Zayas, chief collaborator. Twelve numbers — six single and three double issues — would be printed within a year's time, the final magazine appearing in February, 1916. Originally inspired by Appollinaire's journal, *Les Soirées de Paris, 291* was clearly the most sophisticated American magazine of its day and a prototype for later Dada publications. Art and literature were often intertwined, as in Apollinaire's "ideogrammes", or poem-pictures. There were reproductions of recent paintings and drawings by Picasso, Braque, and

Bibliography

American Amateur Photographer, magazine, New York, 1893-1896.
Camera Notes, journal, New York, 1897-1902 (quarterly).
Pictoresque Bits of New York and Other Studies (12 images), New York, 1898.
J. Keily, *Exhibition of Photographs by Alfred Stieglitz*, New York, Camera Club, 1-15 May 1899.
Camera Work, journal, New York, 1903-17 (quarterly - 50 issues).
291, New York, 1915-16.
G. Bruno, "The passing of 291," in *Pearson's Magazine*, 13 Mar. 1918.
S. Anderson, "Alfred Stieglitz," in *New Republic*, 32, 25 Oct. 1922.
L. Mumford, "A Camera and Alfred Stieglitz," *The New Yorker*, 22 Dec. 1934.
AA.VV., *America and Alfred Stieglitz, a Collective Portrait*, New York, 1934.
G. Engelhard, "The Face of Alfred Stieglitz," in *Popular Photography*, 9, 1946.
P. Strand, "Alfred Stieglitz 1864-1946," in *New Masses*, 60, 6 Aug. 1946.
E. Steichen, "Alfred Stieglitz 1864-1946," in *U.S. Camera*, 9 (Sept. 1946).
D. Norman, *Stieglitz Memorial Portfolio*, New York, 1947.
D. Bry (catalogue), *Alfred Stieglitz*, National Gallery of Art, Smithsonian Institute, Washington, 1958.
D. Bry, *Alfred Stieglitz Photographer*, Boston, 1965.
D. Norman, *Alfred Stieglitz, an American Seer*, New York, 1973.
M. Hiley, *Alfred Stieglitz*, Millerton, 1976.

50 original photographs from Alfred Stieglitz's known output, now in the archives of the Zabrinskie Gallery in New York, form the subject of this exhibition. The anthology documents the salient phases in the photographic career of a decisive figure in American contemporary culture.

Picabia, whose emphasis on the duality of machine imagery lent a decidedl French flair to the magazine. Picabia, who had been conscripted into the French army, jumped ship in New York and calmly took up residence in Manhattan. Beginning with the second issue, he was a frequent contributor *291*. He was so taken with Stieglitz's magazine that upon his return to Europe, in 1917, he initiated a similar review in Barcelona, *391*.

One issue of *291* was completely devoted to photography (no. 7-8, September-October, 1915) and included a large-format photogravure of "T Steerage", the original having been a small-scale silver print of which very few copies exist. A small version of "The Steerage", in photogravure, had been tipped into *Camera Work*, no. 36, October, 1911. Five hundred *291* large proofs were pulled on Imperial Japan paper, with a smaller deluxe edition pulled on thin tissue. When *291* was no longer being printed, and th 291 Gallery closed, Stieglitz sold most of the remaining 8,000 magazine copies to a rag picker for $ 5.80. It was wartime, and the gesture matched Stieglitz's contempt for a public that had largely ignored his daring and lovingly crafted magazine. Eventually he destroyed the greater part of the deluxe edition also.

After *Camera Work* and *291* Stieglitz persuaded a small group of writers wl clustered around him to take the responsibility of seeing their own work in print. *MSS* (for "Manuscripts"), a small literary magazine with a cover designed by Georgia O'Keeffe, contained articles by such authors as Sherwood Anderson, Waldo Frank, William Carlos Williams, Leo Stein and Carl Sandburg. It concentrated on poetry, criticism, and music, with six issues appearing between the years 1922-23. It was about this time, in 192 that Stieglitz married his second wife — Georgia O'Keeffe — who had become a favorite photographic subject since their meeting in 1916.

After *291* closed, Stieglitz was associated with two additional galleries: The Intimate Gallery (1925-29) and An American Place (1929-46). In 1932 he showed 127 of his photographs at An American Place. This show, the first one-man exhibition since 1924, was retrospective in nature, with works spanning his entire career. The occasion for the show was ostensibly to exhibit new photographs of New York, 8"x10" silver chloride contact prints all of which were taken from the high windows where he lived and worked the Shelton Hotel and An American Place. The show was rounded out with 28 "Equivalents" and portraits of friends, O'Keeffe, and Lake photographs Lake George. The discovery of 22 glass negatives in the attic of his Lake George home, works from the early European days, prompted a small second show at the Place, in 1934. These plates were printed on modern chloride papers, an experiment in comparisons with platinum prints of the same subjects made in the 1880's and 1890's. Other photography shows would follow (Ansel Adams, Eliot Porter) but 1934 was Stieglitz's final one-man exhibition, and aside from a few prints included in a group show i 1941 (in which he exhibited his own work next to collages, drawings and prints by Dove, Marin, O'Keeffe and Picasso) he would not show again publicly.

Beth Urdang

Equivalent, n.d.

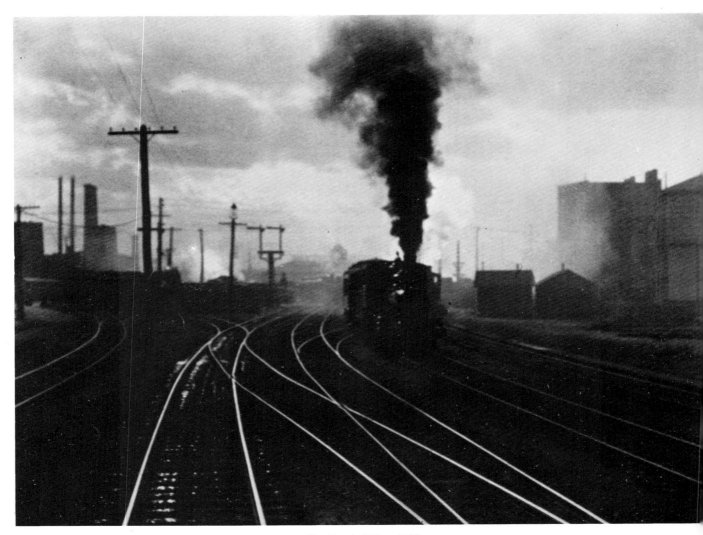

The Hand of Man, 1902

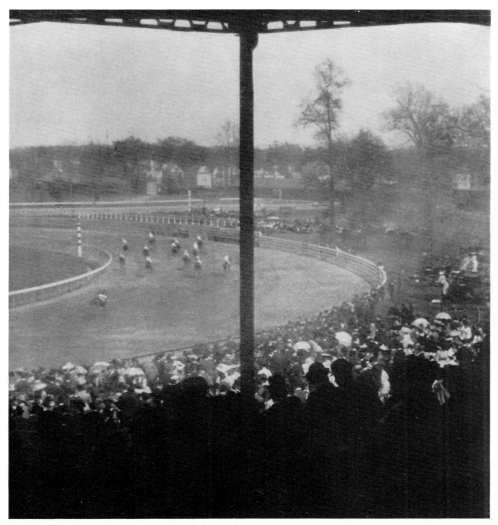

Going to the Start, 1904

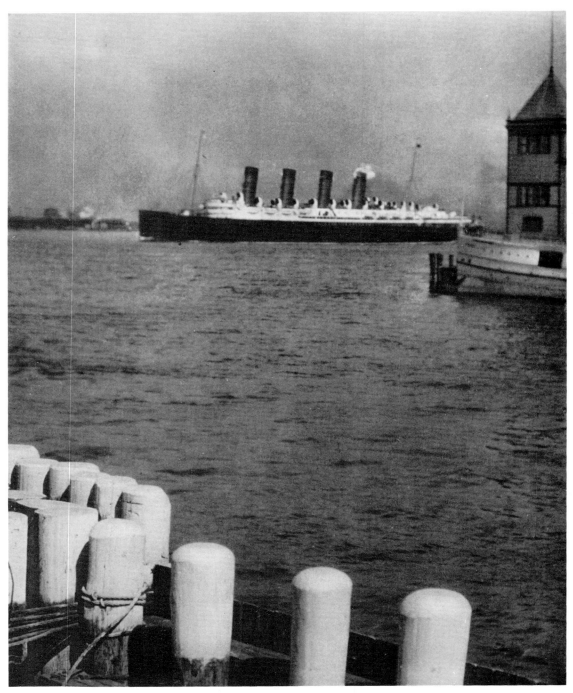

The Mauritania, 1910

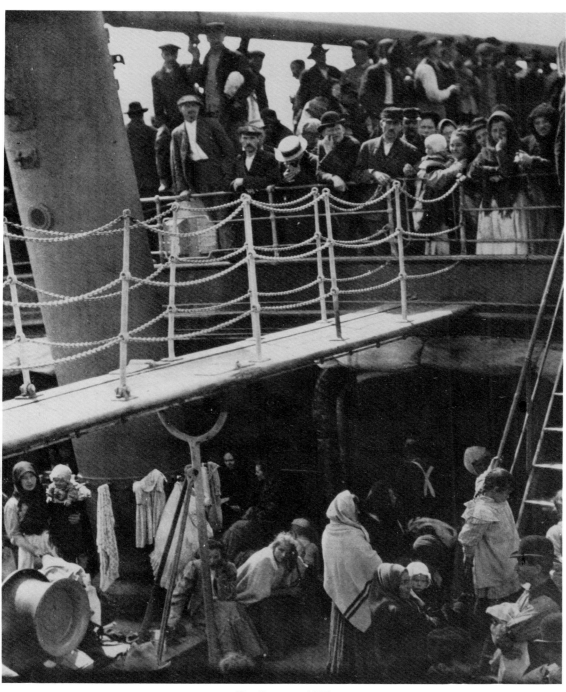

The Steerage, 1907

Lower Manhattan, 1910

A Dirigible, 1910

Equivalent, 1926

Equivalent, 1929

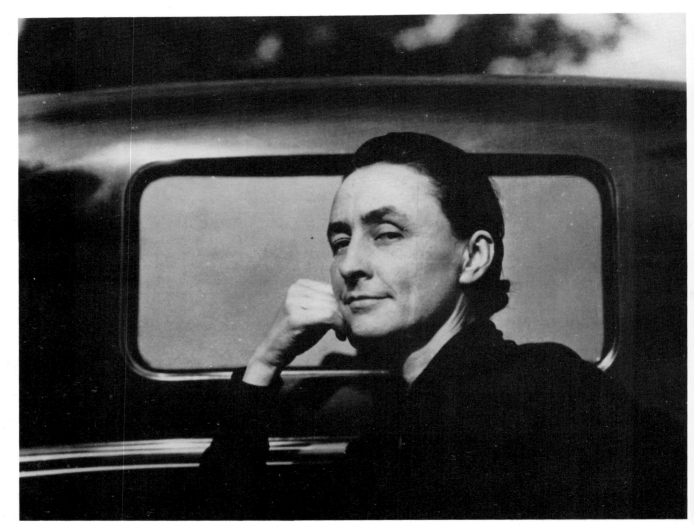

Portrait of Georgia O'Keeffe, 1929

View of Small House, Lake George, New York, n.d.

101

102

From the Shelton, Looking North, early 1930's

Edward Weston's Gifts to His Sister

Edward Weston's
Gifts to His Sister

Born at Highland Park, Illinois, in 1886, he died in California in 1958.
He took up photography in 1902, devoting himself to painterly portraits. But he gave up this technique around 1920 in favour of the "direct" photography energetically suggested by Stieglitz and already applied by photographers like Paul Strand.
In 1923 he travelled to Mexico and stayed there for two years, becoming a friend of the painters Siqueiros, Rivera and Orozco. His companion was Tina Modotti, an artist and a revolutionary of Italian origin. She was also his pupil and model.
Weston did research into the "specific" (extreme sharpness of detail, for example) and into the expressive autonomy of photography; he was always faithful to the physiognomy of his subjects, which he sharply decontextualized in order to highlight their meaningful *form*.
In 1929 he photographed the landscape of Point Lobos and in 1936 the Californian desert, producing his most important collections of pictures. In 1932, with Ansel Adams, Imogen Cunningham, Willard Van Dyke and others, he founded the "Club F/64", which became an emblematic signpost for the "new photography."Its equivalent in Europe was represented by the "Neue Sachlichkeit" photographers and particularly by Albert Renger-Patzsch, with whom he showed at the exhibition in Stuttgart in 1929, organized by the Deutsche Werkbund under the title "Film und Foto."
In 1937 Edward Weston won the first Guggenheim award to go to a photographer. He married Charis Wilson in 1938. In 1947 he worked on the film *An American Photographer* as colour consultant. In 1955, with the help of his son Brett he published a summary of his work in *50th Anniversary Portfolio*.

In his Daybook on April 9, 1927, Edward Weston wrote: "I have been fortunate to have a sister so close to me." This closeness began during childhood, when Edward's mother died and his sister, May, assumed a maternal role. Although Edward and May were frequently separated by great distance, they maintained their closeness through a continual exchange of letters and postcards. Edward wrote about his work, his daily schedule and i later years told of the activities of his sons. He also sent well over one hundred prints to demonstrate his achievements. This continuing flow of photographs enabled May to share in her brother's work. The exhibition presents an opportunity to examine this collection of photographic gifts.

The first exchange of photographs undoubtedly took place soon after Edwar established his studio in California in 1911. Edward and May, who had married John Seaman, were living in Tropico, a suburb of Los Angeles, now called Glendale. Perhaps due to parental pride, Edward's earliest gifts to Ma were portraits of his own children and of his nieces and nephew. The Westo and Seaman children were ideal subjects for Edward and he captured them at various ages and in many different poses. These family photographs are rare examples of Weston's early portrait work, highlighted by the personal overtones of the family relationships. This group of photographs dating from the second decade of this century serves, as the only examples in this collection of Weston's so-called pre-Mexican period. Although it seems clea from one of Edward's 1942 postcards to May, that her collection at one time contained examples of her brother's prize winning salon photographs. He wrote: "... return the old Weston 'salon' prints for editing!" May must have followed her brother's instructions because examples of this genre have not survived in her collection.

It is generally accepted that Weston's 1922 visit to Middletown, Ohio, and th work he did there represent a turning point in his photographic career. The Seaman family had moved to Middletown in about 1920 and Edward was eager to visit with his sister prior to his departure for Mexico in 1923. May's husband John, an electrical engineer, had numerous industrial contacts in Middletown and was able to arrange for Edward to photograph at the Armco Steel Mill. Weston found the industrial subject matter exciting and the resulting photographs forecast a new direction in his work: sharp focus. May and particularly John, then helped to finance Edward's visit to New York where he met his east coast counterparts, the photographers Alfred Stieglitz Paul Strand, and Charles Sheeler. Edward remained grateful to the Seaman for their encouragement and financial help.

Edward traveled to Mexico in 1923 and stayed there until 1927. Brother and sister maintained their correspondence during this period, although it is uncertain how many Mexican photographs Edward actually sent at that time. Edward's financial situation was constantly strained in Mexico and the cost o his then preferred platinum paper was very high. Because of this and the additional expense of mailing, it seems unlikely that all the Mexican and 192 San Francisco photographs presently in the collection were sent during the 1920's. That May was both conscious of and sensitive to her brother's situation in Mexico emerges from Edward's comment in his Daybook on the occasion of his birthday in 1924: "From dear sister a letter enclosing a U.S. 'greenback' which will be promptly transposed into ten pesos plus." While Edward sent a few examples of his Mexican work at the time to keep May current on the progress of his work, the majority of the prints in the collectic were probably sent years later during a period when Edward was reassessir his earlier work. May was always anxious to receive any and all of her brother's photographs.

bliography

Rivera, "Edward Weston y Tina Modotti,"
Mexican Folkways, II, Apr.-May 1926.
merica und Fotografie, in catalague of the
hibition "Film und Foto," Deutscher
rkbund, Stuttgart, 1929.
Armitage (ed.), *The Art of Edward Weston*,
w York, 1932.
Weston, "My photographs of California," in
gazine of Art, 1939.
Weston and C. Wilson, *California and the
st, New York, 1940.
Whitman, *Edward Weston, Leaves of
ass, New York, 1942.
Newall, *The photographs of Edward
ston, New York, The Museum of Modern
*, 1946.
Newall, *Edward Weston*, New York, 1946.
Wilson, *The Cats of Wildcat Hill*, New York,
47.
Weston, *My Camera on Point Lobos*,
ston, 1950.
and N. Newall, *Master of Photography*,
w York, 1958.
Newall (ed.), *The Daybooks of Edward
ston, New York, 1973.
Maddow, *Edward Weston: Fifty Years*,
lerton, New York, Aperture, 1973.
Wilson, *Edward Weston: Nudes*, Millerton,
w York, Aperture, 1977.

Edward returned to California and settled in Carmel in 1929, where he embarked on a new aspect of his photographic career, concentrating on fruit and vegetable forms, shells, and the local natural wonders at Point Lobos. He kept May appraised, sending fine examples of his fruit and vegetable studies: bananas, onion, and kale. Certainly May was well acquainted with this period of her brother's work, for she had moved to New York around 1930 and was there to celebrate the opening of Edward's one-man exhibition at Alma Reed's Delphic Studios in 1932. May spent a great deal of time at the Delphic Studios studying Edward's most recent work. It is clear from the correspondence that not only was May receiving frequent photographic gifts but that she even requested specific prints she had grown fond of during the exhibition. May wrote: "It is simply bewildering to try to decide so I have marked a number... The Cabbage Sprout Magnified I have held to from the first. The Cypress Root... is very different from anything I have so I'd love to have that." May did receive the Cabbage Sprout Magnified and a Cypress Root and cherished these prints as she added them to the growing collection of her brother's photographic accomplishments. May obviously became firmly attached to the photographs Edward sent, because in her reply to her brother's request that she deliver a print to one of his friends she wrote: "I never gave her the print — If you want to send her one you'd better send it direct as I can't let any of them go once I get my hands on them."

May returned to Glendale in 1935 and a photograph of a pepper was appropriately inscribed and sent by Edward to mark his sister's return to California. Speculating why Edward selected certain images to send to May, Weston's sons Brett and Cole commented that they felt their father chose photographs in which he was particularly interested at the time. They also believe that Edward was especially sensitive to selecting photographs which would delight May. One cannot help but wonder if the embracing form of this pepper was chosen as a symbol of welcoming May back to California.

105

Brett and Cole both acknowledge that their father's love for his sister was constant and enduring and recognize the important role she played throughout his life. Brett even adopted his father's practice of sending photographs. From 1935 to 1937, when Edward and Brett were living in Santa Monica, they often made day trips to photograph the dunes at Oceano. Edward sent a number of his Oceano dunes prints to May in 1936 and inscribed two of these photographs to celebrate his sister's birthday and mark the Christmas season. Brett followed his father's example and sent photographs of his own work at the dunes to Aunt Mazie, as he called her. The group of Oceano photographs contains the only print of a nude which May received. While nudes are an important part of Weston's oeuvre, he seems to have felt it inappropriate to send these to his sister.

In 1937 Weston received a Guggenheim Fellowship which enabled him to travel and photograph throughout the western United States. Charis Wilson, Edward's second wife and partner on the Guggenheim trip, recalls that Edward would visit May when he returned to the Los Angeles area and take unmounted prints with him as gifts. This accounts for the large number of unmounted Guggenheim photographs in May's collection. In some cases these photographs are unique prints since another view of the subject was selected for subsequent printings. In 1938 when Edward's Fellowship was renewed, he and Charis returned to Carmel so that he could undertake the task of printing his Guggenheim photographs. Undoubtedly, the mounted Guggenheim prints in May's collection were sent at this time and in subsequent years.

With Ansel Adams, Edward conducted a photographic class in 1940 in the area around Lake Tenaya. It was on this trip that Edward made "Church Door, Hornitos" as well as "Wall Scrawls, Hornitos" both of which are included in May's collection. Ansel photographed Edward preparing to photograph Lake Tenaya, as part of the instruction for their class. May received one of Ansel's prints, on the verso of which Edward had written "E W. at work. We took our class here (Lake Tenaya). This photograph is a discard by Ansel." Although a proof print, it depicted Edward with his camera, thus giving May further insight into her brother's method of working

Edward accepted a commission from the Limited Editions Club in 1941 to travel throughout the south and the east to photograph illustrations for a new release of Walt Whitman's *Leaves of Grass*. About this time May suffered a stroke which left her partially paralyzed. In an effort to keep her spirits bouyant Edward increased his correspondence so that his cards arrived almost daily. The cards and letters were interspersed with packages of photographs, containing current as well as earlier work, which Edward hoped would please his sister. Edward maintained this correspondence even while traveling for the *Leaves of Grass* commission. The outbreak of the second World War brought him back to Carmel to develop his negatives and complete the Whitman project. As he selected the images to submit to the Limited Editions Club, Edward simultaneously picked our photographs from his travels to send to May. These photographs were a visual complement to the narrative of Edward's postcards from the ten month trip. Edward continued sending *Leaves of Grass* prints to May throughout the 1940's comprising a group of images which are little known and rarely exhibited. These photographs provide a fascinating view of the America Weston visited in 1941 highlighted by the written comments in his postcards to May. With the aid of these postcards, serving as a log of the trip, the more than thirty *Leaves of Grass* photographs can be arranged according to Edward's 1941 itinerary.

Probably the last gift May received from her brother before her death in 1952, was the *Edward Weston Fiftieth Anniversary Portfolio 1902-1952* inscribed "To my one and only little sister with all my love, Brother." The portfolio included twelve of Edward's finest photographs, limited to an edition of one hundred copies. The portfolio certainly gave May further cause to be proud of her brother's accomplishments. May's encouragement of her brother never flagged and the photographic gifts which she received not only brought her tremendous pleasure but satisfied her intuition that Edward was immensely gifted. In her letters, May praised his photographic work and expressed delight at his success: "My brother has arrived all over the world!... It is no more than you deserve, my darling brother... How proud I am of you!"

This collection is indeed a very special one, unique because Edward personally selected the photographs he sent as a continual renewal of the closeness that he and his sister shared. It is important not only because of the many rare photographs it contains, but also that so often the prints were accompanied by Edward's own writings. Finally, it is important because of Edward Weston — a consummate artist, whose images speak for themselves.

Kathy Kelsey Foley

Gathered together in this exhibition are one hundred and fifty photographs which in various circumstances Weston gave to his sister May. These works were first assembled and exhibited at the Dayton Art Institute of Dayton, Ohio, under the directorship of Kathy Kelsey Foley.

Mojave Desert, 1937

108

New Mexico, 1933

Untitled (Ship, San Francisco), 1925

Shell, 1927

111

Kelp, 1930

Model for Mould, 1936

Rubber Dummies, MGM Studios, 1939

Untitled (Juniper, Lake Tenaya), 1937

Plantation House Ruins, New Orleans, 1941

115

Connecticut, 1941

117

Untitled (Powerhouse, Connecticut), 1941

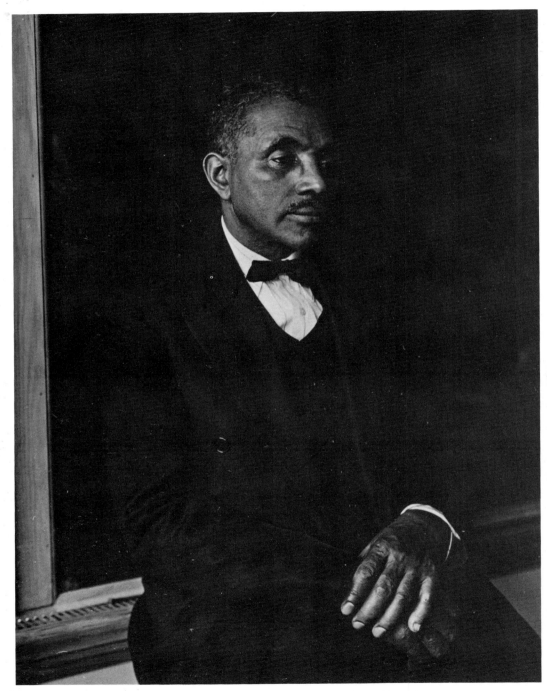

Untitled (Mr. Brown Jones, Athens, Georgia), 1941

Tina Modotti

Tina Modotti

Born at Udine in 1896, Tina Modotti emigrated with her family to the United States in 1913. She married the painter Richey and lived in Los Angeles, where she made a number of commercial films in Hollywood in the role of the beautiful, hot-blooded and jealous Italian woman. In 1921 she met Edward Weston and with him moved to Mexico, where she took up photography. In 1927 she became a member of the Mexican Communist Party and worked in both political and artistic circles. She was connected with the Artists' Union group, which included Orozco, Rivera and Siqueiros and whose *murales* she photographed. Her style moved from still-lives and spatial compositions with strong abstract references to a closer account of the Mexican environment and people. Accused of having murdered her new companion, the young Cuban revolutionary Julio Antonio Mella, she was expelled from Mexico in 1930. From 1930 to 1937 she lived in Germany, Russia and France. She gave up photography to devote herself to the International Red Relief beside Vittorio Vidali, together with whom she also fought in the Spanish Civil War. She succeeded in re-entering Mexico in 1939, where for a while she resumed photography. She died of a heart attack in 1942.

Bibliography

AA.VV., *Tina Modotti, Garibaldina e Artista*, Udine, 1973.
M. Constantine, *Tina Modotti, A fragile Life*, New York, 1975.
AA.VV., *Tina Modotti fotografa e rivoluzionaria*, Florence, 1979.

120

A Vittorio Vidali, Comandante Carlos

Yo sabía de ti, Tina Modotti,
de tu precioso nombre, de tu gracia,
de tu fina y dulcísima presencia,
mucho antes de verte, de encontrarte

cualquier noche de guerra, una mañana
madrileña de sol, en esos días
en que se alzaba el Quinto Regimiento
como el inmenso brote de una espiga
que se abriera cubriendo los campos de batalla.

Apenas si te vi. Pero me basta
recordarte sabiendo lo que eras:
el humano fervor de tus fotografías,
tristes rostros de México, paisajes,
ojos de amor para fijar las cosas.

Tú vives entre todos, no es preciso
pensarte lejos de ninguna tierra,
tu tierra está en el aire que nos trae
la luz dichosa de tu bello ejemplo.

Es verded. No estás muerta. Tú no duermes
porque lograste al fin lo que querías.
Dame la mano, hermana, caminemos.
Hoy has de hablar aquí. Ven. Te escuchamos.

Rafael Alberti
Madrid, julio de 1978

Through 85 original photographs this exhibition arranged by Megi Pepeu illustrates Modotti's creative development from her lyrical compositions between naturalism and abstraction during the early 1920s and her later work which was more steeped in the vital and political reality of Mexico.

121

Composition with sickle, cartridge-belt and guitar, 1927

122

Electric wires, 1928

Elegance and Poverty, 1927

124

The typewriter of Julio Antonio Mella, 1929

125

Stadium, Mexico City, 1926

Reservoir no. 1, 1928

A Private Collection: Sam Wagstaff

A Private Collection: Sam Wagstaff

How just that photography, whose subject is light, should come to the one city in the world whose magic is so largely one of mirrors — by moonlight, in the perpendicular light of midday, those few minutes in the late afternoons when the windows of San Marco's facade are on fire, or squirming on the ceiling.

The light here speaks a universal language. It needs no translation or guide book — neither does its sister Esperanto of light, Photography. It too is a language we all share — in silence or coated with words. Take your choice, but just remember that when two people speak at the same time neither is heard.

If you think you might be missing something in this show by not reading about it, as you look you could chant these protective thoughts by the poet Wallace Stevens:

Poetry must resist the intelligence almost successfully
and
The poem reveals itself only to the ignorant man
(to the tune of "sul mare luccica l'astro d'argento...").

Many lose, welcome to a temporary addition to the amusement park.

This exhibit comprises about 200 photographs from the Sam Wagstaff Collection in New York based on a standard which, though not neglecting the requirements of historical documentation and of objective quality of the pictures, allows the collector's personal and distinguished taste to be recognized.

Sam Wagstaff

128

Adolphe Braun, Still life, c. 1855

William Henry Fox Talbot, Trafalgar Square, c. 1844

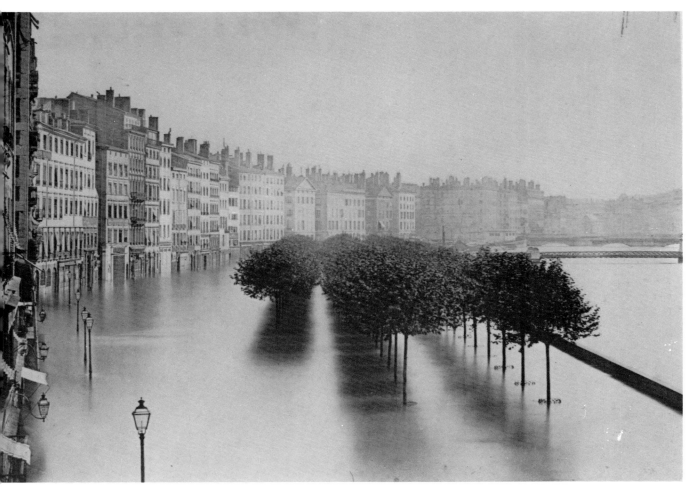

Froissart, Flood at Lyon, 1856

132

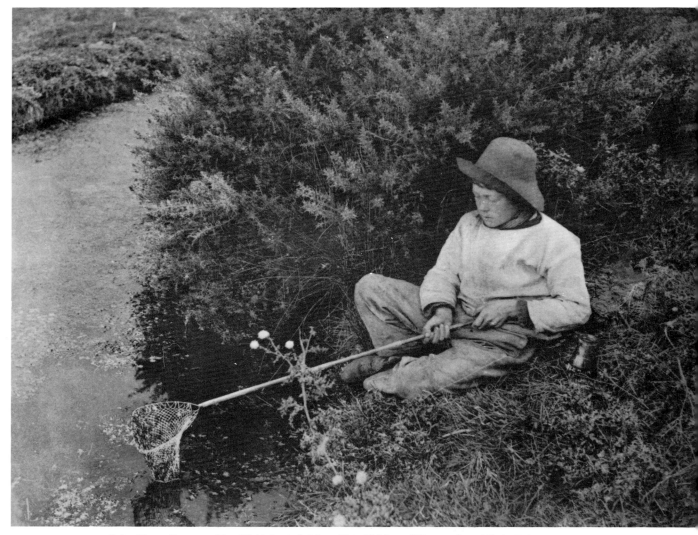

Peter Henry Emerson, The Stickleback Catcher, Plate XVI from "Pictures from Life in Field and Fen", 1887

133

Lewis Carroll (Reverend Charles L. Dodgson), Girl on a sofa, c. 1859

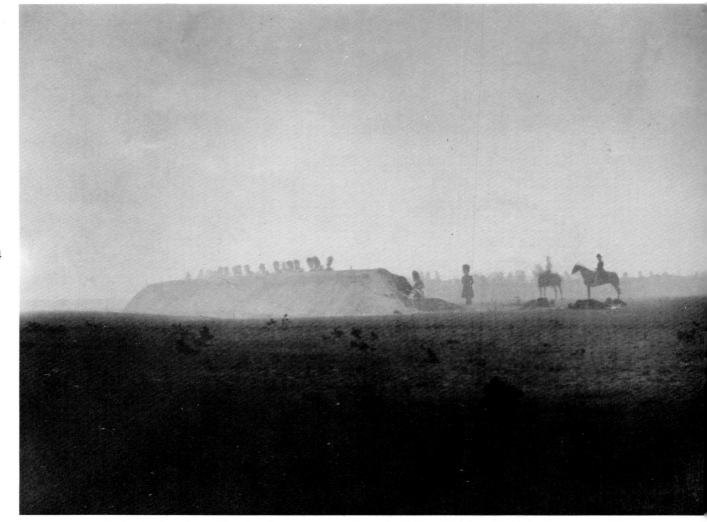

Gustav Le Gray, Annual French military maneuvers, Camp-de-Châlons: The Guard Behind a Breastwork, 1857

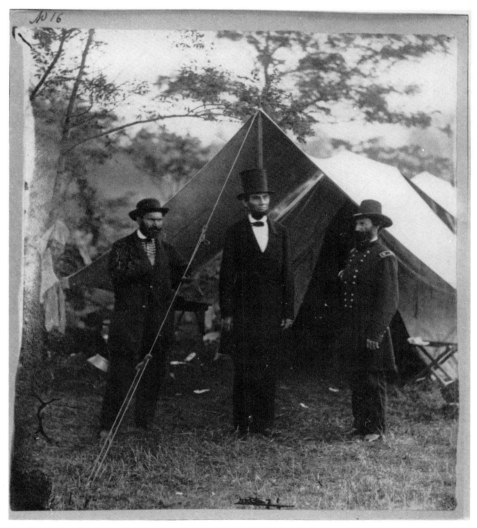

Alexander Gardner, President Lincoln on the Battlefield of Antietam, Md., with Major General McClernand and Allan Pinkerton, Chief of the Secret Service, October 3, 1862

136

Felice A. Beato, Japanese in Mackintosh, c. 1865

Carleton E. Watkins, "Vernal Fall, 350 ft. Yosemite Valley, Cal. No. 44"
published by Thomas Houseworth & Co., San Francisco, c. 1864-66

138

Baron Wilhelm von Gloeden, Boy Holding Lilies, Taormina, Sicily, 1902

Karl Moon, Navajo Boy, 1907

Arnold Genthe, New Orleans Mammy, c. 1920 Cecil Beaton, Marlene Dietrich, 1932

140

Walker Evans, Liberté, Promenade Deck, Port Forward, 1958

Robert Capa

Robert Capa

Born in Budapest in 1913, he died in Indo-China in 1954 while on a front-line report.
He arrived in Berlin from Budapest when still very young, and attended university there. But from 1931 to 1933 he worked as an assistant photographer and cameraman before fleeing to Paris to escape the Nazi racist persecutions.
In Paris he worked at first for the agency ''Dephot'', introducing French journalism to the new methods of German photographic reporting which were being defined in those years especially by Salomon and Zille.
In 1936 he joined the Republicans in the Spanish Civil War, during which he took some of his most famous and dramatic pictures. In 1938 he was in China at the time of the Japanese invasion, and as correspondent for *Life* he photographed the war in Europe between 1941 and 1945. But his work is marked not so much by his observation of war itself as by a human interest in the existential condition of the civilian populations affected by the conflicts.
With Cartier-Bresson, Rodger, Vandivert and Seymour, he founded the ''Magnum Photos'' agency in 1946.
Between 1948 and 1950 he documented the struggle to set up the independent State of Israel; next he was in Indo-China, where he met his death.

142

Bibliography

R. Capa, *Death in the Making*, New York, 1937.
R. Capa, *The Battle of Waterloo Road*, New York, 1943.
R. Capa, *Slightly out of Focus*, New York, 1947.
J. Steinbeck, *The Russian Journal*, New York, 1948.
I. Shaw, *Report on Israel*, New York, 1950.
R. Capa, *Images of War*, New York, 1964.
A. Farova, *Robert Capa*, Prague, 1968.
C. Capa-B. Karia, *Robert Capa: 1913-1954*, New York, 1974.

This exhibit is especially prepared for ''Venezia '79/La Fotografia'' by Robert Capa's brother, Cornell. It contains some of Robert Capa's best known photographs as well as others that are unpublished. The emphasis of the exhibit is not on the clashes of armies, bravery or the humiliation of uniformed soldiers, but rather on the physical and spiritual indignities and suffering inflicted on civilians, without prejudice of race, creed or age.

I know nothing about photography. What I have to say about Capa's is stric[t] from the point of view of a layman, and the specialists must bear with me. I[t] does seem to me that Capa has proved beyond all doubt that the camera need not be a cold mechanical device. Like the pen, it is as good as the m[an] who uses it. It can be the extension of mind and heart.
Capa's pictures were made in his brain — the camera only completed them. You can no more mistake his work than you can the canvas of a fine painte[r]. Capa knew what to look for and what to do with it when he found it. He knew, for example, that you cannot photograph war because it is largely an emotion. But he did photograph that emotion by shooting beside it. He cou[ld] show the horror of a whole people in the face of a child. His camera caugh[t] and held emotion.

Capa's work is itself the picture of a great heart and an overwhelming compassion. No one can take his place. No one can take the place of any fine artist, but we are fortunate to have in his pictures the quality of the ma[n]. I worked and traveled with Capa a great deal. He may have had closer friends but he had none who loved him more. It was his pleasure to seem casual and careless about his work. He was not. His pictures are not accidents. The emotion in them did not come by chance. He could photograph motion and gaiety and heartbreak. He could photograph though[t]. He made a world and it was Capa's world.

The greatness of Capa is twofold. We have his pictures, a true and vital record of our time — ugly and beautiful, set down by the mind of an artist. But Capa had another work which may be even more important. He gathere[d] young men about him, encouraged, instructed, even fed and clothed them; but, best, he taught them respect for their art and integrity in its performanc[e]. He proved to them that a man can live by this medium and still be true to himself. And never once did he try to get them to take his kind of picture. Thus the effect of Capa will be found in the men who worked with him. The[y] will carry a little part of Capa all their lives and perhaps hand him on to their young men.
It is very hard to think of being without Capa. I don't think I have accepted that fact yet. But I suppose we should be thankful that there is so much of him with us still.

John Steinbeck
From *R. Capa Images of War*, New York, 1964

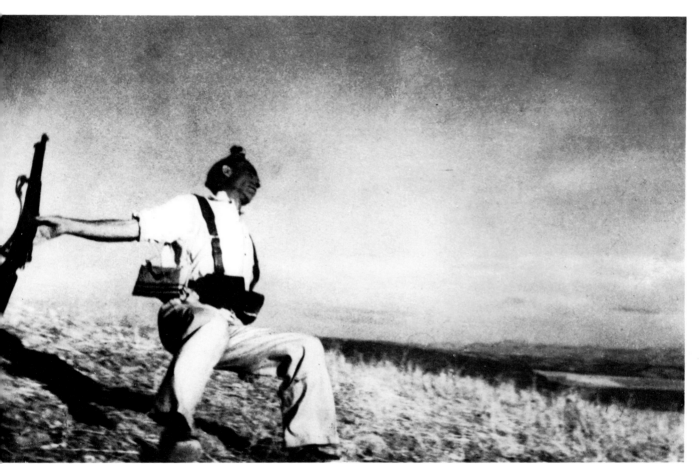

Soldier at the very moment of death during the Spanish Civil War in 1936

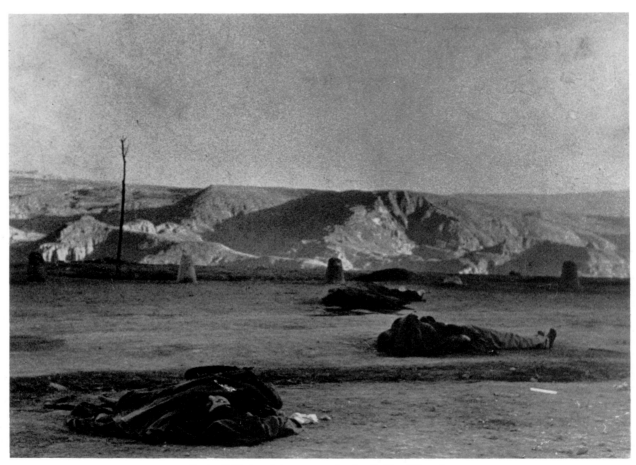

144

Spain, 1936. Loyalist corpses after the Battle of Teruel

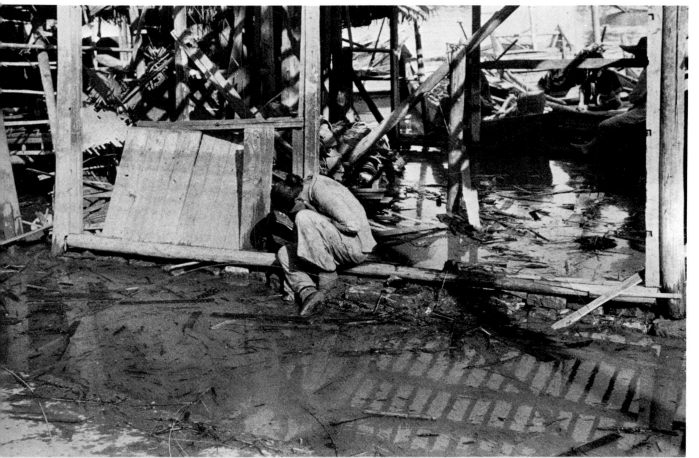

145

Hankow, China, 1938. Aftermath of an air raid

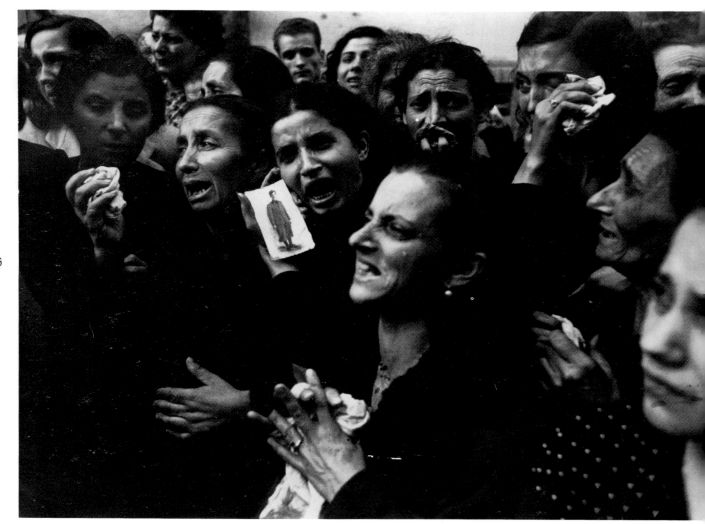

146

Italy, 1944. Grieving mothers of Naples

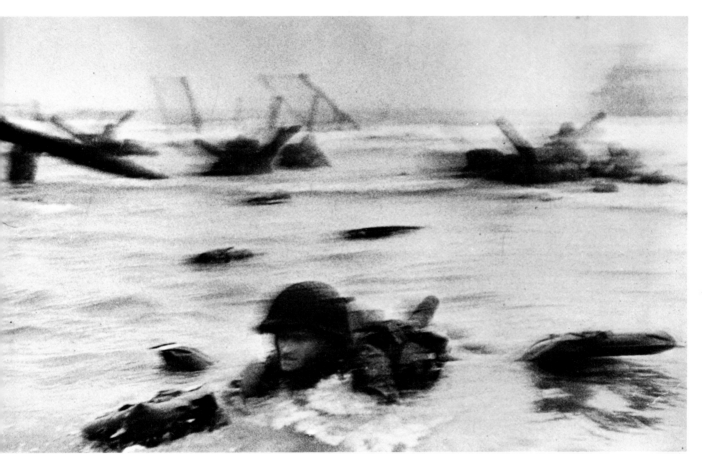

Omaha Beach, France. D-Day, June 6, 1944

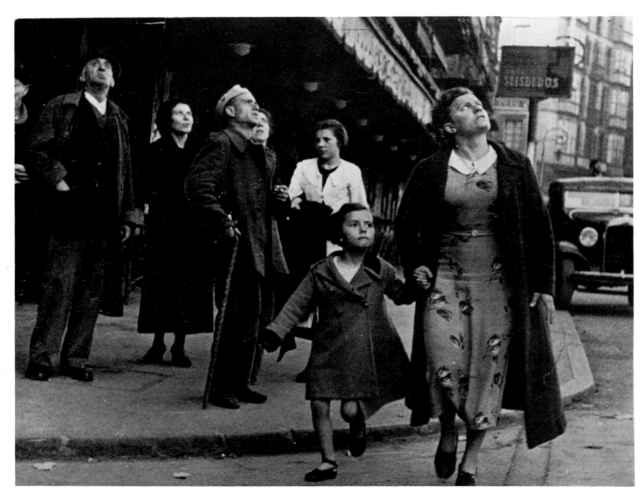

Barcelona, Spain, 1936. Air raid

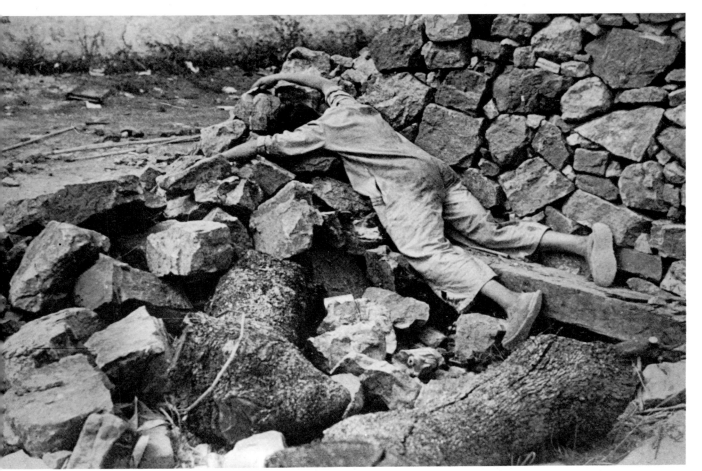

Spain,1936. Dead child in rubble

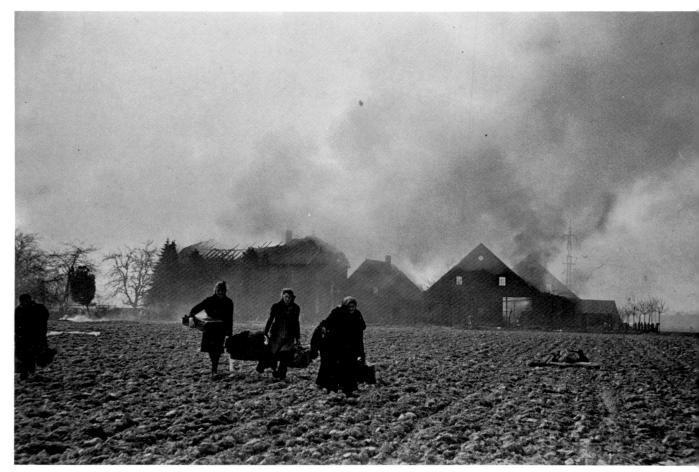

Germany, 1945. German civilians leave their blasted farmhouse

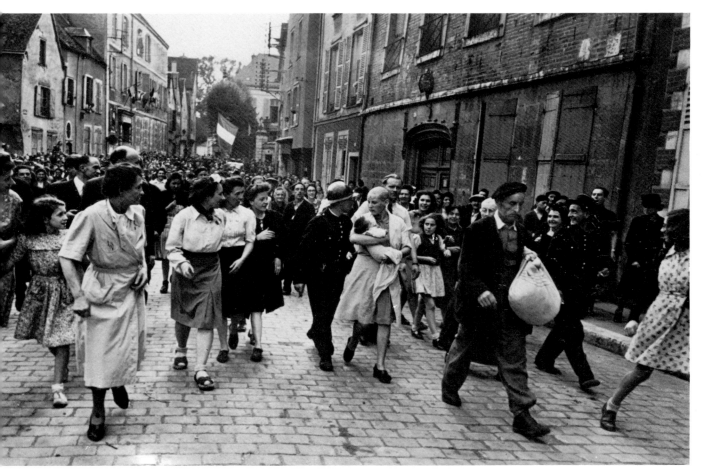

France, 1944. Woman collaborator is paraded through the streets of Chartres

Naples, Italy, 1944. Anti-Fascist slogans painted on walls

Poland, 1948, Rubble in Warsaw was all that was left of the Jewish ghetto

154

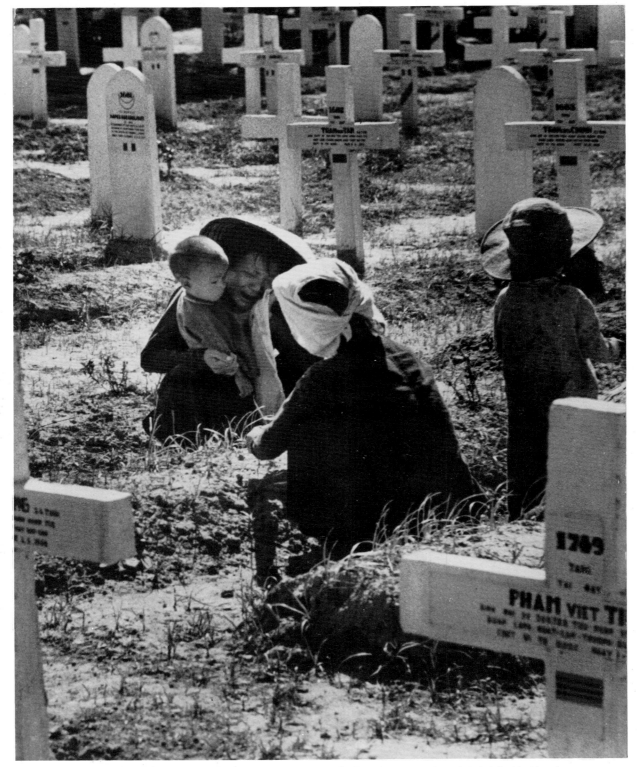

Indo-China, 1954. Vietnamese widows with their children grieve at the graves of their fallen husbands

Henri Cartier-Bresson

Henri Cartier-Bresson

Born at Chantelup in 1908, he lives in Paris. At the age of twenty he studied painting, attending André Lhote's studio. In 1928 he was at Cambridge, where he also studied literature. From 1931 he devoted himself to photography, producing a number of reports in Africa and in Europe.
In 1934 he exhibited with Alvarez Bravo in Mexico and, a year later, with Walker Evans in New York.
He collaborated with Jean Renoir on the films "La vie est à nous" (1936), "Une partie de campagne" (1936) and "La règle du jeu" (1939). In 1939 he also produced his series of photographs "Dimanche sur la Marne". Captured by the Germans in 1940, he escaped from Wüttemberg prison in 1943; two years afterwards he photographed the *liberation* in various parts of Europe and resumed his contributions to leading illustrated magazines.
He founded the "Magnum Photos" agency in 1946, with Capa, Rodger, Vandivert and Seymour. The ideology of this group (photography as the image of the "decisive moment") represented a concept of photo-reporting which gave its imprint to visual information after the war and up to recent years.
In 1952 Cartier-Bresson published his most important book, *Images à la sauvette*, which also includes some of his definitive theoretic writings on photographic journalism.
The Louvre in 1955 dedicated an exhibition of 400 photographs to him in the Pavillion de Marsan, showing the work of a photographer for the first time.
In 1966 another exhibition of his work was arranged at the Louvre and shown in various cities, including Milan, in October 1967.
In Italy in 1978 a selection of 70 pictures, arranged by Daniela Palazzoli, was shown.

One of the men of our time who must have paid the most attention has but one care: not to attract attention. Henri Cartier-Bresson likes to resemble his camera, which is penetratingly discreet. He is never without his Leica, where everything that could shine is painted in the lustreless colour of walls, like a dark lantern.
For more than forty-five years Henri has travelled all over the world, from the corner of his street to the antipodes, those sensitive eyes extended by a sensitive camera; together they compose one of the most benevolent combined gazes in the world. By which I mean that they watch well and see well, with what this implies in terms of objective detachment and attentive sympathy, alert curiosity and critical detachment, self-effacement and passio for what is.

He has written at the beginning of one of his albums these words by Cardin de Retz: *"There is nothing in this world that does not have a decisive moment."* In an essay on his profession, Cartier-Bresson defined the camer as appointed to imprint on film *"the eye's decision"*. This word *decision* bes defines Cartier-Bresson's photographs, setting them above those "beautiful photographs" which are at times in other photographers windfalls of chance or the over-calculated result of a "mise-en-scène." For Henri Cartier-Bresson quite simply concentrates all his interest on the image which he is about to inscribe (on film, in his drawing book, on canvas). "Interest is a slightly feeble word. This phlegmatic man has the courtesy of a tightly controlled ball of fire. He makes himself look calm, but one should not be deceived; Henri is a walking passion. Why are his portraits (Giacometti crossing the street in the rain, Sartre on the Pont des Arts, Bonnard, the frightened cat, Modeste, etc.) undoubtedly the truest of our time? Why is it that when looking at a print of his France, his Russia, his China or his Indonesia one says to oneself: "Look, a Cartier-Bresson!" and at the same time, "isn't that just him!". Because Henri, this image-thief, is really, (tense and proud as he may be) someone who forgets himself, erases himself. He is strained towards the world, faces, the fleeting instant. The meaning of his gaze is the meaning of life itself. Not at all a predator or captor. Aggressive to the right degree, to inscribe the record. But so light, mobile and alive that he rubs out everything that might get between the decisive instant and his lens. The precautions that Henri takes to avoid being noticed, to be the man who has seen (like nobody) but who is never seen (as too many are); his ol colourless Leica, hardly a lens in his pocket; his manner of dressing, of walking like a cat, of not having a "known face", of always looking as if he just happened to be passing by, are not tricks to avoid notice, the cunning c a light-thief. They are more than this: a moral standpoint, an aesthetic-ethic. A way of being-in-order-to-see, of being utterly concentrated-relaxed, aime like a gun and as smooth as a mirror, emptied of himself yet watchful over his own heart: attentive. I have never watched him work without admiring both his capacity for self-effacement in taking his picture and the sovereignt of his eye in the result. In a black church in Harlem, with the Reverend and his faithful in a trance, the congregation chanting and clapping their hands, a woman confessing, foaming at the mouth, I saw the "invisible man" flitting among the praying people. He captured them point-blank without their havin even noticed the presence of this transparent bird in their midst. Similarly, I have seen Henri "operating" in the streets of New York and Paris. We are chatting together. Suddenly, a furtive "click". He had seen. He had taken. The subject had seen only light. Henri is the bow and the arrow, and the shortest way from a sensation to a look.

As for technique, or the "cooking", this would not appear to interest this

bliography

Levy, *Photographs by Henri
rtier-Bresson, and an exhibition of
ti-graphic photography*, New York, 1933.
Kirstein and B. Newall, *The Photographs of
nri Cartier-Bresson*, New York, 1947.
and N. Newall, *Master of Photography*,
w York, 1958.
Farova, *Henri Cartier-Bresson*, Prague,
58.
Norman, "Stieglitz and Cartier-Bresson,"
turday Review*, 38, 1962.
Donzelli and P. Racanicchi, "Henri
rtier-Bresson," in *Quaderni di critica e
ria della fotografia*, Milan, 1963.
Gruber, *Grosse Photographen unseres
rhunderts*, Düsseldorf, 1964.
Zannier, "Henri Cartier-Bresson: l'immagine
rita," in *Photography Italiana*, Milan,
ril-May, 1971.
Roy, "Le cher Henri" in *Photo*, Paris, Nov.
74.
Haas, "Henri Cartier-Bresson: a lyrical view
life," in *Modern Photography*, New York,
v. 1971.
Roy, *Henri Cartier-Bresson*, Delpire, Paris,
76.
Palazzoli, *Henri Cartier-Bresson*, Milan,
78.

otobooks by H. Cartier-Bresson:

ages à la sauvette*, Paris, 1952.
s Danses a Bali* (text by A. Artaud) Paris,
54.
s Européens*, Paris, 1955.
une Cine a l'autres* (preface by J. P. Sartre)
ris, 1955.
scou*, Paris, 1955.
ina as photographed by Henri
rtier-Bresson*, New York, 1966.
pression de Turquie* (text by A.
bbe-Grillet), Istanbul, 1968.
e la France* (text by F. Nourissier) Paris,
70.
e face of Asia* (text by R. Shaplen) Paris,
72.
propos de l'U.R.S.S.*, Paris, 1973.

matchless technician particularly. He shrugs his shoulders if one talks to him about craft. There were never any books visible in Baudelaire's house. He would have found that ill-bred.

All his life Henri Cartier-Bresson has kept the diary in images of an alert witness who is also a rigorous artist. He will have missed nothing of what has *mattered* during his travels across the earth. He has been out to meet history and he has let the familiar faces come to that meeting. The extraordinary and the ordinary have found him equally receptive and searching. He accompanied the soldiers and the people of the Spanish Republic in their struggle. He followed the Allies from liberated Paris to Berlin destroyed. He was in Indonesia when the Dutch pulled out and in Peking when the communists came in. He has been present wherever time rocked on its hinges, at every junction of past and future. He has deciphered glorious or unknown faces, Sartre and the Spanish peasant, Nehru and the worker from Billancourt, Castro, Kennedy and the Italian fisherman, an old woman at the market in rue de Buci in Paris, and Gandhi on his funeral pyre, the wrinkles on the pensive mask of Samuel Beckett and on that of an old eunuch, a survivor from imperial China. Few men have been more present in their time. There too I see a *moral* in what is only apparently the luck of the reporter. Cartier-Bresson was in India when Gandhi was killed. He was on the spot when Indonesia proclaimed its independence. He was there when Chiang Kai-shek collapsed. These were not just "strokes of luck". It is that he was already straining beforehand towards what is important and essential and charged with universal significance. One ends up by finding it normal and natural that his curiosity about men should set them before him exactly when they happen to be most interesting. The photographer's good fortunes are the rewards of the man's mind. Nothing ever happens to us except what we await with all our strength.

157

But the importance of Cartier-Bresson's work cannot be gauged quantitatively by the miles of printed film and the distances travelled across the surface of the earth, by the repercussions of events *covered* and the prodigious ubiquity of the traveller. There are great reporters whose greatness is no slight merit. Henri Cartier-Bresson, however, is an artist first. He does not simply relate events as a chronicler or analyst. He expresses privileged and meaningful instants ("à la sauvette", as he modestly puts it). A photograph by Cartier-Bresson is always the happy spark which in a flash of truth condenses a long meditation and slow contemplation of life. It has the essential virtues of the plastic work of art; it is composed with intelligence; light and space and values perform in a necessary order. It is, in a word, beautiful. A photo by Henri is *composed*, his eye to the view-finder, immediately constructed, instantly organized (he never cuts or re-frames). Henri Cartier-Bresson would never allow himself to show a rectangle that was not at once a significant second of life and a "thing of beauty", a testimony and a delight to subtle eyes, a "report" on reality and composition which is not noticeably a composition at first sight.
The beauty which Cartier-Bresson traps or seduces is intended to be a meaningful beauty. His intention is to put down on film a minute of truth, a second of fullness. The truth of a face, the plenitude of a situation. It is not only relationships of black and white, of light and chiaroscuro, the geometry of forms and space which are so harmoniously or intensely established in a photograph by Cartier-Bresson. It is also the human relationships that are expressed or suggested in them with a wondrous subtlety or force. The movement which gives these photos their value is an inner, psychological movement. Cartier-Bresson is first of all a lover of relationships; the relations

of men to nature and history, to the solitude and to the crowds of fellow-creatures. His images live, not simply in the naturalistic sense of a reproduction satisfying the forms and movement of reality, but because they condense a great complexity, a great richness of life, of exchanges and conflicts, accords and antagonisms. One cannot lightly touch them in a quick immediately satisfying glance. They have to be read, and left to unfold like grains thrown into water which spread out, leaving a flower to open. If one lives with a photograph by Cartier-Bresson, one gradually discovers that it has more to look at than one thought one had seen. Something happens. It is the moment whose duration is not coagulated or frozen, but which has an origin, a culmination and an outcome. It this sense Cartier-Bresson's images are almost always a dramatic action. He may abandon himself to the serenity of a landscape, or jubilantly fondle a remarkable or beautiful object. But his real predilection is for the movements of the soul, for the subtle or brutal relationships established among beings. All his photographs *speak*.

The result, after more than forty-five years of painting, photography, cinema and of drawing again, is that if the expression to be ''a witness of one's time'' has a meaning it is in the work of Henri Cartier-Bresson. Wherever they fought, from the jungles of the Pacific to the cities of Europe, the GIs wrote upon the walls, to laugh while living through a history where there was nothing to laugh about, the name of a mythical character: ''*Kilroy was here.*'' I am sure that, looking carefully at the walls of the history of our time, from the death of Gandhi to the passing of unknown figures in an alley, from celebrated faces to nameless ones that speak books, from our own familiar streets to the horizons of Asia, there is written everywhere, in very small letters: ''*Henri Cartier-Bresson was here.*'' That pedestrian whom nobody noticed, that kind of jinn disguised as nimble smoke, as a thought that can walk through walls, has had the merit of being wherever something was happening, and of bringing out something essential wherever he happened to be passing. ''*Henri Cartier-Bresson was here*''. He was there. He is there. He will be there, for a long time to come.

158

Claude Roy

The Imaginary from Nature

Photography has not changed since its origin, except in its technical aspects, which are of no great concern to me.
Photography seems an easy pursuit; it is a diverse and ambiguous business where the only common denominator among its practitioners is the tool. What comes out of this recorder does not escape the economic constraints of a messy world, the increasingly strained tensions and the senseless ecological consequences.
"Fabricated" or contrived photography does not concern me. And if I pass judgement it can only be psychological and sociological. There are those who take photographs arranged beforehand and those who go out in search of the image and seize it. The camera for me is a sketch-book, the instrument of intuition and spontaneity, the master of the instant which visually questions and decides at the same time. To "signify" the world, one must feel involved in what one cuts out through the view-finder. This attitude demands concentration, a discipline of the mind, sensitivity and a feeling for geometry. It is through a great economy of means that one achieves simplicity of expression. One must always photograph with the greatest respect for one's subject and for oneself.

To photograph is to hold one's breath when all one's faculties are joined in the face of a fleeing reality; it is then that the capture of the image is a great physical and intellectual joy.
To photograph is, in a single instant, in a single fraction of a second, to recognize a fact and the rigorous organization of visually perceived forms which convey and signify that fact. It is to bring one's head, one's eye and one's heart into the same line of aim.
As far as I am concerned photography is a means of understanding which cannot be separated from the other media of visual expression. It is a manner of crying out, of freeing oneself, and not of proving or asserting one's own originality. It is a way of life.

Henri Cartier-Bresson

159

Violon mémorable

Ce pont sur la Vistule où vibre un violon / Sous l'archet misérable
D'un petit Juif coiffé d'un vieux chapeau melon / Et ces terres arables
A la dérive entre l'ombre et l'inondation / Ce gris qui vire au noir
C'est ou plutôt c'était mil neuf cent trent-deux / En la société de
Mon merveilleux ami Henri Cartier-Bresson / Qui j'évoque ce soir
Comme il était et comme il n'a pas cessé d'être / Normand comme le hêtre /
Et pourtant erratique
Doué d'un troisième oeil par grâce de l'optique / Nous fîmes du chemin
Nous en ferons encore un joli bout peut-être / Avant la claire fin.

André Pieyre de Mandiargues

e exhibition comprises 187 photographs
lected by Cartier-Bresson himself from his
st output. The definition of his art is thus
trusted to a nucleus of pictures which
entify his aims as a photo-correspondent.

Alicante, Spain, 1932

Calle Cuauhtemocztin, Mexico, 1934

162

Valencia, Spain, 1933

163

Seville, Spain, 1933

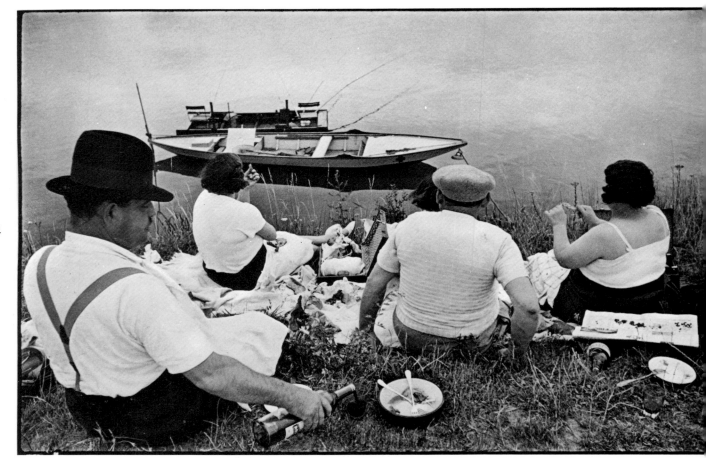

164

On the banks of the Marne, 1938

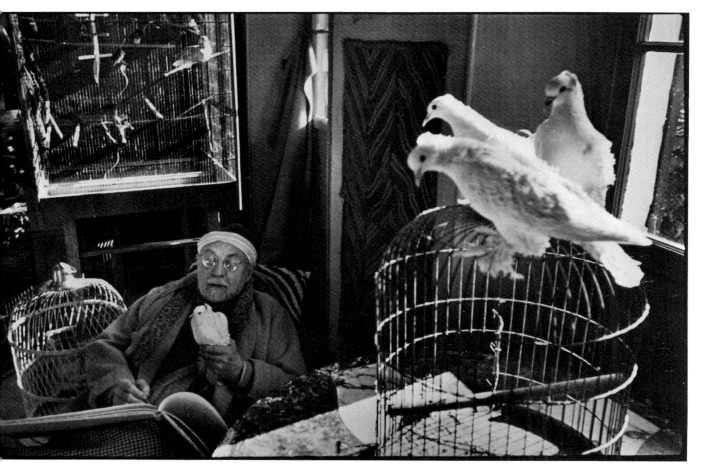

Henri Matisse, 1944

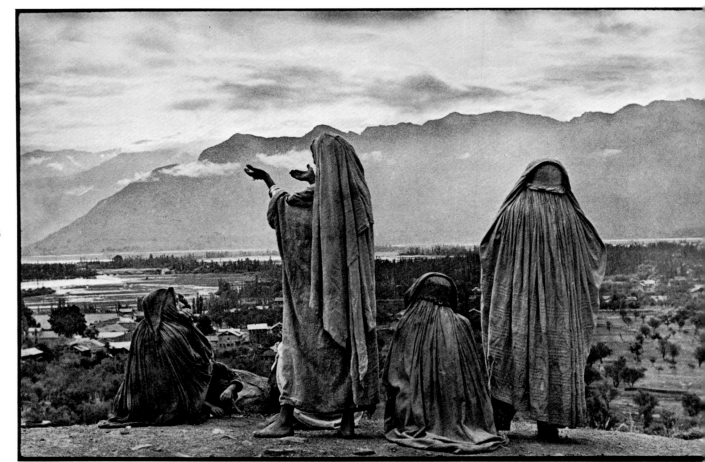

Srinagar, Kashmir, 1948

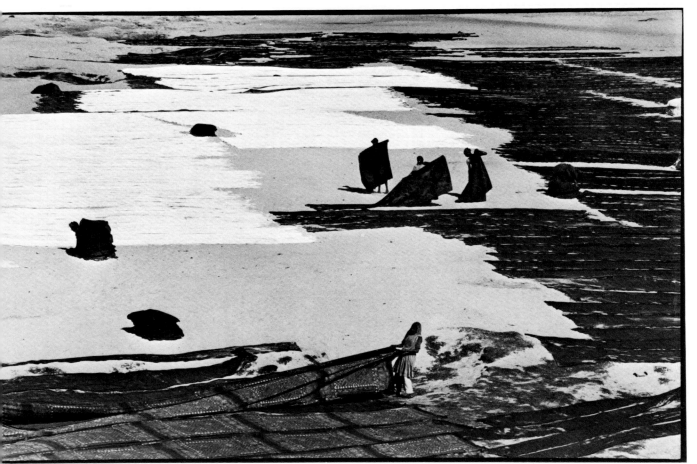

Ahmedabad, 1967

168

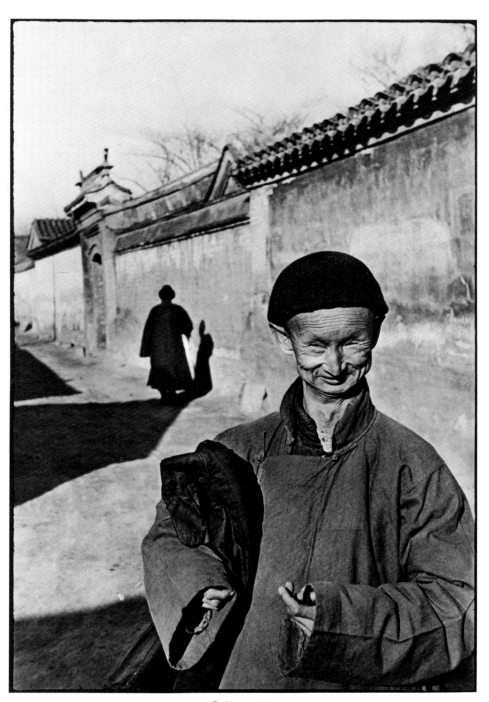

Peking, 1949

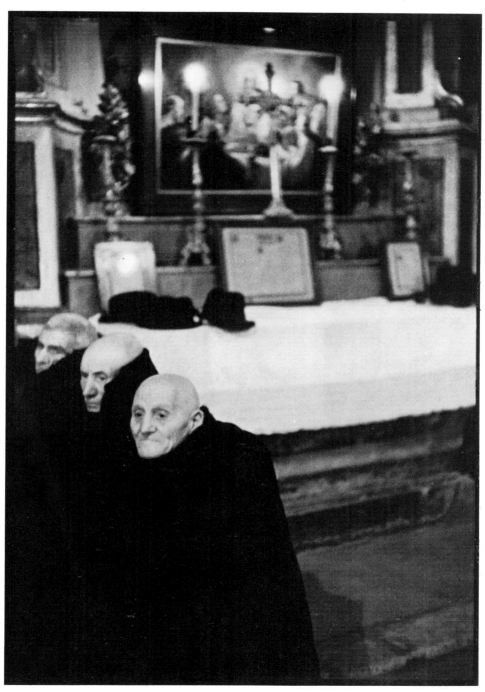

Midnight mass at Scanno, Abruzzo, 1953

Cell in a model prison in the U.S.A., 1975

W. Eugene Smith

W. Eugene Smith

Born in 1918 at Wichita, Kansas, he died in 1978.

He began to photograph at the age of fifteen and in 1936 he attended for a brief period the Notre Dame University school of photography. In 1937-38 he worked for *Newsweek* and a year later was employed by *Life*, to which he continued to contribute up till 1941 and between 1944 and 1945.

He fought in World War II. 1945 found him at Okinawa and he has left an outstanding photographic record of that experience. He returned to *Life* in 1947 and in the years that followed he did a number of memorable reports, among which was his famous "The Spanish Village" (1950).

He worked with small cameras and natural light, achieving pictures of great documentary intensity.

He left *Life* in 1955 and joined the "Magnum Photos" agency. He also started a series of reports for *Pittsburgh*, in one of the most convincing sociological surveys conducted in industry.

After 1959 he worked alternately at photography and teaching.

He won three Guggenheim awards (1956, 1957, 1968).

Bibliography

T. Maloney, "Wonderful Smith," in *U.S. Camera*, New York, August 1945.
W. E. Smith, "The Photo Journalist" (broadcast interview), in *Infinity*, New York, May 1959.
P. Racanicchi, "W. Eugene Smith," in *Critica e storia della fotografia*, Milan, 1963.
W. E. Smith, *A Chapter of Image*, New York, 1963.
H. M. Kinzer, "W. Eugene Smith," in *Popular Photography*, New York, February 1965.
N. Lyons, "Eugene Smith Photography (1954)," in *Photographers on Photography*, New York, 1966.
W. E. Smith e C. Thomas, *Hospital for Special Surgery*, New York, 1966.
L. Kirstein, *W. Eugene Smith Photographer*, New York, 1969.

Arranged by the Tucson Center of Photography, where Smith taught until his death in 1978, this exhibit is made up of 75 photographs, chosen by Smith himself who is considered a fundamental landmark in contemporary photo-reporting.

The death of W. Eugene Smith in Tucson, Arizona, has ended one of the most remarkable careers in the history of photography and of journalism. Known especially for his combat coverage in the Second World War and for his pioneering photographic essays for *Life* magazine, he was generally regarded as one of the greatest of contemporary photographers. He was 5... Smith first worked professionally for the two newspapers in Wichita, Kansas his home town. He moved to New York and in 1942 he volunteered as a w... correspondent, first for *Popular Photography*, then for *Life*. His courage in t... South Pacific became legendary and he was severely wounded in covering the 1944 invasion of Okinawa. After two years of convalescence, Smith rejoined Life and began producing his memorable series of photo-essays. These began with "Folk Singers" (1947) and continued with "Spanish Village" (1941), "Nurse Midwife" (1951), and "A Man of Mercy" (1954), o... Albert Schweitzer.

He resigned from *Life* in 1954 because of what he regarded as limitations ... his freedom of expression and began free-lancing, at first through the photographer co-operative group, Magnum Photos, then on his own. His fi... essay showed the effect of mercury pollution on the people of Minimata, Japan.

Smith's status as a photographer was unusual in that he was also recognis... in the art world. His work was known for its compassionate involvement wi... his subjects, for occasionally biting satire, and for its photographic craftsmanship.

Despite his professional success, Smith's personal life was one of pain, poverty and torment. His father committed suicide in the Depression, and h... himself was seldom financially secure. During his freelance days, he turned down thousands of dollars in offers from magazines that refused to grant h... control over layout and picture selection. Smith's Okinawa wounds left his jaw shattered. When he was able to resume photography, his first self-assignment produced the memorable photograph of his children which he called "The Walk to Paradise Garden," after the work by Delius. It was one of the most popular images.

Shortly before his major 1971 show Smith was badly mauled by a Philadelphia street gang. He later managed to locate two members of the gang, and invite them to the New York opening. In Japan, he was beaten a badly blinded by chemical company thugs. Friends in America raised mone to bring him back for treatment, and to finish his Minimata book. In the Sixties, partly because he lacked both the strength and the support to photograph intensively, he turned to teaching, lecturing and exhibitions, an in 1977 he was appointed to the faculty of Arizona University.

John G. Morris
In *The Sunday Times*, October 29, 1978

Saipan, Wild and Scurrying Things, 1944

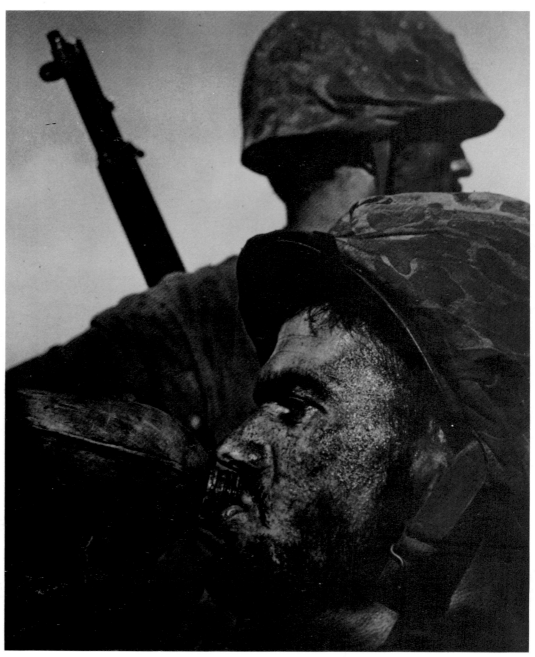

World War II, Soldier with Canteen, Saipan, 1944

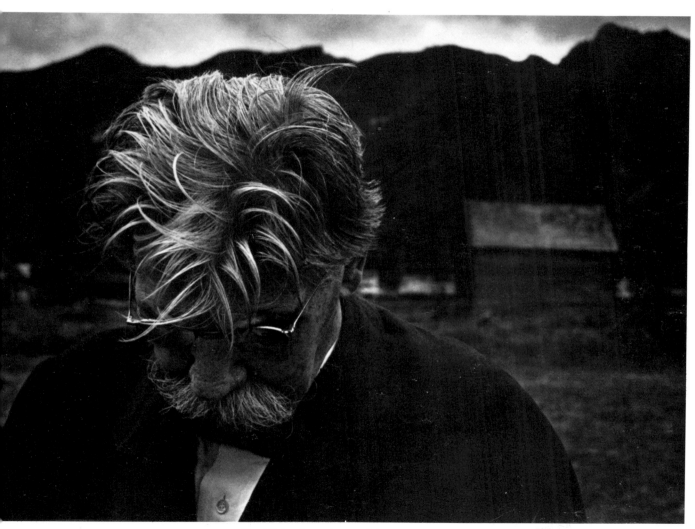

Albert Schweitzer, Aspen, Colorado, 1949

176

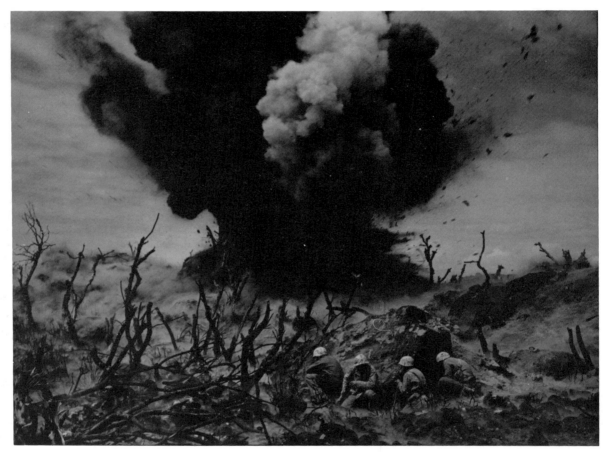

World War II, Sticks and Stones and Bits of Human Bones, Iwo Jima, 1945

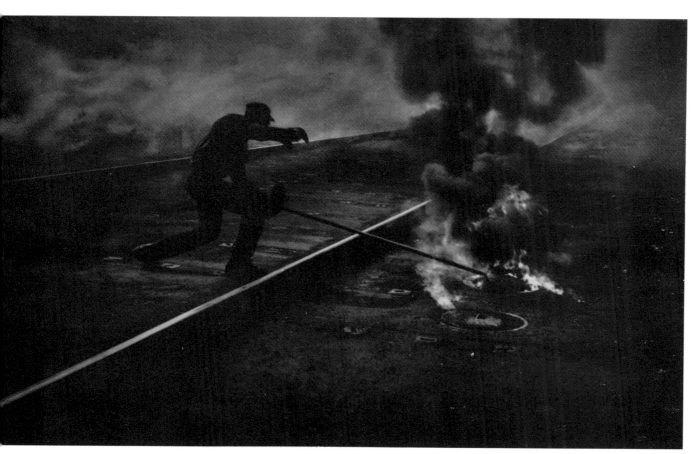

Pittsburgh, Dance of the Flaming Coke, 1955

Pittsburgh, Pride Street, 1955

First Day of Spring, 1957

Minimata, Tomoko in the bath, 1971-74

Spanish Village, Spinner, 1951

182

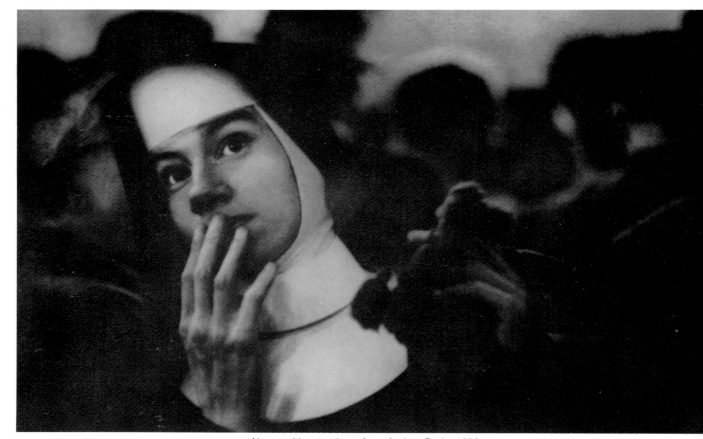

Nun awaiting survivors from Andrea Doria, 1956

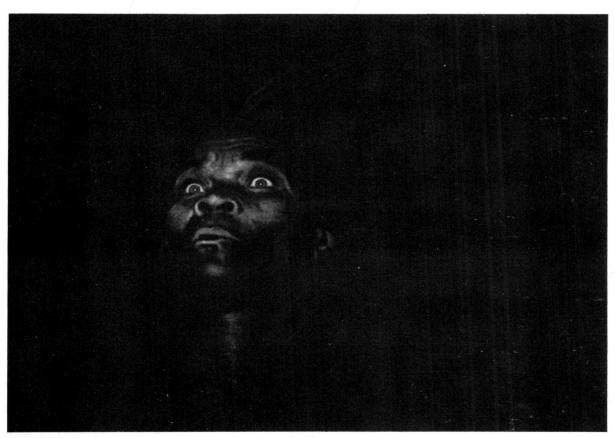

Haiti, Mad Eyes, 1959

184

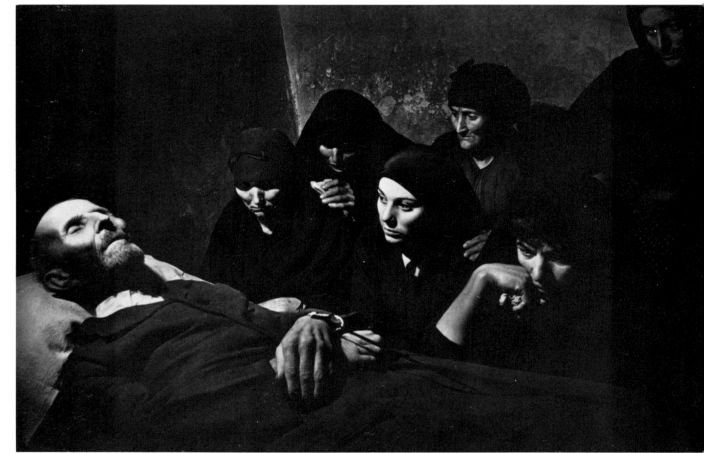

Spanish Village, Spanish Wake, 1951

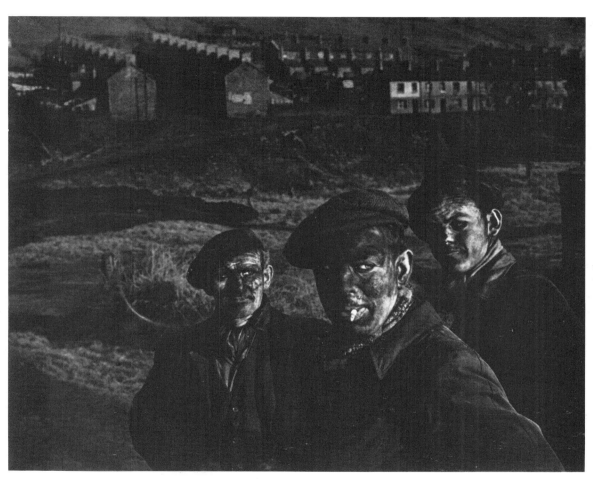

Welsh Miners, 1950

Mad Hands. Variation 2, c. 1959.

Images des Hommes

Images des Hommes

Yves Auquier
Werner Bischof
Bill Brandt
Brassaï
René Burri
Henri Cartier-Bresson
Robert Doisneau
Mario Giacomelli
Bert Hardy
David Hurn
Andre Kertesz
Josef Koudelka
Jacky Lecouturier
Charles Leirens
Aleksandras Macijauskas
Constantine Manos
August Sander
Gotthard Schuh
Josef Sudek
Ed van der Elsken
Jean-Marc Vantournhoudt
Francis van Uffel

188

The Ministry of French Culture in Belgium wished to organize an exhibit which would convey man's condition through his image, as described by 22 European photographers of different outlooks but with a common civilized commitment.
The exhibition has come to Italy for the first time after touring France and Belgium in 1978. It was prepared by the Belgian Group "IMAGES", with the collaboration of Rosellina Burri, Sue Davis, Elsa de Fever and Jean Claude Lemagny.

Is it not towards man that these images lead us, towards him alone? Is he not the magnetic pole by which we may judge and control our wanderings? We pass through appearances to regain the evidence. These lovers in a park, in front of a statue, are European, yes, but they are the world's love. These two miners marching towards the pits in a mining village are from our own mines, but they represent the work of all men, just as these dockers in Egypt, beside a ship, belong to all the ports of the earth. These troopers riding past may belong to the Swiss army, but they evoke images of cavalcades in all the world's plains. These are what must be called photographs of identity.
They open up the land of men. Henceforth, we shall discover continents. They are no longer called Asia, America, Oceania, Africa or Europe... They are called Childhood or Old Age, Play or Labour, Laughter or Sadness, Love or Solitude. And we discover that we must ceaselessly discover them. This not to say that their peculiar characteristics are effaced. You see this child: he is playing with a ball as all children do and yet his attitude, when he takes aim, belongs to his race: it is like that of a dancing girl from Java. The same gracefulness, the same precision of gesture. The photographer's merit is to break with the bazaar, to throw off the tinsel and to discard the accessory, without however removing the essential flavour of his subject. All children plus a Child. All men plus a Man. So the portrait speaks to us. We look at image. The image looks at us. The dialogue begins.

Max-Pol Fouchet
In *Images des Hommes* (catalogue), Gand, 1978

Joseph Koudelka, Bed, Okres Roznava, 1967

Andre Kertesz, Paris, 1926

Brassaï, Parade à la fête foraine

Josef Sudek, Z Kolinskeho, 1924

193

Charles Leirens, Ronde d'enfants

Robert Doisneau, Les chiens de la chapelle

David Hurn, Old Time Dancing Lesson, 1962

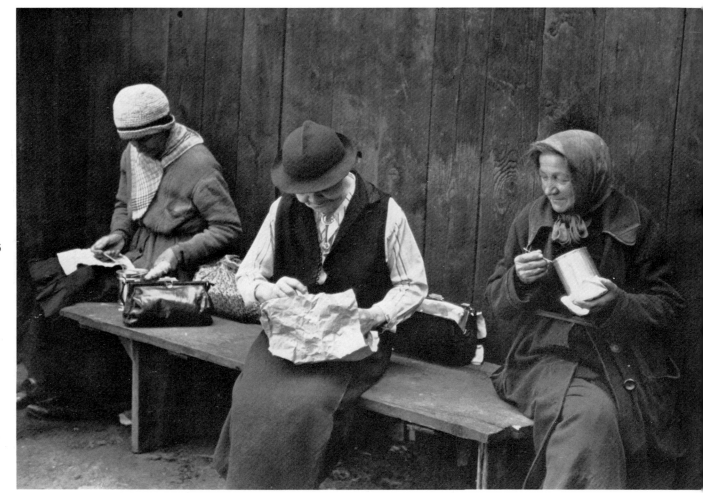

Gotthard Schuh, Charity Soup in Vienna, 1937

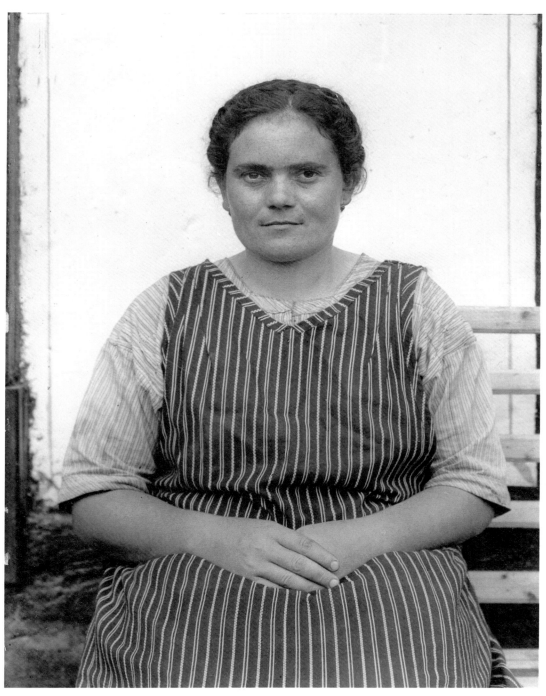

August Sander, Peasant Woman from the Hohen Venn

197

René Burri, Salvador da Bahia, 1966

199

Jean-Marc Vantournhoudt, ''New York'', 1978

200

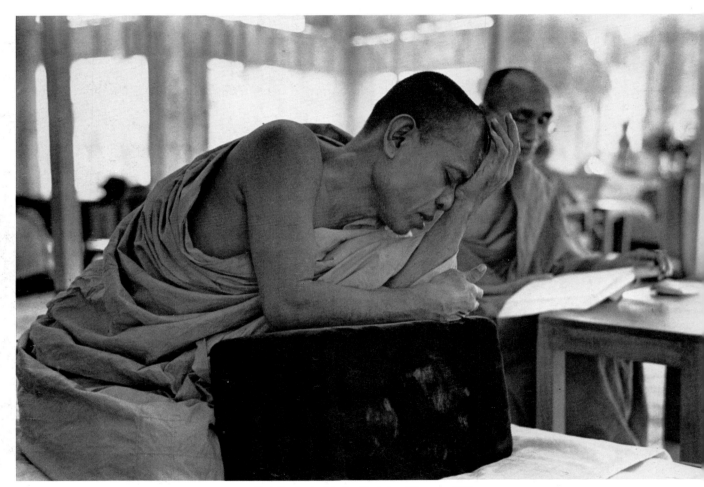

Bert Hardy, Inside the Temple of Burma, 1950

The Land

The Land

202

In his account of the Renaissance Burckhardt describes the poet Petrarch as the first modern man to climb a mountain for pleasure. He climbed Mont Ventoux, near Avignon. Reaching the summit he looked across the panorama towards his native Arezzo. He read St. Augustine's words to his brother and then would say no more: "... and men go forth, and admire lofty mountains and broad seas, and roaring torrents, and the ocean, and the course of stars and forget themselves."

The sense of landscape is based on displacement from the land. Continually new channels of feeling are cut back to the land in images. We live in a symbolic landscape wherever we live, language breeds metaphors and similes to keep us in that landscape. To quote a favourite saying of Bertrand Russell's, "Love of the mountains is virtue, love of the sea is wisdom." Photography has from the first taken landscape as one of its richest subjects. Almost every notable mountain, valley, cove or even rock in Britain was photographed in the nineteenth century. Cameras moved west with the great geological surveys conducted in the United States in the third quarter of the nineteenth century; European explorers and photographers provided images of the Holy Land, the Himalayas, China, and Japan. Alongside this quest for illustrations has occurred a more profound quest for images. The contrast of 'image' over against 'illustration' is a favourite one with the painter Francis Bacon: it is the image, he has repeatedly said, that "gets onto the nervous system", that reveals.

The exhibition, "The Land", is taken from the documentary film made by Robert Flaherty in 1938-41, a brilliant attempt to reconcile the acute conflicts surrounding land use during the Dustbowl era in the United States. Dorothea Lange's photograph showing power farming displacing small tenants in Texas, became a symbol of part of the problem, while Margaret Bourke-White's photograph of contour ploughing, a means of fighting erosion of top-soil, summed up in one image part of the solution.
The main burden of preparing the exhibition was borne by Bill Brandt who has also chosen and sequenced the photographs. He worked at top speed and rarely altered a decision. In the course of one of the most versatile careers in the history of photography, he has made a remarkable series of close-ups of the eyes of certain artists. His own eyes are as formidable as any he has photographed.
Casting about for a description of Bill Brandt's approach to the task of selection, I can only recall what Theodore Roethke wrote of Dylan Thomas: "His taste was exact and specific; he was loyal to the poem not the poet; and the list of contemporaries he valued was a good deal less than might have been supposed." To put it another way, he examined the photographs which came under his eye with the mixture of sympathetic responsiveness and impartiality with which he must examine his own work when preparing an exhibition or collection. Young photographers always interest him: one of his special discoveries was the colour work by the Australian Grant Mudford. If he is asked to give some definition of his principles of selection he will only reply: "Instinct".

Bill Brandt's first great series of landscapes was made between 1944 and 1948, following a decade in which he had brilliantly documented the "Two Nations" which persisted in Britain. It was at much the same time that Ben Nicholson turned back to landscape painting for a few memorable years. A renewal of the landscape painting tradition also occurred in the work of Sutherland, Piper, Craxton, Minton, and in the last magnificent Cornish landscapes of David Bomberg. Fraser Darling and the archaeologist of

Britain's lost villages W. G. Hoskins. In making his first landscapes Brandt sought out places with a strong charge of the past about them, such places as the Malvern Hills, Stonehenge, Avebury. His photographs cut a new channel back to those places and the influence of his images has remained strong in the last thirty years. They are among the best-known landscape photographs ever made. I leave it to Thomas Hardy to make one point about the *light* in many of these landscapes. Like Tess, Brandt "knew how to hit to a hair's breadth that moment of evening when the light and the darkness are so evenly balanced that the constraint of day and the suspense of night neutralize each other, leaving absolute mental liberty. It is then that the plight of being alive becomes attenuated to its least possible dimension."
Half-tones vanish like half-truths, appearances elide, presences emerge. This "mental liberty" is not quiescent, it is like the elemental exhilaration of Emily Dickinson's poems.

The plates are drawn not only from the work of photographers who have advanced the medium as a creative art. Photography is indivisible and it is stunting to think of creative photography as a sort of nature reserve for talents separated from the multifarious professional uses of the medium. Accordingly, the exhibition contains photographs made by scientists — such as that of the cliff in Pembrokeshire, the work of the geologist T. C. Hall in 1909, and the aerial view of the amphitheatres at Muyu-uray in Peru, the largest of which is said to seat 60,000 (to witness what spectacle is not known), which resulted from an expedition from the American Museum of Natural History in 1931. The panoramic view of Church Stretton Valley in Shropshire was taken for the Cambridge Air Survey archives by Professor J. K. St Joseph: the archives are drawn upon by all faculties of the university and the photographs must accordingly convey absolutely accurate information. The view of the earthquake in Chile in 1960 is by a photojournalist with the Magnum agency, the photograph of the volcanic island of Surtsey made in the following year is by an Icelandic sea captain. Perhaps the finest of all mountain pictures, is the work of the present Director of the Boston Museum of Science.
Of the other photographs, many were made by men celebrated for photographs of a quite different kind: Man Ray for his abstract "Rayographs" and solarized portraits; Lartigue for his child-prodigy photographs of his family and friends almost seventy years ago; Albert Renger-Patzsch for his "Neue Sachlichkeit" precision close-ups in the 1920's; Cartier-Bresson, Brassai, and Doisneau for the Comédie Humaine. It is nearly always the professional photographer, whatever his preoccupation, who reveals landscape. He has two qualities: an eye and a technique. The Victorian photographer Frank Meadow Sutcliffe put it this way: "The photographer lives in two worlds, the world as it is, and the world as it is photographed. It is the difference between the two which gives him so much trouble."
The question of technique can be merely obfuscating. When asked by photography annuals to detail developers, type of film, etc., Minor White will simply say "The camera was faithfully used", Cartier-Bresson just says "Who cares?". On the other hand, a sense of camera and lens function and control and the properties of light sensitive materials must be the starting point. In the words of that most Princely craftsman Ansel Adams: "It is futile to visualize the mechanically impossible; we cannot perform something on the violin and expect the sounds of a full orchestra."

The American tradition was succinctly summed up in a lecture given in 1958 by Aaron Siskind. He described what he saw as the basic tradition bequeathed to photographers by the work of Alfred Stieglitz after 1910. This

203

kind of photograph was "sharp all over... with a full tonal range... made with the light present at the scene... using the largest possible camera, preferably on a tripod, the negative is printed by contact to preserve utmost clarity of definition, ... and the look of the photograph is pretty well determined by the time the shutter is clicked". This was the "classic" photograph. It has, actually, the qualities of a print by Eugene Atget or Frederick H. Evans but no comparable tradition resulted from their procedures in France or England. The American "classic" photograph is seen in perfection in Brett Weston's "Mono Lake". Sharp in every plane, printed with stark clarity by contact on glossy paper, it is photography at its most transparent — a technical triumph in which any sense of the medium vanishes before the thing itself.

The gift of seeing photographically is clearly demonstrated in the unique work of Edward Weston which combined a sharpness of physical realization with a free release of rhythmic, organic form which remains unrivalled. Edward Weston once wrote to Ansel Adams about photography as creative expression. Such photography, Weston felt, "must be seeing plus; seeing alone would mean factual recording, — the illustrator of catalogues does that. But photography is not at all seeing in the sense that the eyes see. Our vision, a binocular one, is in a continuous state of flux, while the camera captures and fixes forever (unless the damn prints fade!) a single, isolated condition of the moment. Besides, we use lenses of various focal lengths to purposely exaggerate seeing, and we often 'over-correct' colour for the same reason. In printing we carry on our wilful distortion of fact by using contrasty papers which give results quite different from the scene or object as it was in nature. This, we must agree, is all legitimate procedure; it is not 'seeing' literally, it is done with a reason, with creative imagination."

Aaron Siskind placed the creation of the new aesthetic of photography back in 1910. The credit for the development of this magnificent tradition belongs to Alfred Stieglitz and Paul Strand. It was slowly bred out of the Pictorialist era which dominated the medium between 1890 and 1910 and has ever since been regarded as a cuckoo in the nest of photography. The style is seen at its best in Edward Steichen's gum bi-chromate print "The Big White Cloud'" in which pure photographic values are minimized in the interests of subtle, hand-worked, richness of tonality. Pictorialism was brilliantly successful because it seemed to be the way for photography to become a full art medium instead of an ambiguous hand-maiden of science and art. Pictorialism won art status, largely under the guidance of Stieglitz, culminating in an exhibition at the Albright Gallery, Buffalo, in 1910 (after which the museum set up a permanent photography room). The Pictorialists had to concede their own success and accept the realization that the medium was still nowhere in sight of becoming a contemporary expression capable of addressing the realities of the new century. The breakthrough came with Paul Strand's portfolio of eleven photographs published in *Camera Work* in 1917. In a famous essay of 1917 Paul Strand wrote: "The photographer's problem therefore, is to see clearly the limitations and at the same time the potential qualities of the medium, for it is precisely here that honesty no less than intensity of vision is the prerequisite of a living expression. This means a real respect for the thing in front of him, expressed in terms of chiaroscuro (colour and photography having nothing in common) through a range of almost infinite tonal values which lie beyond the skill of human hand. The fullest realization of this is accomplished without tricks of process or manipulation, through the use of straight photographic methods. It is in the organization of this objectivity that the photographer's point of view towards life enters in..." By tunnelling through the mountain of Pictorialist photographs Strand gave photography back its past, as well as giving it a present and a future. There is an ancestral connection between the hay stack

204

which is the subject of one of the earliest photographs ever made — by Fox Talbot, published in *The Pencil of Nature* in 1844 (the detail of which Fox Talbot so much admired) and the hay barn photographed by Emmet Gowin, who was born a century later. Photography remains the magnificent draughtsmanship foreseen by Fox Talbot.

The purity of pure photography would be unengaging if it denied the power of other kinds of image-making — but it never has. Take for example Emmet Gowin's personal device of the 'pin-hole' or key-hole which operates very much like the eye-hole through which spectators view Marcel Duchamp's curious pastoral diorama in the Philadelphia Museum of Art. The effect is similarly heightened, secretive, incomplete. Paul Strand himself fought Pictorialism with another sort of Pictorialism, brilliantly derived from Cubism. Aaron Siskind has been intimately associated with the development of Abstract Expressionist painting and his "Chilmarck 28" takes its needle-sharp sedge from photography but its composition belongs in the New York School. Raymond Moore photographed Pembrokeshire beaches and cliffs, especially in his colour work, fully aware of what British painters were doing in the same decade. Beside these influences the long tradition of European painting, with its store of devices of interval, recession, even "points of interest", has not been ignored. Paul Strand's "Tir A'Mhurain" is inexhaustible not only because it epitomizes the Western Isles particularly in its light, but because it is composed as it is.

The images in this exhibition could easily, simply, and with some justice, be called "Romantic". We can be naive neither about the medium of photography nor the issue of conservation. A *classical* rigour is inherent in the medium. Photography has now an achieved moral bearing in the face of the world. It is essentially dispassionate before the reality it can uniquely record, becoming a transparent window on experience. It shares, at this date, the qualities required of his fellow-conservationists by Frank Fraser Darling, whose chief work — a turning point — was done among those Highlands and Islands of Western Scotland which inspired some of the finest images, as we have seen, in twentieth-century photography. Fraser Darling's words have already become a talisman: "We can be of little service to our fellows until we become disillusioned without being embittered."

his exhibition Bill Brandt offers a personal
ction of 50 photographs which suggest a
dscape image through the photographic
s of some of the 20th century's
standing photographers.

Mark Haworth-Booth
In *The Land*, New York, 1976

Giorgio Lotti, Mare, 1970

Minor White, Edge of Ice, 1960

208

Gianni Berengo-Gardin, Ploughing in Tuscany, c. 1960

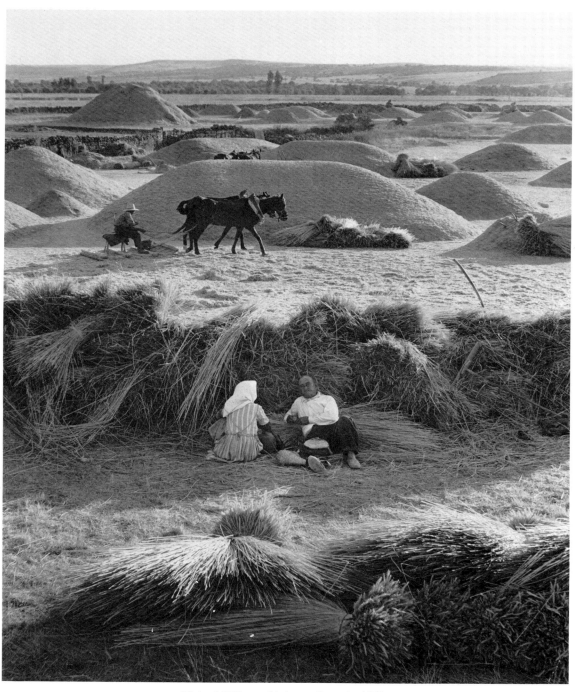

209

Michael O'Cleary, Madrone, Segovia, 1962

George Rodger, The Great Western Erg, Algerian Sahara, 1957

Mario Giacomelli, Paesaggio marchigiano, 1947

Grant Mudford, Red Mountain

National Aeronautics and Space Administration, Crescent Earth from Apollo 12, 1969

214

Bill Brandt, Skye Mountains, 1947

Fleeting Gestures: Treasures of Dance Photography

Fleeting Gestures:
Treasures of Dance Photography

Dance, so universal an activity and yet so varied in the forms it assumes, uplifts the spirit as it liberates the body. Orchestrated movements of great complexity executed with apparent ease, dance movement is charged with emotion and infused with the mystery of a culture.

Photography, by nature silent, immobile, and the prisoner of two-dimension space, would seem at first glance ill-equipped to deal with such complexiti of movement and meaning. Yet these apparent limitations have been overcome time and time again. For more than a century photographers hav succeeded in capturing these fleeting gestures and, eclipsing documentati created a wide range of eloquent imagery.

Photographers have never allowed themselves to be restricted by the confines of theater and stage. Restless, inquisitive, and responsive to happenstance, many prefer the studio, the nervous energy backstage, or tl vitality of dance in its social guises. Reflecting this wide arc of photographi subject matter, the exhibition draws not only from the superb work of the professional dance photographer, but from photojournalism, portraiture, fashion, advertising, and the avant garde. We are fortunate in presenting images which have never been exhibited, together with acknowledged master works by such notable figures as Dégas, Muybridge, de Meyer, an Steichen. These works were gathered from major museums and public an private collections in the United States and Europe. The wealth of these collections was matched by the interest and generosity of the lenders.

It was hoped that an exhibition which would gather this material together fo the first time, reflecting the diversity of the photographic enterprise, would encourage renewed interest in the area, lead to further discoveries, preservation, and exposure to photography's ever growing public.

216

The exhibition comprises more than 150 photographs collected by William Ewing by appointment from the I.C.P.
First exhibited in New York, its aim is to give an idea of dance through photographers' eyes, from the 19th century to the present.

William A. Ewing

James Abbe
Berenice Abbott
Lucien Aigner
Aldene
Gordon Anthony
Diane Arbus
Ollie Atkins
Atelier Baruch, Paris
Cecil Beaton
Ilse Bing
Margaret Bourke-White
Brassaï
Anton Bruehl
Francis Bruguière
René Burri
Saul Bransburg
Byron
Henri Cartier-Bresson
Jean-Philippe Charbonnier
William Coupon
Imogen Cunningham
Davidsen
Lynn Davis
Edgar Degas
Robert Demachy
Baron Adolf de Meyer
Disdéri
William Dyer
Harold Edgerton
Arthur Elgort
Hugo Erfurth
Maren Erskine
Walker Evans
Larry Fink
Simone Forti
Foulsham and Banfield, London
C.D. Fredericks and Co., London
Roland Freeman
Arnold Genthe
Victor Georg
Maurice Goldberg
Bob Golden
Louis Goldman
Lois Greenfield
John Gutmann
Ernst Haas
Philippe Halsman
Ira Hill
Paul Himmel
E.O. Hoppé
Horst
George Hoyningen-Huene
Iris Studio, Paris
Lotte Jacobi

Joyce Jaffe
Gertrude Käsebier
Andre Kertesz
Jill Krementz
Suzy Lake
Jacques Henri Lartigue
Lipnitsky
George Platt Lynes
Norman McLaren
Elaine Mayes
Herbert Migdoll
Gjon Mili
Herbert Mishkin
Jack Mitchell
E. Moeller
Barbara Morgan
Alphonse Mucha
Martin Munkacsi
Gordon Munro
Nickolas Muray
Eadweard Muybridge
Ikko Narahara
Lusha Nelson
Arnold Newman
Helmut Newton
Nicholas Nixon
Suzanne Opton
Jack Partington
Edgar Phipps
Sylvia Plachy
Man Ray
Nancy Rexroth
Houston Rogers
Laura Rubin
Charles Rudolph
Eric Sanford
Phillip Sobel
Howard Sochurek
Edward Steichen
Soichi Sunami
Martha Swope
Joseph Szabo
Edwin Townsend
Doris Ulmann
James Van Der Zee
Franz Van Riel
Jack Vartoogian
Max Waldman
Eva Watson-Schütze
Dan Weiner
Garry Winogrand
Christina Yuin

217

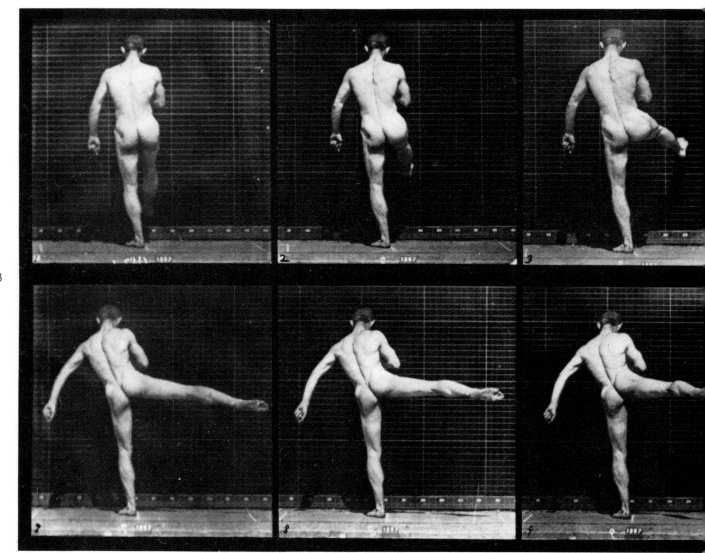

Eadweard Muybridge, First Ballet Action, Plate 369, 1885

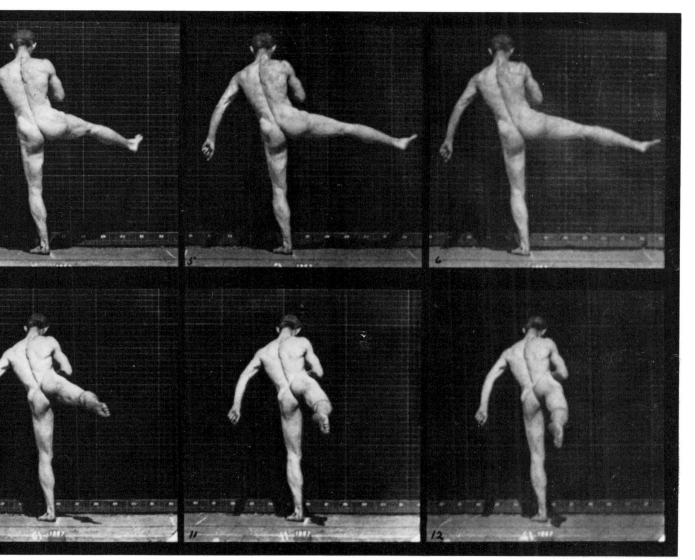

220

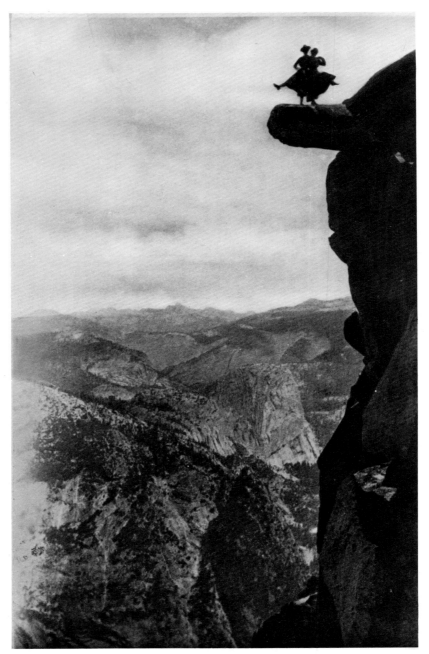

Anonymous, Clowning on Observation Point, Yosemite Valley, California, c. 1905

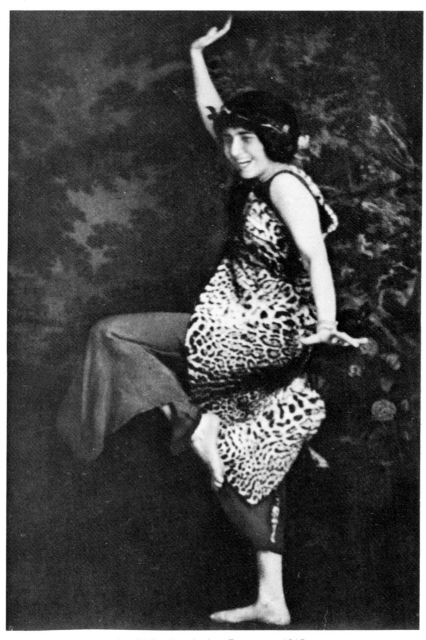

Arnold Genthe, Andrea Zamora, c. 1915

222

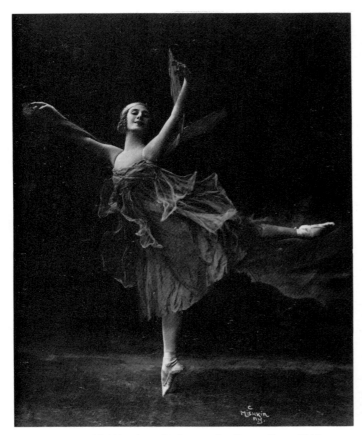

Herbert Mishkin, Anna Pavlova as the Dragonfly, c. 1911

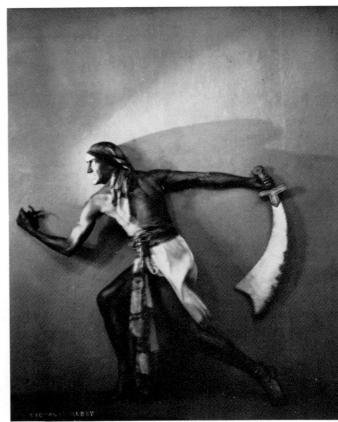

Nickolas Muray, Hubert Stowitts, n.d.

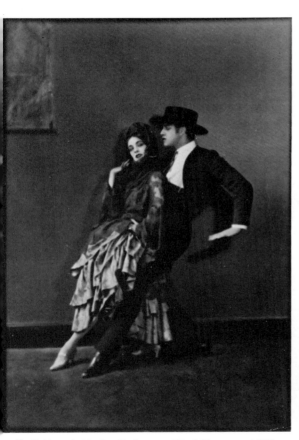

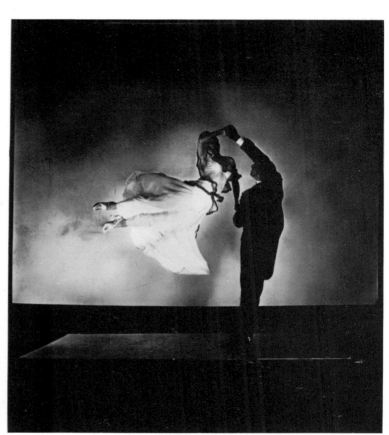

E. O. Hoppé, Martha Graham and Ted Shawn, c. 1926

Edward Steichen, The de Marcos, Vanity Fair, August 1935

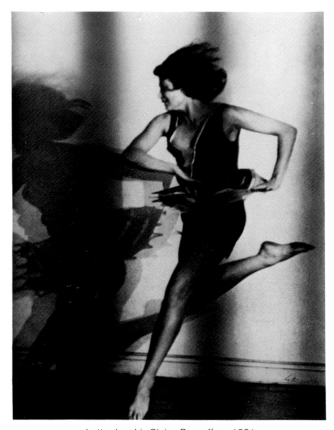

Lotte Jacobi, Claire Bauroff, c. 1931

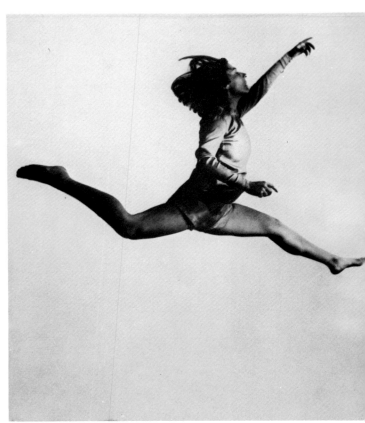

Hugo Erfurth, Dresden, Palucca, n.d.

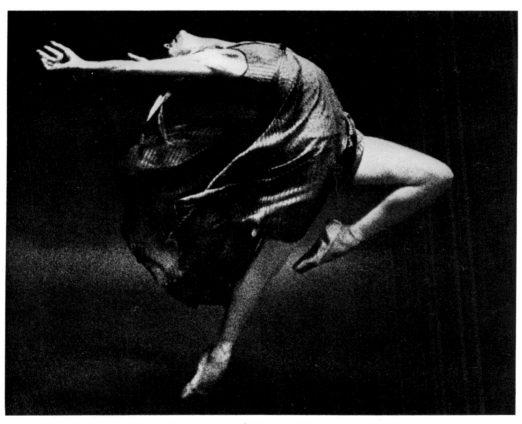

Max Waldman, Natalia Makarova - Other Dances, 1976

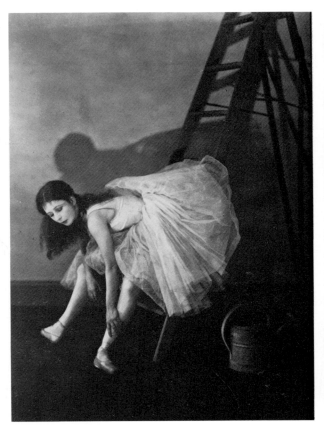

Soichi Sunami, Agnes de Mille, c. 1930

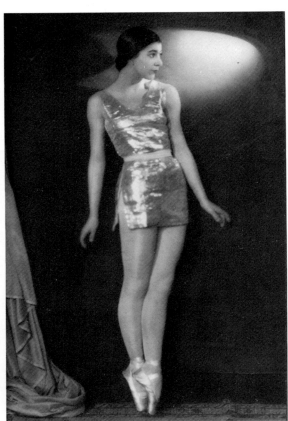

E.O. Hoppé, Margot Fonteyn, c. 1933

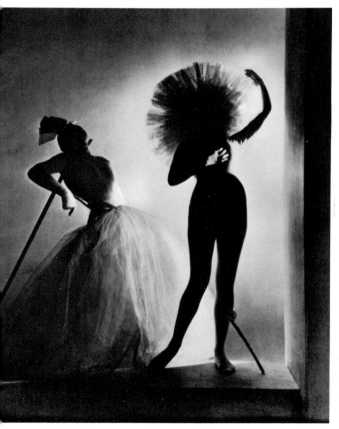

Horst, Dali Ballet, Paris, 1936

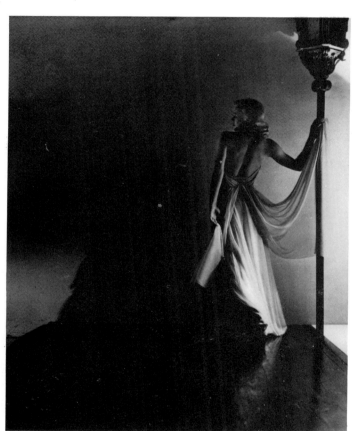

Horst, Ginger Rogers, 1935

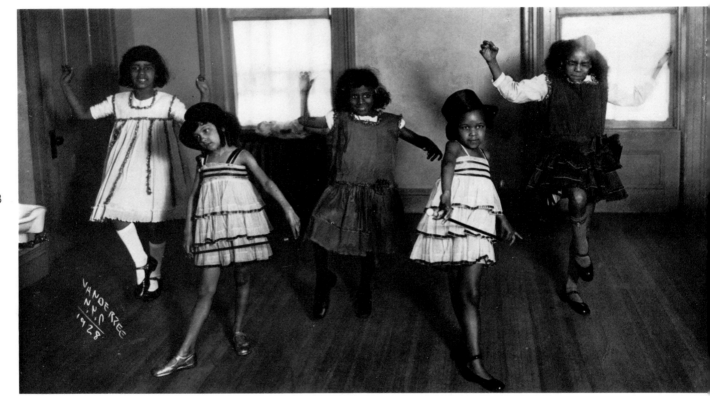

James Van Der Zee, Children Dance Class, 1928

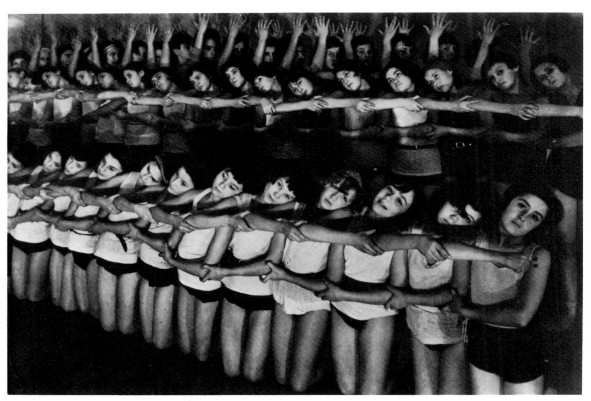

Margaret Bourke-White, Sitting Chain as an Artistic Motif in the Soviet Ballet, Vanity Fair, September 1936

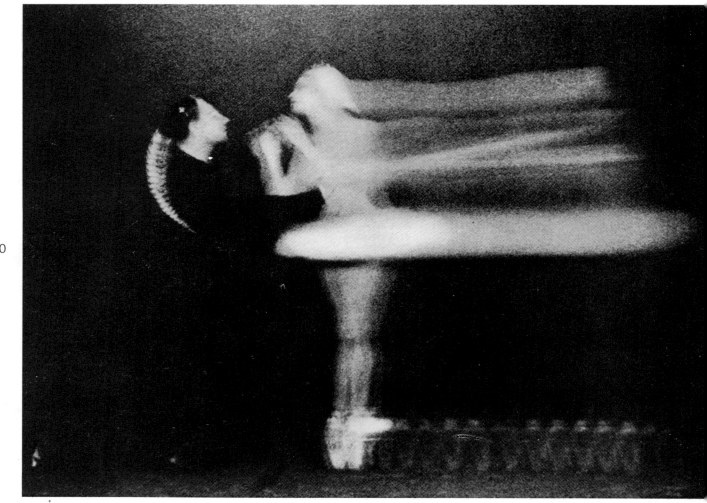

230

Paul Himmel, Untitled, 1953

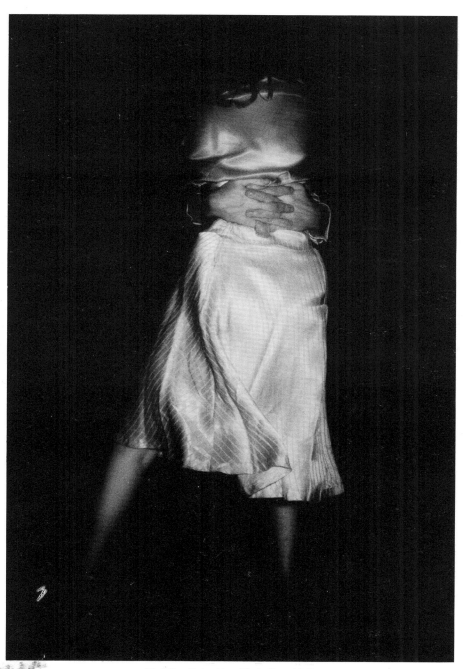

Christina Yuin, New York City, 1978

232

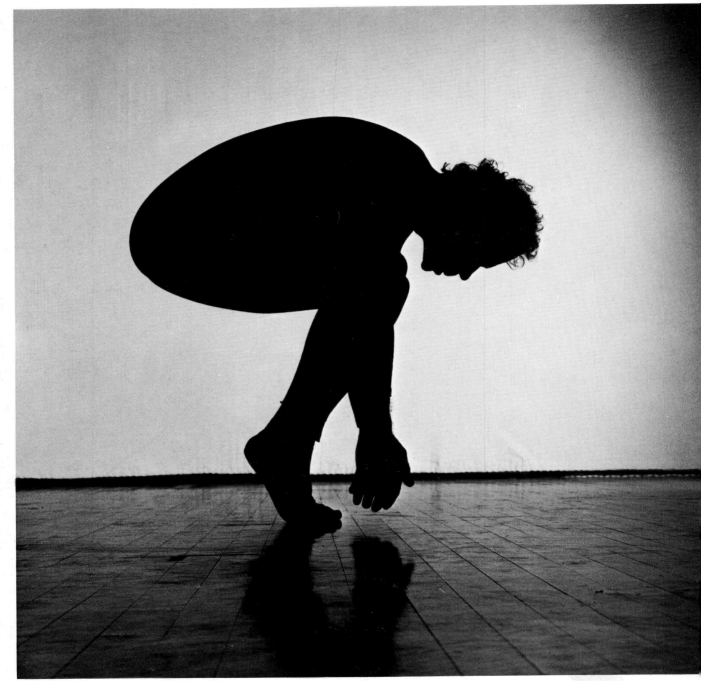

Jack Mitchell, Merce Cunningham, 1975

Eye of the Beholder: the World in Color

Eye of the Beholder:
the World in Color

Brian Brake
Jerry Cooke
John Dominis
David Douglas Duncan
Doug Faulkner
Joe Franklin
Burt Glinn
Ernst Haas
Bhupendra Karia
Jay Maisel
Gordon Parks
Eliot Porter
Harry Redl
Co Rentmeester
Marc Riboud
Emil Schulthess
George Silk
Howard Sochurek
Takeyoshi Tanuma
Peter Turner
John Zimmerman

234

It is fitting that many of the world's most renowned photographers — whose talents are totally dependent upon their ability to see — would graciously contribute their work to the cause of preventing blindness. That contribution has taken the form of an exhibition of fifty-nine large, color prints that has traveled around the world to publicize the work of The National Retinitis Pigmentosa Foundation headquartered in Baltimore, Md., U.S.A. a non-profit group dedicated to the study of retinal degenerative diseases. These genetic eye diseases rob the vision of hundreds of thousands throughout the world. Now in Venice, the exhibition features the work of twenty-one distinguished photographers. Each color print captures a dramatic moment that transcends the image reproduced. The richness of color, texture and pattern becomes apparent through the photographer's special vision: the ability to see beyond the surface and catch what most of us miss. Only an artist can see and catch the excitement of an open boat surging through the surf, an antelope herd in a stampede, the sun freezing a sea with light, or a girl kissing the rain with her skin. The distant becomes near, the unseen seen, the familiar becomes foreign. In this precise instant, a photograph becomes art.
"Eye of the Beholder" was organized by E. R. Squibb & Sons, Inc. for the benefit of the National Retinitis Pigmentosa Foundation.

A committee of experts, composed of Alan Fern, Bryan Holme, Arnold Saks and Grant Wolfkill, has chosen twenty-one of the most celebrated contemporary photographers, those who have devoted special attention to the technique and language of colour photography, bringing them together here in an exhibition that illustrates its many-sided expressive resources.

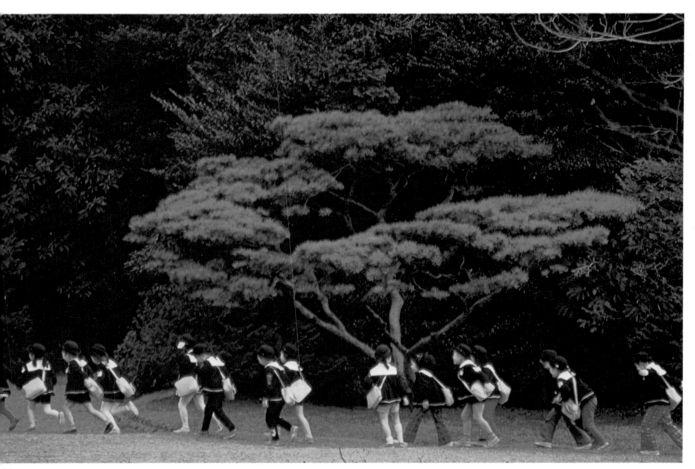

Jerry Cooke

236

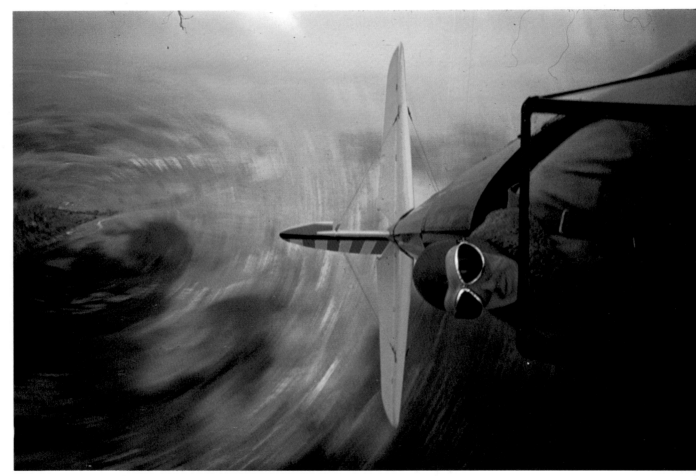

John Zimmerman

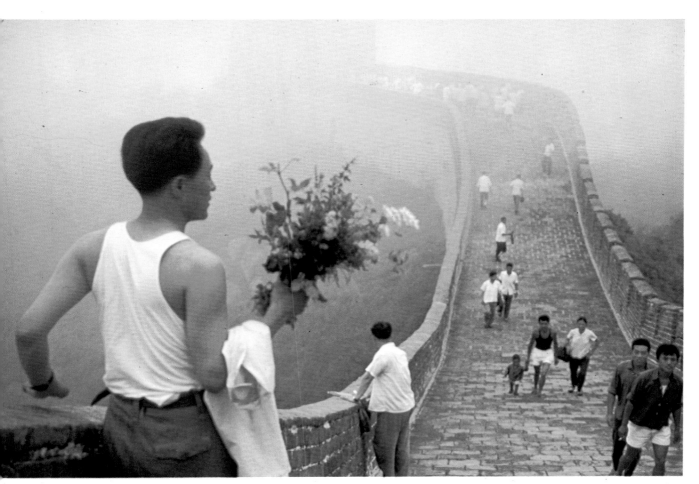

Marc Riboud

238

Pete Turner

239

Emil Schulthess

Howard Sochurek

Ernst Haas

242

Jay Maisel

243

Joe Franklin

244

Doug Faulkner

245

Brian Brake

Gordon Parks

Hecho en Latino America

Hecho en Latino America

Argentina
Eduardo Comesaña
Alicia D'Amico
Sara Facio
Maria Cristina Oribe
Juan Travnik

Brazil
Luis Abreu
Rosa Ma. Alves Santos
Abelardo Bernardino Alvez Neto
Claudia Andujar
Francisco B. Aragao
Sebastian Barbosa
Antonio Luiz Benckvargas
Ricardo Chaves
Maria Beatriz R. De Alburquerque
Odilon De Araujo
Ayrton De Magalhals
Ceraldo De Barros
Fernanda Maria De Castro Paula
Manuel Antonio Da Costa Junior
Renato De Luna Pedrosa
Adriana De Queiros Mattoso
Luis Carlos Felizardo
Januario Garcia
Rosa Gauditano
Mauri Granado
Assis Hoffmann
Boris Kossoy
Ney Krüse
German Lorca
Ricardo Mardelli Matta
Delfin Martinz Lourenco
Luiz Humberto Martinz Pereira
Alberto Melo Viana
Milton Montenegro
Ameris M. Paolini
Mazda Perez
Penna Prearo
Reginaldo Rosa Fernandez
Antonio Carlos Silva Davila
Vera Simonetti
Leonid Streliaev
Evandro Teixira
Ysteu Urban
Luis Carlos Velro
Ricardo Van Steen

Chile
Patricio Guzman

248

It is not by chance that in the course of 1977 two initiatives arose in Mexico destined to affect photography with definitive force. One was its inclusion in the First National Graphics Biennial, held that year, on an equal level of importance as that of any other artistic printing technique. Another was the continental reunion, also held in Mexico City, in which photographers from latinamerican countries participated, either personally or through their work. Such a gathering signified the starting point for an evaluation of latinamerican photographic production as well as an expression peculiar to an artistic family, traditionally lacking ties as a result of an isolation and a nationalism forcibly diminished. The narrow confinement within our borders was becoming unbearable; the ample response to an invitation to the First Latinamerican Photography Encounter and to its programmed exhibition is proof of the urgent need for dialogue and exchange.

And it is not fortuitous, because ever since the first decades of the present century, photography has been an art saluted by militants of the mexican contemporary plastic arts movement as a significant component of their contemporaneousness. In 1926 Diego Rivera emphasized the presence of Edward Weston and Tina Modotti in eloquent terms of equality: "Today our sensibility is no longer fooled by the novelty of the camera process and we modern men, feel clearly the personality of each one of the authors of different photographs taken under equal conditions of time and space. We can feel the personality of the photographer as distinctly as that of the painter, draughtsman or engraver. In reality the camera and the laboratory work it implies are as much a technique as are the oils, pencils and watercolors and, above all, there persists the expression of the human personality that makes use of it."

Years later, in 1955, on occasion of Hector Garcia's first exhibition, Rivera insists on his unrestricted acceptance: "It has been for a very long time discussed whether photography is no more than a mechanical-plastic graph document or if it is a technique based on physical and chemical phenomen that nevertheless serves the expression of an artistic sensibility. Many such works have already been produced on all types of photographic genre, from static still pictures to ultrainstantaneous cinematography, so that only utter obstinacy, reactionarism or simple foolishness may persist in denying photography its quality as an art, which is possibly the most vivid expressio of modern graphics, *particularly in cinematography and fotoreportage*, with much right to be considered a work of art as any other work resulting from any other technique. What really counts is the sensibility, imagination, intelligence and human intention added to the dynamic balance of the expression of whoever uses such techniques, which not by themselves bestow, through their adequate know-how, the quality of art such quality springs from the aforementioned conditions present in the individuality of the person who expresses them, molded by the social and political circumstances under which life evolves."

In 1945, during the exhibition of Manuel Alvarez Bravo's work presented b the Society of Modern Art, David Alfaro Siqueiros undertook an in-depth analysis of the photographic profession. Siqueiros reminisced upon the fac that it was painters or people somehow linked to the technical preoccupations of painters who ever since pre-christian Greece conceived and developed the mechanical process of still images and that such a search, surging forth during the beginning of the Italian Renaissance, materialized as a full-fledged technique in the nineteenth century. Siqueiros recalled the innumerable benefits of photography upon science and technique: "Physics in all its specialties (astrophysics in a particularly

surprising manner), chemistry, medicine (through the use of X-rays and other more recent procedures), cartography (geography, consequently), education, art, and the military sciences all owe to photography a greater debt than to any other of their scientific tools. As we must all know, photography has transformed into documental proof that which up to now was no more than a hypothesis. Moreover, with such documental proof, photography has opened the door — better and wider than any other tool — to the enormous contemporary progress in all its scientific and technical means. Photography has given the term 'scientific proof' the sense of unquestionable reality. Propaganda, publicity and sports owe it as well, no less a debt".

Siqueiros recalled that it was plastic artists who undertook the documental proof of the way in which a horse runs or an object burst, of the rythm of a man's actions, of the materialization of weeping, fear and happiness. These plastic artists, said the mexican muralist, "were never able to imagine that such sought-for documental aid was not to be simply a weak creature destined to be led by the hand of the art of painting but was, precisely its opposite, destined to become an instrument for the discovery of unexpected realistic elements."

Siqueiros mocked landscape artists and academic portrait painters who used photography as a childish trick. He held photography to be an autonomous art which modernized painting, linking it to the new preocupations of the art movement and of the physical and psychological actions. To the prejudiced, who diminished the value of photography's aesthetic production only because they sprang from a machine, Siqueiros retorted: "It is only with machines that man can create either plastically or graphically. All tools used in the production of the plastic arts are machines, even those most remotely primitive", and he emphasized the fact that photography, as a multireproductible art with all its possibilities for a public and democratic distribution, was the art form of its time and of the future.

249

Today, when latinamerican photographers for the first time gather together with all their differences and similarities here in Mexico City, one inevitably recalls that it was precisely here, almost 50 years ago, where Tina Modotti ('hermana', Pablo Neruda called her) wrote her only photographic manifest. This happened on the occasion of the exhibition of her mexican work, presented from the 3rd to the 14th of December of 1929 in the library of the National Autonomous University of Mexico. Said this universal, internationalist Italian: "Whenever words such as art or artist are used in regards to my photographic work I am unpleasantly impressed, due I am sure, to the abuse and inadequate use that is so often made of them. I consider myself no more than a photographer and if my work is in any way different to that generally produced in this field, it is because I try precisely to produce not art but honest photography — without tricks or manipulations, while the majority of photographers still search for artistic effects or for the imitation of other means of graphic expression, from which results a hybrid product that fails to bestow the work with that which would be its most valuable asset: photographic quality.

Much has been discussed during the last years, whether photography may or may not be a work of art comparable to other art forms. Naturally, opinions vary: on the one hand, from those who accept photography as a means of expression equal to any other, and on the other hand, from the shortsighted who continue to perceive the world of the twentieth century with eighteenth century eyes and who are therefore incapable of accepting the manifestation of our own mechanical civilization.

For those of us who use the camera as a tool just as the painter uses his brush, these adverse opinions do not count; we have the acceptance of

German Herrera
Pedro Hiriart
Enrique Ibarra
Graciela Iturbide
Nacho Lopez
Rosa Lilia Martinez
Fabian Medina
Felipe Mendoza
Oscar Menendez
Pedro Meyer
Rodrigo Moya
Carlos Montenegro
Jose Luis Neyra Torres
Carlos Noriega
John C. O'Leary S.
Ricardo Ortega
Pablo Ortiz Monasterio
Roberto Pacheco
Sergio Rivera Conde
Akram Saab Hassen
Jesus Sanchez Uribe
Pedro Span R.
Oberto Tellez Giron
Manuel Trejo
Marianne Yaampolsky
Michel Zabe

250 *Panama*
Sandra Eleta

Peru
Armida T. De Figari
Jose Gushiken
Carlos Montenegro
Jorge y Vicky Loayza

Porto Rico
Roger Caban
Hector Mendez Caratini

Salvador
Cesar Trasmallo

United States
Lou Bernal
Charles Biasiny Rivera
Francisco y Camplis
Isabel Castro
Arturo Dell'Acqua
Eduardo Del Valle Y Mirta Gomez
Nancy Gamboa
Frank Gimpaya
Jose Lopez y Luis Medina
Diana E. Mines

those who recognize the merits of photography and its multiple functions, who accept it as the most eloquent and direct means to record present times. Neither is it important to know if photography is or is not an art; what counts is the distinction between good and bad photography — good being that which accepts the limitations inherent to the photographic technique and makes optimum use of the possibilities and characteristics that such a mean offers; while bad is that which is produced, one could say, with a certain inferiority complex, with an incapacity to appreciate that which photography possesses on its own, resorting to all sorts of imitations, these giving the impression of having been made almost with shame by someone trying to hide all that is truly photographic in his work, masking it with tricks and falsifications that can only please those with a perverted taste.
Being that it may only be produced in the present time, based on that which is objectively before the camera, photography emerges imposingly as the most satisfactory means of recording objective life in all its manifestation; thus its value as a document. If moreover one adds sensibility and understanding of the theme and, above all, a clear comprehension of the place that it must assume in the field of historical development, I believe that the result is worthy of taking its place in the social revolution to which we must all contribute.''
Certainly, not all photographers active today in Latinamerica would subscribe Tina Modotti's manifest; there are many aesthetic tendencies and diverse aesthetic positions. But the fact that a good number among them would support it, leads us to consider the prevalence of that photographic work whose critical eloquence and evaluation helps express a latinamerican being to the scorn of the imitation of realizations revered in other latitudes; realizations from which much may and must be learned, but holding as a premise the contempt of mimetism.

This exhibition, we know, is a launching into circulation of worthy portions of the genuine photographic work accomplished in our countries, imposing its presence with a maturity greater than the critical appraisals that on the whole have been made up to now. Deeply affective similarities, surprising contrasts and historical differences emerge from this first concrete action that permits us to detect some of the features common to latinamerican photographers: the rejection of an alienating and unjust society; the denunciation of exploitation, margination and colonization; a rupture with conventional aesthetic models; an impulse towards a reaffirmation that recognizes in concrete things an unexhaustible quarry of creativity; a conscious reading of the geographic and ethnic peculiarities in order to place them, within the image, in their levels of signification; the beginnings of new interrelations, new orders to conquer greater scope and complexity; a contempt for superficial description that do not tend to reveal man's relations to his social and natural space; a neatness of execution that demonstrates a capacity to see and feel; the rejection of the technical subterfuges placed before the photographer by a consumer industry; a denial of sophisticated techniques that make perfection an end in itself to the detriment of creativity and imagination; a will to transmit those facts from daily reality which many choose to ignore and others deform or conceal, considering them bothersome or offensive; a will to interpret deeper into meanings for all they have to say; a repugnance to appropriate, through insipidly taken plates, a reality that oscillates between violence and hope; an acceptance of the fact that it is not the camera but the photographer who lies when making use of his right to explore symbolism; the avoidance of all manipulation and a strict respect for the subject; and finally, a will to serve the viewer without seducing him.

Statements such as these may possibly constitute a platform for the latinamerican photographer who, frequently occupied with national affairs, has become involved in the economic, politic and military pressures that occur in the process of dependence on imperialism and the oligarchic exploitation under which the greater part of latinamerican countries live.

We know that in Latinamerica, as in the rest of the world, photography has penetrated in such a way that it affects the thoughts and the feelings of the people. If in no more than one century its influence has been great, it will be greater in the future since the compenetration of and increasing number of photographers with the preoccupations and problems of their countries is greater every day. The quality and originality of a good part of this production will permit it to fulfill, in a comprehensive manner, its functions of communication and participation.

251

exhibition comprises 300 photographs by american photographers actively engaged sociological analysis and in erimentation with photographic language. anged by the Consejo Mexicano de ografia and first shown in 1978 at the seum of Modern Art in Mexico City, it ns the most important account of tography in South America to date.

Raquel Tibol
In *Hecho en Latino America*, (catalogue),
Museo de Arte Moderna, Mexico City, May 1978

252

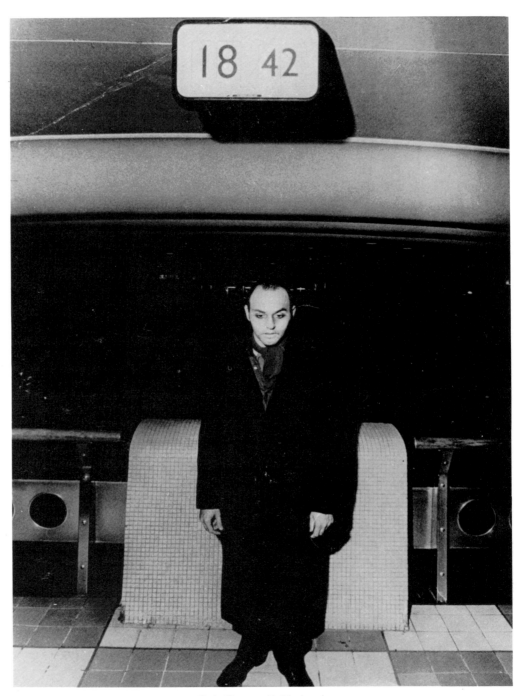

Boris Kossoy, Untitled, n.d.

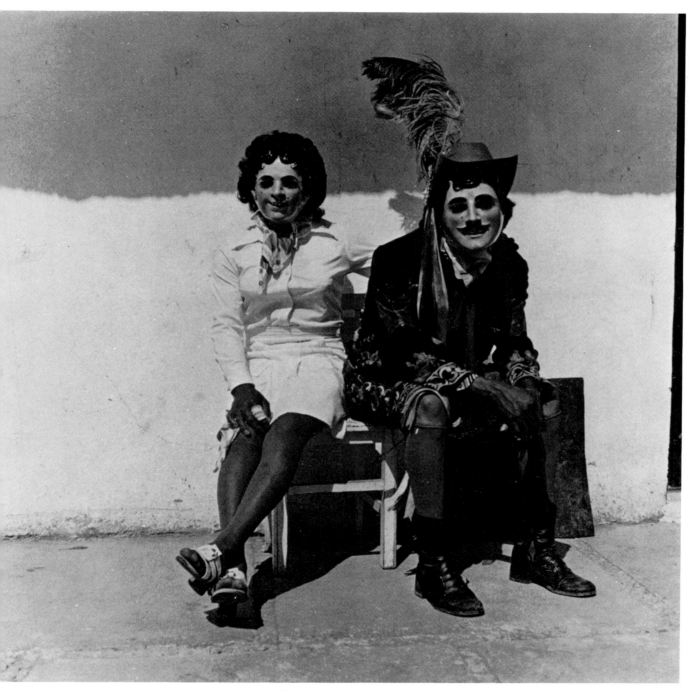

Carlo Blanco Fuentes, Untitled, n.d.

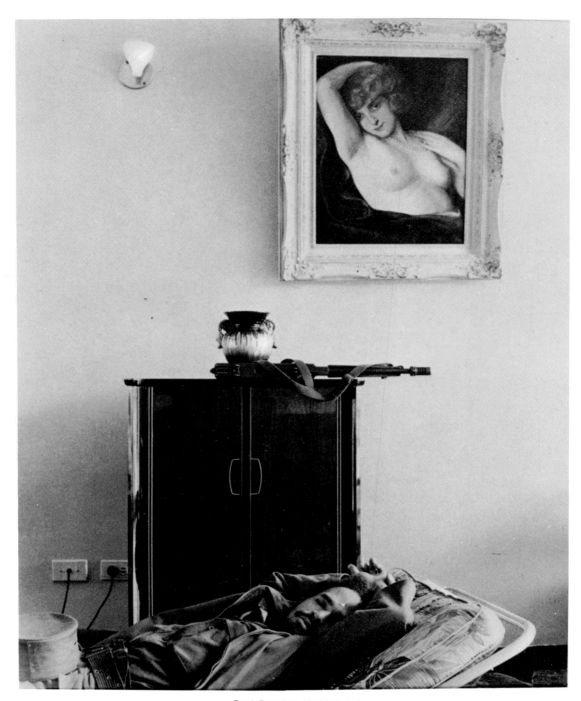

Raul Corrales, Untitled, n.d.

Carlos Caicedo, Chiquinquira, n.d.

256

Sara Facio, Approximation of Life, 1963

Nacho Lopez, Untitled, n.d.

Pedro Meyer, Untitled, n.d.

Allen Carter, Isabel III, 1978

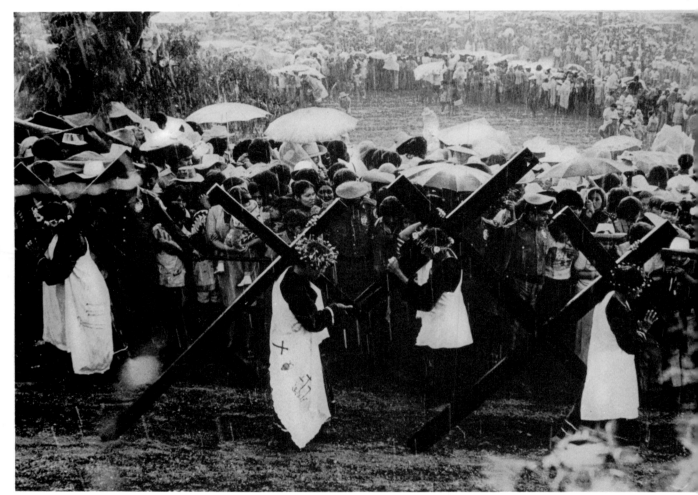

260

Ruben Cardenas Paz, Untitled, n.d.

José Lopez y Luis Medina, San Lázaro, 1973

262

Odilon de Araujo, "Anna", 1977

Luiz Carlos Felizardo, Cemetery of Santa Barbara, n.d.

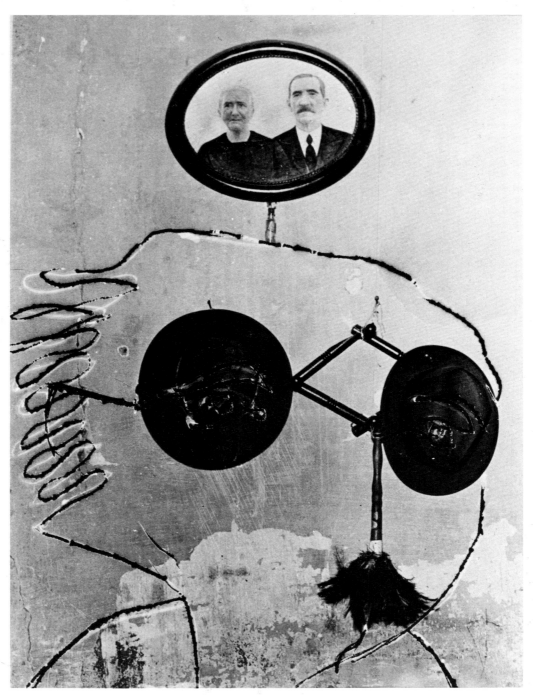

Geraldo de Barros, Homage to Stravinsky, 1948

Self-Portrait: Japan

Self-Portrait: Japan

Ryoji Akiyama
Nobuyoshi Araki
Masahisa Fukase
Hiroshi Hamaya
Shinzo Hanabusa
Ikko
Miyako Ishiuchi
Kikuji Kawada
Jun Morinaga
Daidoh Moriyama
Kishin Shinoyama
Issei Suda
Shomei Tomatsu
Haruo Tomiyama
Hiromi Tsuchida
Shoji Ueda
Gasho Yamamura
Hiroshi Yamazaki

266

This exhibition is part of the "Japan Today"
programme.
Designed by Cornell Capa and a Japanese
Committee chaired by Shoji Yamagishi and
composed of Hiroshi Hamaya, Jun Miki,
Shomei Tomatsu, Ikko Narahara and Ryoji
Akiyama, it illustrates the historical
development of the photographic art in Japan
since World War II.

More often than not, "cultural exchange" is used as a means of expressing
the military or economic dominance of one country over another. It is also
sought to ameliorate troubled relations and can assume the form of flattery.
In either case, the motives are suspect, the effect paltry.
However, when individuals take it upon themselves to express to each other
what lies within their hearts, it is possible that friendship, trust and self-
restraint will be the basis of a beautiful exchange. It allows for new bonds of
confidence to be formed. "Japan: A Self-Portrait" is indeed a project with
such humanistic concerns. Having received this generous invitation from the
United States to participate in its program, I and the five members of the
Japanese committee have endeavored to meet these new standards.

Photography has always been called an international language and as a
result, has too often been misused and misperceived by the public at large.
Even an international language must be interpreted in light of the person who
is using it. This exhibit does not simply show photographs of Japan, but
rather represents the unique visions of individual Japanese photographers.
The selection was made primarily to show their work. Viewing each of their
varied, sometimes fantastical images, I believe the reality of Japan emerges.
Finally, this exhibit takes place in 1979, and I take this occasion to look back
upon postwar Japan with a special focus upon this past decade. It becomes
clear that in these last ten years, Japanese and American cultures have
come closer in influencing each other. Let us hope that this forecasts
developments for the 1980s.

Shoji Yamagishi

Haruo Tomiyama, Japanese people drink 2,458,600,000 bottles of beer per year (original in color)

Issei Suda, Fiesta, Kanda, Tokyo, 1975

Hiroshi Yamazaki, The Sun, The Pacific Ocean, 1978

Masahisa Fukase, Black Bird, Ishikawamon, Kanazawa, 1977

Jun Morinaga, Sea: On the Waves, Nokono Island, Fukuoka, 1972

Daidoh Moriyama, Another Country, Saku, Nagano, 1978

Hiroshi Hamaya, Mt. Fuji, 1960-61

274

Haruo Tomiyama, Tokyo: Spring, 1979

Kikuji Kawada, Los Caprichos, Space Square, Toyosu, Tokyo, 1978

Kishin Shinoyama, Meaning of the house, Living room of a farmer's house, Kagoshima, 1975

Gasho Yamamura, Of Vegetation, Izu Kogen, Shizuoka, 1975

Ikko Narahara, Zen, Sojiji Temple, Soto Sect, 1969

Contemporary Italian Photography

Contemporary Italian Photography

Gabriele Basilico
Walter Battistessa
Gianni Berengo-Gardin
Romano Cagnoni
Marcella Campagnano
Lisetta Carmi
Vincenzo Carrese
Mimmo Castellano
Elisabetta Catalano
Giuseppe Cavalli
Carla Cerati
Cesare Colombo
Mario Cresci
Luigi Crocenzi
Mario De Biasi
Pietro Donzelli
Mario Finocchiaro
Franco Fontana
Luigi Ghirri
Mario Giacomelli
Paolo Gioli
Gianfranco Gorgoni
Franco Grignani
Guido Guidi
Mimmo Jodice
Ferruccio Leiss
Giorgio Lotti
Paola Mattioli
Pietro Francesco Mele
Pepi Merisio
Nino Migliori
Paolo Monti
Ugo Mulas
Luca Patella
Federico Patellani
Tino Petrelli
Fulvio Roiter
Roberto Salbitani
Chiara Samugheo
Ferdinando Scianna
Tazio Secchiaroli
Oliviero Toscani
Franco Vaccari
Luigi Veronesi

In his introduction to the *1943 Photography* annual, Ermanno Scopinich wrote: ''Italian photographers do not willingly carry out technical research; they are still not sufficiently conscious of the need for experience in this fie The Italian photographer improvises. He improvises in the exposure room with haphazard lighting arrangements and in the dark room with primitive equipment. He makes up for the gaps in his knowledge and the drawbacks of his work tools with a touch of genius...''

The war was still going on but twenty years of Fascism were drawing to a close and at last the yoke of a hapless cultural autarchy, which had influenced so many technological and intellectual areas for so long, was about to be lifted.

Despite the new promptings of publishing and journalism, and although they continued to improvise, Italian photographers seem to have succeeded in getting out of a peripheral ghetto and competing within a relatively short tim without inibitions on an international scale. And they did so, despite the indifference of which they are still victims today, in circles conditioned by lingering, humanistic attitudes, which can hardly bear the appeal of such direct idiom as photography, which is, moreover, ''machine-made.''

Inevitably they have resorted to energies and channels often extraneous to the Italian cultural, artistic and publishing world which is reluctant and distrustful and would prefer to exploit this medium mainly for its craft aspect at times depriving the photographer of his right to be a conscious *author* ideologically responsible for his own decisions. Young Italian photography is also the fruit of these contrasts and prejudices, which have fed the debate photographic language ever since the 1940s, when the ''gruppo degli otto'' and later that of *Domus*, first embarked upon their endless and profitable ta of revising and analysing the specific, mainly in the wake of the European avantgarde pioneers.

The exciting work done by Bragaglia in 1912 passed unnoticed, however, neutralized as it was by several decades of pleasant pictorialism. This was evidently not altogether harmless seeing that the struggle was to last so lor against this artistic affectation which was nevertheless being steadily erased by photo-reporting.

After the war, photographers too became enthusiastic about neorealism. They felt a congenital sociological vocation for it, whilst among amateur photographers a ''school'' formed by the ''Bussola'' group began to take shape. This group shunned the documentary in particular and stirred up the age-old and sterile diatribe on the *photographic art*, which has perhaps still not quite run its course.

An equivocal distinction between photo-reporting and creative photography has for the past twenty years characterized the work of Italian photographe in search of their identity.

By the mid-fifties the surprise caused by the inevitable foreign influences which had affected all the arts had been overcome. Publishing and the illustrated press rose to a European rank and photographers found it less necessary to improvise, especially during the boom when industry boosted the visual advertising market.

In the north, ''still life'' photographers began to emerge, while in Rome the ''dolce vita'' called for the ''paparazzo'' (the scandal-magazine photo-repor invented by Fellini), whose coolly aggressive pictures did however also offe an alternative to the polished conformism of the smart glossy magazines.

In the 1960s people talked increasingly about photographic *culture*; innumerable trade journals were printed, many of which were warranted

bliography

A.VV., *Fotografia*, Gruppo Editoriale Domus - ilan, 1943.
iuseppe Turroni, *Nuova Fotografia Italiana*, chwarz, Milan, 1959.
ladimiro Settimelli, ''La fotografia italiana'', in A. Keim, *Breve storia della fotografia*, naudi, Turin, 1976.
lo Zannier, *70 anni di fotografia in Italia*, unto e virgola, Modena, 1978.

solely by the remarkable popularity of photography as a hobby. Even collecting began timidly; and art galleries started to show photography too... Despite everything, academic circles are still indifferent to photography although its use is increasing and plays a determining part in all mass media. Educational circles, which ought to have taken a greater interest in this technique-art-language, have been restricted by habit and a commonplace outlook and have granted photography nothing more than an out-of-school role, once again at a dilettante level.

The Italian photographer still has to improvise and even to invent his own schools, relying on macroscopic foreign publishing and climbing on to the bandwagon of worldwide photography. Meanwhile he has picked up the formulas of international photography and adapted them in an intermingling of cultural interests which a few professional experts have facilitated by means of exhibitions and publications that have at last emerged from underground.

In recent years the crisis in photo-reporting has taken a particularly worrying turn also as regards the photographer's professional place in society. Only recently have these practitioners won a modest recognition of quality vis-à-vis their journalist-writer colleagues, after years of struggle often at the cost of emigration but repaid in several cases by success in leading international publications.

For a number of years now the inclusion of ''*aesthetic operators*'' among photographers has added to the problematics of this medium. It now faces new ambiguities and doubts about the photographic image which for one hundred and fifty years has offered a cherished but perturbing illusion of reality.

281

he exhibition, arranged by Italo Zannier, esents a selection of works by forty-four lian photographers picked from those who ve effectively distinguished the historical evelopment of Italian photography since 45.
he four hundred pictures in this anthological chibit are intended to illustrate the most ried and at times contradictory work carried ut during the past thirty years in Italy both in e experimentation with language and in hoto-reporting in its manifold aspects.

Italo Zannier

Luigi Veronesi, Kinetic Photography, 1940.

Giuseppe Cavalli, The Chessboard, 1954

Ferruccio Leiss, Reflections in the Venice Laguna

ANDIAMO
IN PROCESSIONE

racconto
fotografico
di LUIGI CROCENZI

Luigi Crocenzi, Photographic story «Il Politecnico», no. 35, Jan-March, 1947, pp. 54, 55, 59.

Pietro Francesco Mele, Lepcha Girl, Yatung

Vincenzo Carrese, Black Market, 1945

Federico Patellani, Invasion of the Lands, 1946

Mario De Biasi, Hungary: Budapest, 1956

Fulvio Roiter, Spanish Gipsies on the
Guadix-Granada Road, Andalusia, Spain, 1955

Cesare Colombo, Reality-Plane, 1976

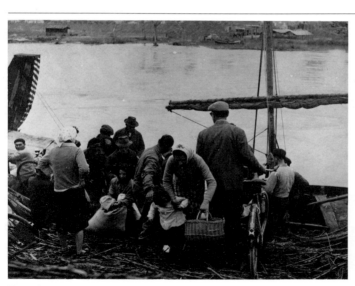

Pietro Donzelli, Series: The Po Delta in the 1950s

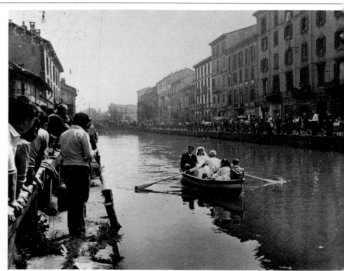

Mario Finocchiaro, Zone: Porta Ticinese, 1970

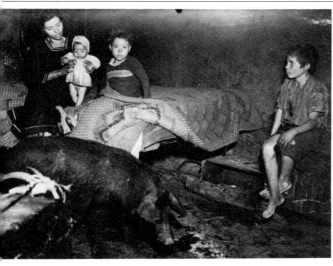

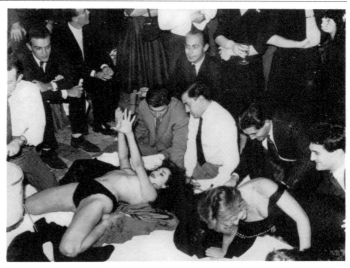

no Petrelli, Africo, 1948

Tazio Secchiaroli, Rome: Strip-tease at the Rugantino, 1958

o Mulas, The Enlargement ''The sky for Nini''

Nino Migliori, Idrogramma, 1954

Franco Grignani, Laceration, 1953

Mario Giacomelli, Awareness of Nature, 1978

Franco Fontana, Italian landscape, 1978

Pepi Merisio, Festa della Trinità at Monte Antore, Latium

anni Berengo-Gardin, Great Britain, 1978

mmo Castellano, from ''Paese Lucano'', 1965

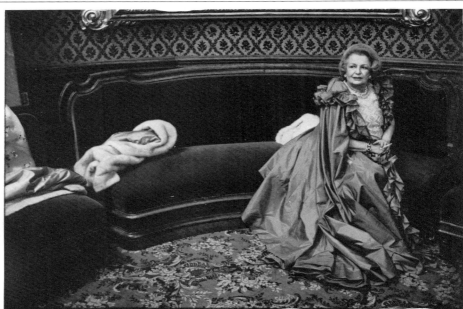

Ferdinando Scianna, Montecarlo - The smart people, 1972

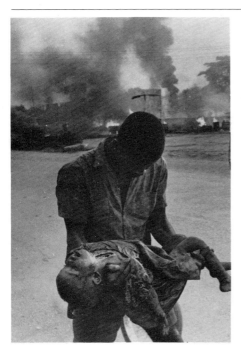

Romano Cagnoni, Ghana

Mimmo Jodice, The Leonardo Bianchi
Psychiatric Hospital, Naples, 1978

Carla Cerati, Barcelona. The writer Gabriel
Garcia Marquez with his wife Mercedes and
children

Giorgio Lotti, Portrait of Chou-en-lai, 1973

Lisetta Carmi, Spanish gipsy 2

Mario Cresci, From the series ''Measurements'',
1978

Paolo Gioli, ''From the dissolute sequences'',
Rovigo, May 1978

Luca Patella, ''Lu' capa tella'', 1974

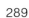

289

LASCIA SU QUESTE PARETI UNA TRACCIA FOTOGRAFICA DEL TUO PASSAGGIO

LASS AN DIESER WAND EINE FOTOGRAFISCHE ZEICHNUNG DEINES DURCHGANGS

LEAVE ON THE WALLS A PHOTOGRAPHIC TRACE OF YOUR FLEETING VISIT

LAISSE SUR CES MURS UN TEMOIGNAGE PHOTOGRAPHIQUE DE TON PASSAGE

Franco Vaccari, Real time exposure no. 4, 1972

Oliviero Toscani, "Jesus"

Chiara Samugheo, Sofia Loren

uigi Ghirri, Landscape, 1979

uido Guidi, Floor for yoga exercises, Treviso, 1976

Gabriele Basilico, Industrial Archeology, 1979

Walter Battistessa, Gemona, Friuli - A helper during the search for quake victims buried alive

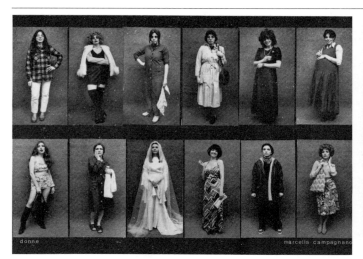

Marcella Campagnano, Two Women

Paola Mattioli, From the ''Cellophane'' sequence, 1978

berto Salbitani, Paris, France, 1976

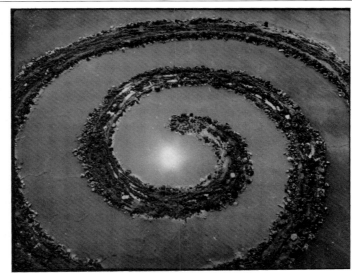

Gianfranco Gorgoni, Spiral Jetty, 1970

abetta Catalano, Portrait of Miklos Jancso

Paolo Monti, Poster, 1971

Weegee

Weegee

Born at Zloczew in Poland in 1899, he emigrated with his family to the United States in 1909, later adopting American citizenship. At the age of twelve he abandoned school to become a street photographer in New York. Between 1931 and 1935 he worked for the metropolitan police as a photographer of accidents and of scenes of crime.
For many years Weegee was employed as a printer in the dark room of a news agency in New York. But at night he photographed the city for himself and collected the pictures which he published in 1945 in a book, *Naked City*, which was also used as the basis for a film. After 1947 he worked for *Life*, *Vogue*, *Harper's Bazaar* and *Look*, and lived for many years in Hollywood. In the 1950s he did a successful series of photocaricatures of celebrities in the entertainment world. In 1959 he was invited to the USSR for a tour of lectures on photography in schools, and in 1962 he exhibited at the Cologne "Photokino" and at the Ligoe Duncan Art Center in Paris. He died in New York in 1968.

296

Bibliography

Weegee, *Naked City*, New York, 1946.
Weegee, *Weegee's People*, New York, 1946.
Weegee-M. Harris, *Naked Hollywood*, New York, 1953.
Weegee by Weegee, an Autobiography, New York, 1961.
J. Speck, *Weegee's Creative Photography*, London, 1964.
L. Stettner, *Weegee*, New York, 1977.

Weegee was a forceful photographer with a unique style and personality, b of those photographers currently judged as serious artists, this maverick almost defies acceptance. The images Weegee brought back from another world deeply trouble us. A gritty, raucous and self-advertising voyeur (who called himself "the famous"), he prowled the nights as a press photograph making the lives of "the tenants of the city" his subject matter. Much of hi seedy, squalid imagery explores human degradation. He reserved his sharpest sarcasms for the rich, whom he portrays as vacuous and greedy, and his exposure of the concrete horrors of the poverty, filth and the violence of big city life, especially in New York in the late 30's and 40's, insists that life just about batters people senseless.

No other art form rivals photography's capacity to be meaningless, to toppl into a void. As a hedge against vacuity, ambitious photographers cloak themselves in a knowledge of art. But Weegee was an innocent, a primitiv who described strong emotions and guilelessly jabbed at ours. In his autobiography, *Weegee by Weegee*, he discusses his early days as a fiddl player in a silent movie theatre: "I loved playing on the emotions of the audience as they watched the silent movies. I could move them either to happiness or sorrow. I had all the standard selections for any kind of a situation. I suppose my fiddle playing was a subconscious kind of training my future in photography."

Indeed, without literal music, his photos did supply their own willful jazz. H blew hot almost as if to escape his feelings of nullity.

His photographs are about immediacy: how some action is caught on the or just after it happened. He was a street photographer out for a scoop. Hi concern was for the life of the city, the tenants at work, at play, asleep, an in death, particularly as the aftermath of criminal activity. These are the categories in which he blocks out his imagery, to which he continuously returned, and that had deep psychological fascination not only for his audience, but obviously for him. But he was not only out to get memorable chance images; they had to have a consistently archetypal character. All Weegee's passion was centered on getting close to his material, to snatch the explosive moment out of the air. Nothing else counted. There is a fran edge to Weegee's imagery. He worked at a point-blank range and at a desperate pitch, the better to catch people in the raw. The only other photographer of note that Weegee apparently had some awareness of was Lewis Hine, whose work is grounded in reformist social judgments, an attitude antithetical to Weegee's apolitical stance. I would imagine, too, tha he would have sensed that Hine, above all, was a visual idealist. There wa nothing he could have used in the beautiful faces of immigrant kids and toiling workers bathed in Hine's sweet rapture. No one so much works as scavenges, grimaces, or screws up in Weegee's tacky, rundown circus.

His own tawdriness led him where few other photographers were willing to go, and gives a terrible, even horrifying edge of remorseless tension to so of his images. Take one from hundreds: the photograph of the psychopath copkiller, who has been arrested, savagely beaten up by his captors, and caught by Weegee's camera at the moment of being booked, fingerprinted and photographed. The bedraggled, abject and beaten criminal, eyes puffe and almost closed, hunches head downcast. Two plain clothed detectives stand with their burly backs to the camera, dwarfing the killer. A huge, out focus hand of the police cameraman cranking the handle of the camera fill the top left corner. It's a portrait of a brute cuffed by other brutes, on our side of the law.

Weegee's use of flash creates a luminous ovoid shape from the dark visua field, a clear center whose edges fade. This effect gives a startling authenticity to the image. We momentarily feel that we ourselves are there

observing the scene.

Weegee successfully evades isolating the movements of people. His photographs, including those taken in daylight, give a continuous sense of implied movement. This potential for movement, perhaps the expression of a face about to change, the rhythmic movement of feet, or the syncopation of various glances, is one of his graphic strengths. It keeps events in his photographs continuously alive. It's hard to guess the next motion of a person in a still photograph, but the behavior in Weegee's is instinctively charged with animate and continuous reflex, or is it, perhaps, that he startles it into being?

Weegee had an esthetic predilection for artificial light. He liked the way in which an object is highlighted and flattened by the freeze action of flash, and slowly dissolves into a saturated black background. He called this "Rembrandt light." This effect is only partly due to his equipment, a 4x5 Speed Graphic with a synchronised flash attached to the chassis, or capable of being hand-held nearby, with the exposure preset to 1/200 of a second, stopped down to F 16, focused to a distance of ten feet. The fast shutter speed and synchronised flash was ideal for Weegee's style of candid photography, which demands split second judgment combined with equally fast reflex action.

His images are snapped rather than compositionally planned. The flash automatically vignetted his subjects, well within the frame. This means he worked without a preconceived notion of composition or its decorum. He focused in on an event and if an image failed to compose itself to his satisfaction, he used the enlarger to crop and bring the viewer nearer to the image by eliminating superfluous detail, especially in the background, which he often burnt to a deep, flat black. Thus, Weegee's images are unleavened by tonal graduations. They have all the expressive qualities, rawness, and punchy visual impact of a woodcut, in comparison, say, to an etching.

Weegee's sense of graphic design is modulated by the fact that his photography was primarily produced for reproduction. His images had to survive being degraded by the printing processes used by the tabloid newspapers, in which the coarse black screen dot turns grey when the ink is sucked into cheap newsprint. Moreover, it was tough for an independent to sell photographs during the Depression, especially to newspapers who employed their own staff photographers. Picture editors are primarily journalists, who would not buy a print unless it looked catchily newsworthy. Weegee had spent long hours with police reporters at the police station waiting for a story to break. For him, the Black Maria was his studio. He knew as well as the editors the "what, why, when, how, where and who" of journalism, and that a photograph must tell it quick, especially if it is to be peddled to the tabloids, whose story headings are simplified and sensational. Similarly, Weegee's photographs have gutty or bold face attributes. They make no concessions to what photographers call print quality, or the idea of a photograph as a beautiful object (though later in life Weegee evidently reprinted some photographs with greater care).

Most photographers differentiate themselves from one another on a style basis, the specific, predetermined and recognizable ways of composing their images. This can hardly be said of Weegee, whose style consists of a raunchy casualness that is nevertheless uniquely his. By virtue of culture (Austrian Jewish) education (the streets) and temperament (neurotically insecure) Weegee developed an expressionist edge. Obsessively, he brought to the surface of his photographs a combustible situation, whose tangled vectors and gestures knit a tableau that is far less and much more than a psychological exposition.

The use of infra-red photography in reconnaissance flights to expose a

297

concealed enemy is well known. Weegee's infra-red photographs of high society cafe life strip away the artifice of his subjects' elegance or pretensions. With infra-red, a woman's makeup is separated from her face, floats on the surface like a mask, and concealed pimples or facial defects a instantly uncovered. Veins normally hidden under the flesh rise to the surfa of the skin, and the suavely dressed and neatly groomed men look tigerish as the film reveals capped or artificial teeth in their grinning mouths. The fil penetrates the skin under their freshly shaven faces and restores their hidden stubble.

It is not unusual for candid photographers to want to conceal the obtrusiveness of their presence. Ben Shahn, for instance, used a right-angled viewfinder to disarm his subjects. But they were always in pub places, and going about their conscious, ordinary lives in daylight. Weegee voyeurism is more furtive. The infra-red film and flash he so often used completely concealed his presence, and penetrated the safety of the dark expose people's intimate secrets: shamelessly entwined lovers in the protective darkness of the movie theatre, who feel they are doubly safe fro observation, as the rest of the audience watches a 3D movie wearing color glasses that blank out all else except the image on the screen. Or children picking their noses, or sucking their fingers as they watch, entranced by a movie. Weegee also prowled the beaches of Coney Island during the warm summer nights and photographed couples lovemaking.

Weegee exposes the terrible disorder and chaos of Life for the poor. Sometimes he catches in his camera transients scurrying around the deserted city at night, hugging the shadows, bedding-roll in hand, searchin for a safe haven to sleep in. Or sleeping anywhere they can, on a bench o in a shop door. Or grimy children of all ages and both sexes pitifully huddle together in a disorderly mass, sleeping like young animals on a tenement f escape to avoid the summer heat of their squalid rooms. In a photograph shot vertically from above, a flabby and nearly naked male sleeps on a mattress on the fire escape below. He is transformed by Weegee's mercile lens into the helpless image of an aging child.

Weegee was as close to a photojournalist as any photographer ever got to be. Weegee had all the necessary instincts to nose out a story for himself, which he would juice up by extravagant, callously written witticisms a la Raymond Chandler, such as "Covering Murders Gets Messy" (a photo of himself having his shoes shined), or "Special Delivery" (a corpse under a letter box). Although Weegee began as an evidentiary photographer, his captions often imposed upon the documents he stored up, the accents of a certain kind of pulp fiction. This lent his several books, supported by his ow written narrative texts, *Naked City, 1945*; *Weegee's People, 1946*; and *Weegee by Weegee, 1961,* the character of hard-boiled fables.

In the 50's, Weegee shifted his attention to distortions, and manipulated photographic cartoons, particularly of politicians.

There is a demonic edge to Weegee's quirky endeavor that bears discussic Sleep, self-absorption, and unawareness were his prime stimuli and people convulsed with pain, shocked, in terror, or blown out of their minds were h special target. In the moment he comes across them, seeking them out instinctively, it's as if he knows that in capturing their images he had a supreme power over them. They could not prevent his act. They literally were the most completely vulnerable people imaginable at that moment, in extremis, convulsed with grief, or totally helpless. This is what makes his work pitiless. It blazes away with its own kind of totally unsolicited awareness, thereby bringing off what photographers claim for the medium, but which it so rarely accomplishes — the rhetoric that unmasks. Weegee

belongs to a very American photographic vein, *to tell it like it is*. But the extreme lengths to which he was willing to take this rhetoric make the viewer's complicity in it all the more apparent. To come across a typical Weegee is to have the stakes in the photographic contract very much upped, emotionally and morally. Diane Arbus and even Les Krims, who surely owe him a great deal, allow us to recognize that self-indicting shiver which Weegee was the first to explore. For once we give public permission to the photographer to invade other people's lives, how can we object to his zeal in the matter, especially when it is slapped into form without any hypocrisy whatsoever?

The element of journalism in Weegee, as I said, also mixes with his expressionist intent. There are a number of journalistic photographers who are equally involved in the critical moment, concision, simplifying the image, and the like. It could be that in Weegee we are not really dealing with a photojournalist at all, but one who instead used photojournalism as a cover, unconsciously or not, for compensating reasons of his own. There is a recognizable level at which Weegee is not a detached reportorial professional, whereas many of his colleagues were just that.

There is a paradox and a contradiction in his apparent nerveless willingness to look upon appalling scenes and drink them in passively, without any apparent tremor of assistance. In one sense his images were no less or more than a ghoulish still life to him. On the other hand, there is his own insistence on focusing on these lurid moments for his own personal satisfaction, and which gives them their exceptional content. Our awareness of his excitement promotes these images of ostensibly banal horror to artistic horror which is capable of moving us. How does he accomplish this? One of the ways is by his Rembrandt lighting another, his biting expressionism. Weegee does not apologise. This private eye had a vital insensitivity that is precious. This is his fascination.

he exhibition comprises one hundred
elected photographs shown for the first time
the International Center of Photography in
w York. Presented by L. Stettner, this
oice documents Weegee's output from the
d of the 1930s to the end of the 1960s.

John Coplans

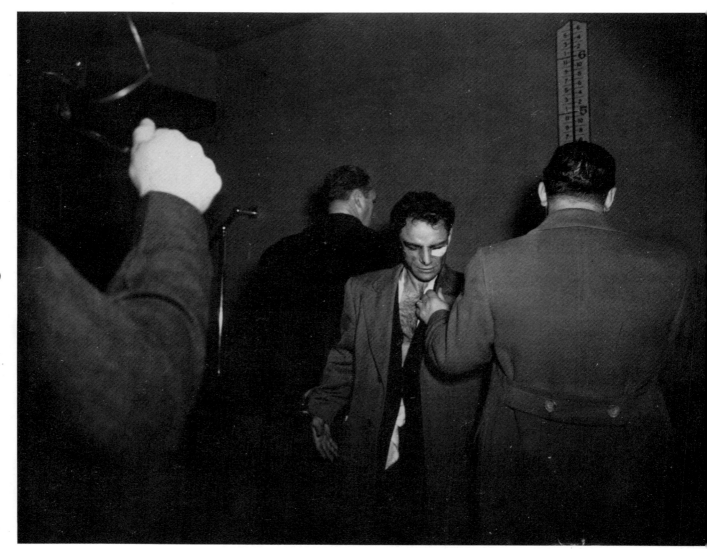

Cop Killer, 1930

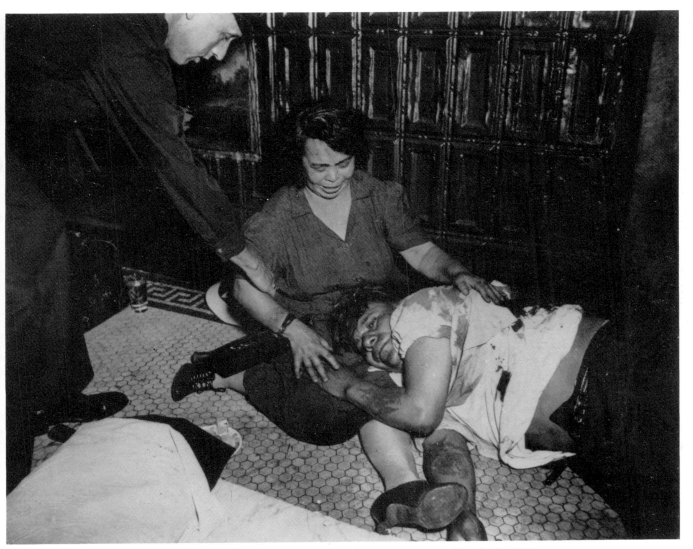

A wife comforts her husband just arrested for killing a member of her family, 1938

302

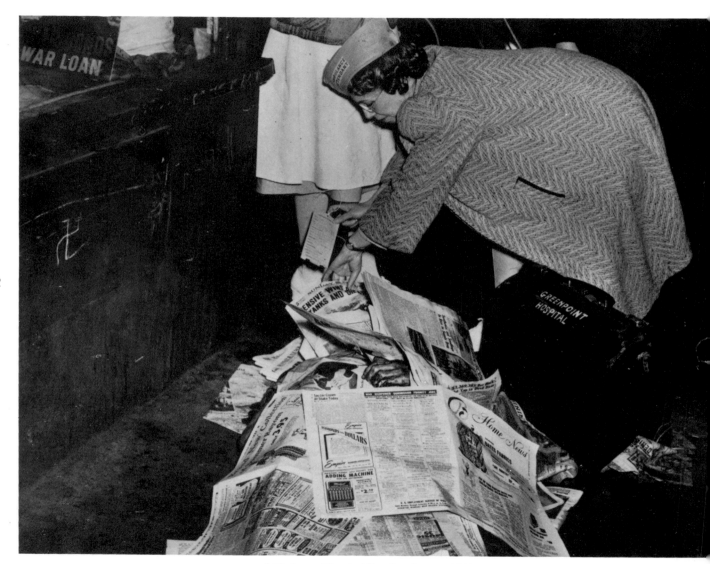

Ambulance Attendant Tagging Corpse, 1941

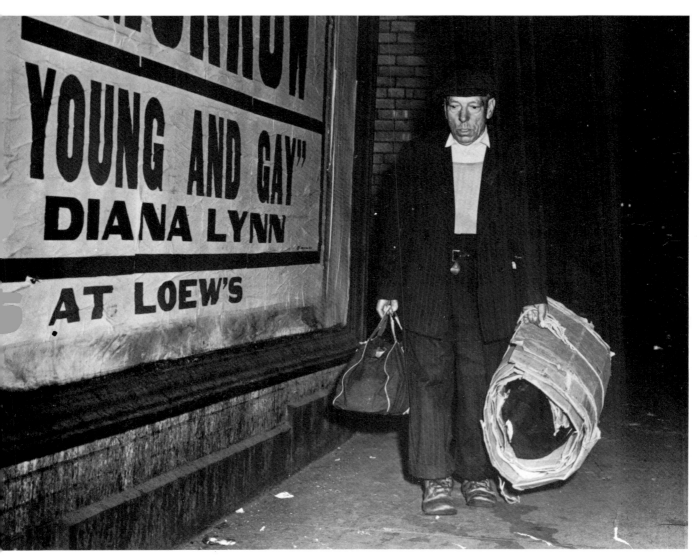

Man with a Bedroll, c. 1940

Easter Sunday in Harlem, 1940

The Critic, c. 1943

Norma, the star of Sammy's on the Bowery, c. 1944

Entertainers at Sammy's on the Bowery, c. 1944

308

A Party, 1947

309

Blonde at Sammy's on the Bowery, 1940

310

Marilyn Monroe, 1960

Robert Frank

Robert Frank

Born in Zurich in 1924, he is an American citizen and lives in the USA.
He began to photograph in 1942 in Switzerland, where he was a follower of Herman Eidenbenz and Michael Wolgesinger. After gaining experience in the cinema he devoted himself, between 1948 and 1955, to fashion and advertising photography for the magazines *Harper's Bazaar*, *Fortune*, *Life*, *Look*, etc. He worked with Edward Steichen on the collection and selection of pictures for the exhibition of "Post War European Photographers." His photographic interest dwells on the everyday and seemingly secondary aspects of the city, in a deliberately elementary style that contrasts with the often hedonistic approaches consecrated by postwar photo-journalism.
Since 1948 he has exhibited several times at the Museum of Modern Art in New York and he was the first European photographer to receive a Guggenheim award in 1955.

312

Bibliography

AA.VV., *Dagli Incas agli Indios*, Feltrinelli, Milan, 1957.
A. Bosquet-R. Frank, *Les Americains*, New York, 1958.
J. Kerouac-R. Frank, *The Americans*, New York, 1959.
J. Kerouac-A. Leslie-R. Frank, *Pull My Daisy*, New York, 1961.
R. Frank, *The Lines of my Hand*, New York, 1942.

The generation of the 1960's responded to *The Americans* with a special fervor, as if Robert Frank's intensely personal, almost eccentric vision was mirror image of its own. Although it showed an America thickening into a mass of gas stations, highways, drive-in-movies, bleak cities, dull jobs and banal pastimes, it was not in conventional terms a social tract. It had none the moralizing attitudes of the documentary photography of the 1930's; Frank's rage seemed to be against the human condition itself without an overt wish to change things. While his view of the system was bleak he ha great reserves of affection and tenderness for the people caught up in it. There was a romantic tenor to his work; an urgent need to experience life without the restraints of social conformity. The young saw in these photographs not things and places but a way of being and an invitation to seek their destiny outside the system.

Considering Frank's reputation as a hero of the counter-culture it is interesting to note that he began his career in Switzerland as an apprentice to a commercial photographer learning to use the view camera and studio lights. In fact when he came to the United States in 1947, at the age of 23 he used an album of his commercial photographs to get work from Alexi Brodovitch, the legendary art director of *Harper's Bazaar*. Frank's real work course was never in a photography studio and it was in Switzerland, in 194 making photographs on the street that he began to establish his style. The direct, artless photographs he made in 1946 set the tone for the work of th following fifteen years and though he was in turn influenced by Gotthard Schuh (the great Swiss photo-journalist was an early friend and supporter Frank,) Andre Kertesz, Bill Brandt and Walker Evans, his voice remained clear and singular. The tone of Robert Frank's work, with its unique mixture of sweetness and violence, is as distinctive as Atget's piety or Stieglitz's passion.
Although the publication of *The Americans* (Paris 1958, New York 1959) marked the beginning of a new episode in post-war photography, it represented a culmination, for Frank, of an intense period of still photography. In spite of the great fame of *The Americans* and to an extent the more recent book, *The Lines of My Hand*, much of Frank's work remai unknown. The fact that Frank exposed more than 28,000 individual 35 mm negatives during the two years he worked on the photographs for *The Americans* alone gives some idea of what remains to be discovered. The present exhibition concentrates on previously unpublished work from his American and European series. There are selections from the photographs he made in New York, Hollywood, Peru, Paris, Wales and London. Include are variants of famous images like the "Covered Car" and series which de with a specific theme or motif.

Frank has made us see for the first time things so obvious they were invisible before. He is the visionary of daily life — the master portraitist of Everyman. There is a series of photographs in the present exhibition of people and cars. A common motif for Frank is the view of people seen through the side windows of their vehicle; something we experience every day but rarely notice. For Frank, this sight, became an emblem of the transient. His decisive moment is when the guard is down and the expression on the subject's face is directed from within. Often his people seem a little lost in the world, bound up in a process they cannot control. It is a measure of Frank's character as an artist that he never ridiculed his subject even when that would have been the most obvious thing to do. Others have exploited the ironic content of his subjects but not Frank. In h Hollywood series there is a photograph (in the present exhibition) that sho

a pretty blond aspirant emerging from the offices of Central Casting. It would have been easy to treat her as a type and make fun of her obvious disappointment but Frank has chosen to treat her as a particular human being. Her hope, her tension, her vulnerability are evident and we are drawn, if only for a second, into another person's space.

There is a particular mood to all of Frank's work — a sadness akin to the blues. It is never depressing or a sign of weakness. Frank saw more clearly than most, the pain of ordinary life — his is the human face that Blake said pity wears. Unlike Diane Arbus he never had to seek out its most extreme manifestations and make a burlesque of despair.

The drama in Frank's photographs is never forced but grows naturally out of the transcendent reality he discovers in his subjects. When Ben James (the Welsh miner) leaves the homely comforts of the hearth to go down into the mines he takes on the aspect of a soul straining to escape Dante's Inferno. Some photographs through their sheer emotional intensity lose their obvious reality and become like icons.

It is not for specific pictures that Frank's fame will endure but for the clearly felt presence of the man behind the work. His anger, his love, his urgent need to communicate something of the emotional essence of what he experiences places him in the rare category of photographers who were true artists. Like Stieglitz, Atget and Walker Evans, Frank compels us to enter his private reality and accept it as our own.

313

e exhibit has been especially prepared for
enezia '79''. It records the experiments in
ual communication conducted by Frank with
tography. The exhibition comprises one
dred and fifty pictures, arranged by Paul
z, with the collaboration of Graphics
rnational Ltd. of Washington.

Paul Katz

314

New York, 1949

New York, 1952

316

New York, 1952

U.S.A., 1955

318

London, 1952

U.S.A., 1955

320

U.S.A., 1955

U.S.A., 1956

New York to Washington, 1957

U.S.A., 1955

New York, 1952

Norman Mailer, 1956

326

James Baldwin

Diane Arbus

Diane Arbus

Born in New York in 1923, she committed suicide there in 1971.
She made her début in *Harper's Bazaar* and *Esquire* as an advertising and fashion photographer. From 1959 she was a pupil of Lisette Model, who encouraged her to use photography primarily as a medium of sociological enquiry.
From then on she concerned herself with the habitat of social outcastes in large cities, in a photographic study of often grotesque, abnormal and unusual characters, revealing an unknown and disturbing face of America in the 1960s.
In 1967 she participated in the "New Documents" exhibition organized by the Museum of Modern Art in New York. Between 1970 and 1971, the year of her tragic death, she taught at the Rhode Island School of Design. In 1972 her work was shown in Italy, in the American Pavilion of the XXXVI International Venice Biennale.

328

Bibliography

D. Arbus-M. Israel, *Diane Arbus*, Millerton, New York, 1972.
Diane Arbus (catalogue), Stedelijk van Abbe Museum, Eindhoven, 1975.

The careers of artists do not always end with their lives. The posthumous fate of Diane Arbus exemplifies the way in which posterity can transform the artist's stature and the significance of his work. Prior to her suicide in the summer of 1971, Arbus was not what could be termed a well-known photographer. She had a certain reputation, which in terms of the profession of photography, was based in part on her commercial work. In the late sixties, she had published pictures, sometimes representative of her best and most serious work, in such publications as *Esquire, New York Magazine Harper's Bazaar, Show,* and *The New York Times Magazine*. However, she was reluctant to contribute to photography journals or to participate in exhibitions; most people, including even her friends and colleagues, knew only a fraction of her total output. She was also loath to become a professional talker (teacher) about photography. Since her death, her work has been included in the 1972 Venice Biennale — the first American photographer to be so honored — she has been given a retrospective exhibition at the Museum of Modern Art, and a stunning monograph, published by Aperture, has been devoted to her photographs. It is questionable whether she would have participated in any of these endeavors had she lived.

Diane Arbus was a photographer of great originality and even greater purity who steadfastly refused to make any concessions whatsoever to her public. Clearly, she must be considered among the two or three major photographers of the last two decades, and it may be said that the character of photography has been changed by her photographs. The influence of her work though most likely not the understanding of it, will increase each year hence. The young photographer of the future will find in her work the sources of a new modernism as well as the portents of a personality cult. But as with the photographs of Alfred Stieglitz and Edward Weston, her photographs can withstand such markings.
When her photographs were first exhibited in New York in 1967, Diane Arbus was forty-four. She was not born into the world she photographed. She came from a comfortable New York Jewish family headed by David Nemerov, who owned a once successful Fifth Avenue store. Her brother is the poet and critic Howard Nemerov. She was educated at the Ethical Culture and Fieldston schools. At eighteen, she married Allan Arbus, and together they became successful fashion photographers. In 1958 Diane abandoned this sort of photography and a year later studied with Lisette Model, that remarkable photographer and teacher whose work remains much less known than it should. It was Model, whose own photographs show the inspired vision of an artist of fundamental human concern, who imparted to Diane the understanding that in the isolation of the human figure one could mirror the most essential aspects of society — the understanding that in a photograph the most specific details are the source of the most general conclusions. Out of this experience, Arbus moved from the unreal world of high fashion to a world composed of people who may seem unreal, or tragic, but whose culture is unfortunately interpreted through the mores of another. It is this — the configuration and imposition of a society's values — that is the root subject of Arbus' photographs.

Since her first major exhibition at the Museum of Modern Art in 1967, which was directed by John Szarkowski and titled by him "New Documents," the work of Diane Arbus has been considered in the context of documentary photography. In that exhibition, she showed with two others: Lee Friedlander whose precisely structured street views were seen to depict a new social landscape, and Garry Winogrand, whose seemingly unstructured pictures

were nonetheless based in the strict logic of environmental circumstance. Many observers of this exhibition mistakenly compared the work of these three to that of men and women of the Depression era who, according to the narrow definition of documentary photography, attempted in their photographs to show actuality and subsequently, through their photographs, to alter the course of events. Or to put it another way, to improve and suggest social change. Materialism was perhaps the identifying concern expressed in this photography of the thirties. In contrast, the 1967 exhibition sought to show these new documentarians, if indeed that is what they should be called, were interested in the redefinition of the freedom of contemporary life and focused on human concerns more complex than material station alone. They portrayed the nature of anyone's daily life, and the subjects of many of their pictures had not been considered meaningful for photography before. These photographers stated the distinguishing characteristics of that quality we call modernity. Their work was often ephemeral, violent, weird, excessive with that acrid bouquet of urban life which, since the 19th century, has been associated with the beauty of circumstance and the sketch of manners.

From the point of view of style, Arbus continued the prewar tradition in so far as Walker Evans may be considered to have been a part of it. For Arbus, like Evans, was a portraitist. Her approach was to devalue a person's outer garments and facts and to concentrate on the individuality of the human being with his combined material and mental presence. In so doing, she was no longer a fashion photographer, nor was she a documentary photographer. She had entered into the realm of larger truths — of art. One can understand how clear her approach was, even at the start of her career, from this statement she wrote to accompany a portfolio of her photographs in 1962:

"These are six singular people who appear like metaphors somewhere further out than we do, beckoned, not driven, invented by belief, author and hero of a real dream by which our own courage and cunning are tested and tried; so that we may wonder all over again what is veritable and inevitable and possible and it is to become whoever we may be."

In considering Arbus as a portraitist we are allowed many interpretations, and these were also the opinions she consciously manipulated. The popular conception of portraits is they are ostensibly intended to show what someone looks like and they are truthful. We know they also tell about people and impart a sensibility of what the person's inner being, or character, is like. But we must not fail to realize that this is a multiple interpretation; the subject's own, the portraitist's, and the viewer's. The portrait exists simultaneously for all three but differently in each case. The individual participants are required to interpret each other by actually asking what they know of themselves. One of the things that disturbed Diane Arbus at the time of her death had to do with how misunderstood her work seemed to be, in the sense that it was thought of mainly in terms of the crudest subject identification with no self-reflection. In terms of the imitators of her photographs, these followers simply felt obliged to seek the bizarre in subject and secure a likeness on film. In so doing, they become even less than documentarians, and their work, because it totally lacks the psychological honesty of Arbus', is not portraiture. Her suicide will have to rest with our consciousness for a very long time, and even then one wonders if its meaning will be understood. It is clear she was not a voyeur. Rather she was a partner of the individuals whose true test was in living with themselves. Her pictures are about control, discipline in life, and controlled accidents in living it. In each case, the people she photographed had made the gesture of life their own affirmation of truth, and they were victorious. Her pictures are not of failures, and immorality is not the will from which these people, or Arbus, found nourishment.

Diane reminds us of Dorothea Lange, because here was another woman who was uncommonly tough. Each of these women could enter a situation that might destroy many people, and photograph, and then withdraw from the edge. We can sense this in their finest work. In this way, one can also understand something of what Arbus found in certain of her visual mentors: August Sander, Brassai, and Bill Brandt. In the photographer Weegee, Arbus found not only formal aspects of his work to her liking, but a sense of that rude honesty which marked his relation to subject or situation. The violence he showed was often more physical, but the consequences of the situations in which both Arbus and Weegee found themselves, were alike.

Her stylistic development seemed to follow a progression from complexity through simplification to highly complex pictures that seemed, however, deceptively simple. From photographs of people take from a distance and in an environmental context, to a gradual close-up isolation of the figure of head and an accompanying monumentality through the physical scale of her prints her last pictures revert again to that security of figures in an inhabitable space that exists apart from the photograph itself. It was perhaps as if, in challenging herself to move away from the type of picture that, since about 1967, she had been identified with, she chose the less dramatic, the less capable of imitation.

Arbus' photographs are superb accomplishments reflecting total control of the medium. Her concentrated work spanned a relatively short time, only ten years, but she seems to have sensed the primary hall-mark of her work from the beginning. The intense, calculated frontality of her subjects affects us immediately. In this sense, her pictures are almost clinical, like Vesalius' anatomical drawings, and their heroic scale, many almost 16x20 inches in size, cause them to embrace us. It is literally true that when we read a photograph we are in it. We may be drawn in swiftly or slowly, but once we are there we are enclosed. It is the power of the photograph, and its success, to interest us in this way. As any viewing of the original prints will prove, Arbus' pictures are very difficult to stay out of. In fact, it seems to me, what disturbs people more than the subjects of these pictures, is the intensity of their power to dominate us, to literally stop us in mid-life and demand we ask ourselves who we are.

It should not be considered unfortunate that Diane Arbus' work is colored by the circumstance of her death. Not surprisingly, Arbus' work is surrounded by a great deal of commentary; the personality of its creator will remain as pertinent as her photographs, Diane Arbus expressed her vision with a unique power. She pushed all the way through to the end logically, emotionally, artistically. One does not need to have seen every photograph she made to admire the courage and purity of her effort, to identify with it, and to recognize the cost. Diane Arbus, and the photographers who constitute that community of serious artists to which she belonged, all affirm Thoreau's declaration, "Be it life or death, we crave only reality."

330

Arranged by Marvin Israel, this exhibit consists of seventy-five emblematic photographs by Arbus, taken in the space of a decade, through which she renders a critical and merciless portrait of American society.

Peter C. Bunnell

Reprinted with the permission of the *Print Collector's Newsletter*, vol. III no. 6, Jan.-Feb. 1973, p. 128-130.

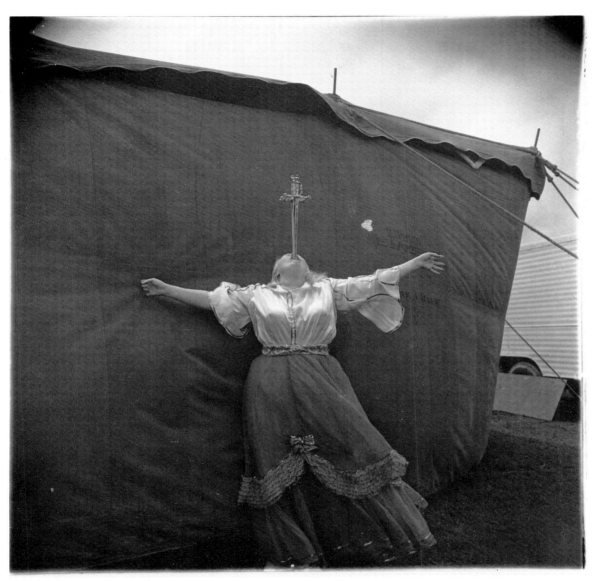

Albino Sword Swallower, Maryland, 1970

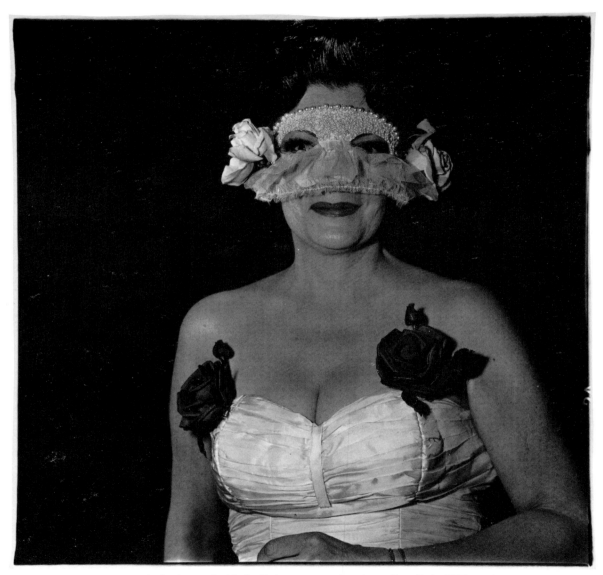

Lady at a masked ball with two roses on her dress, New York, 1967

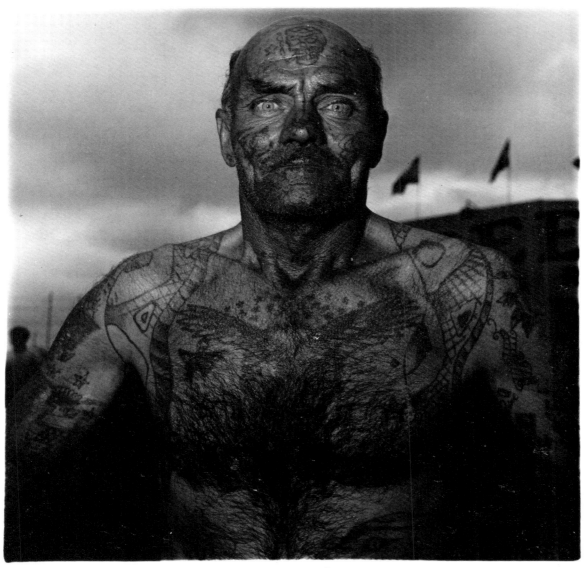

Tattooed man at a Carnival, Maryland, 1970

334

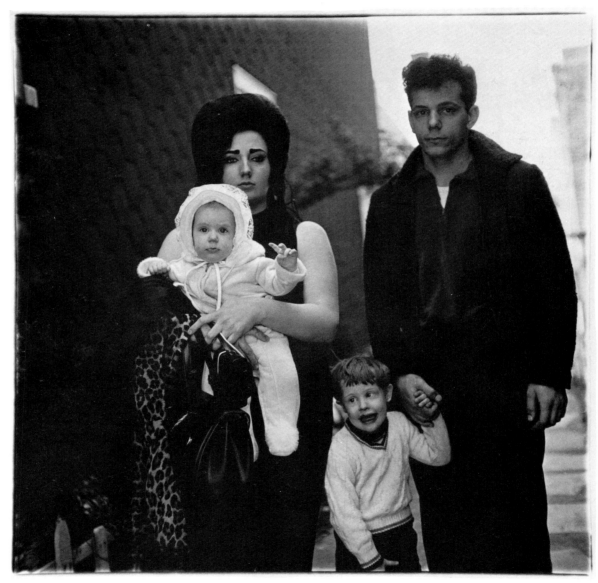

A young Brooklyn family going for a Sunday outing, New York, 1966

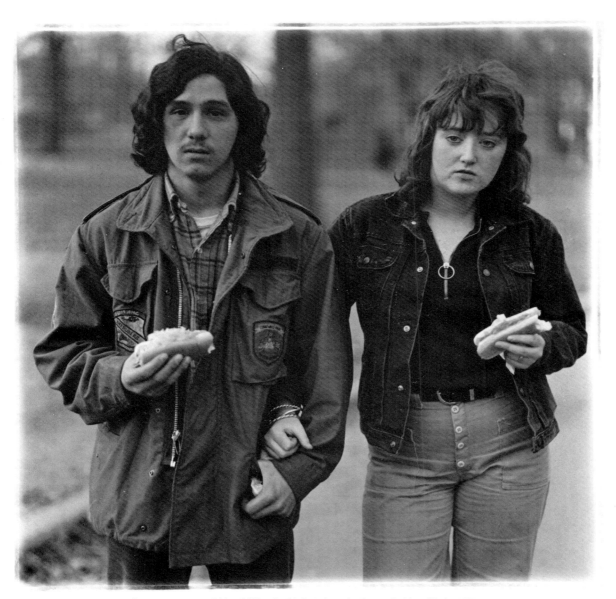

A young man and his girlfriend with hot dogs in the park, New York, 1971

336

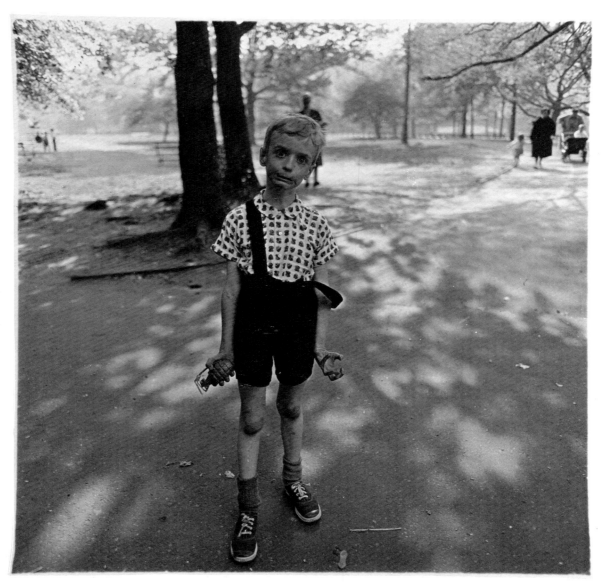

Child with a toy hand grenade in Central Park, New York, 1962

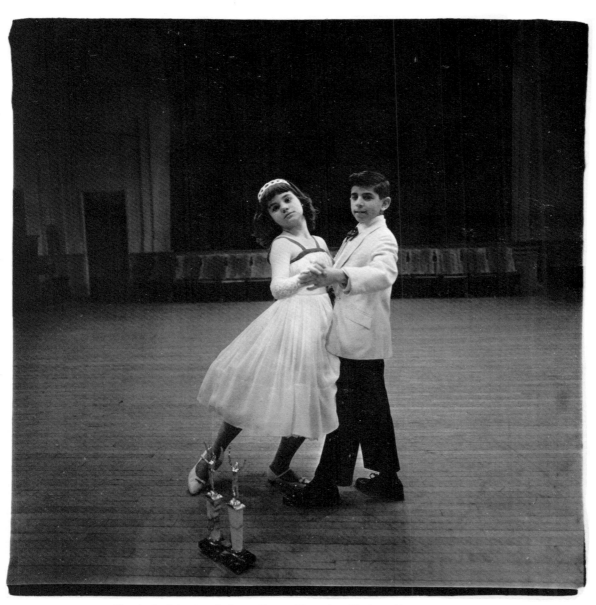

The Junior Interstate Ballroom Dance Champions, Yonkers, New York, 1962

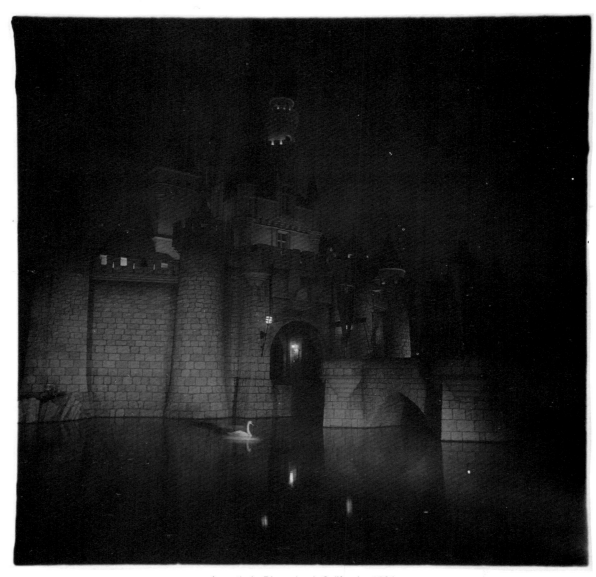

A castle in Disneyland, California, 1964

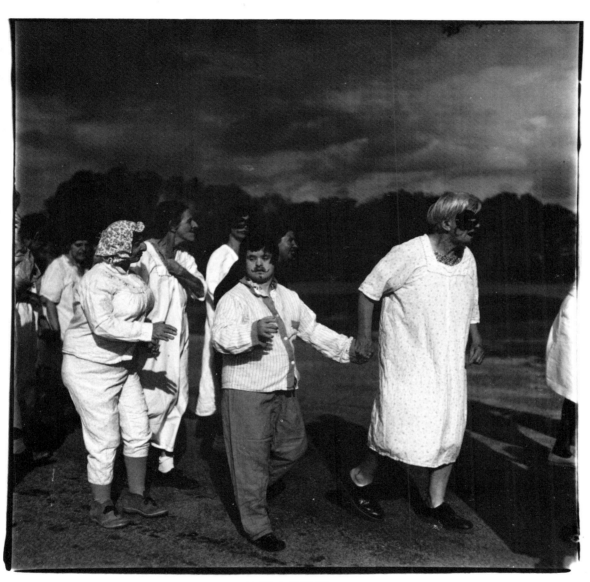

Untitled, 1970-71

339

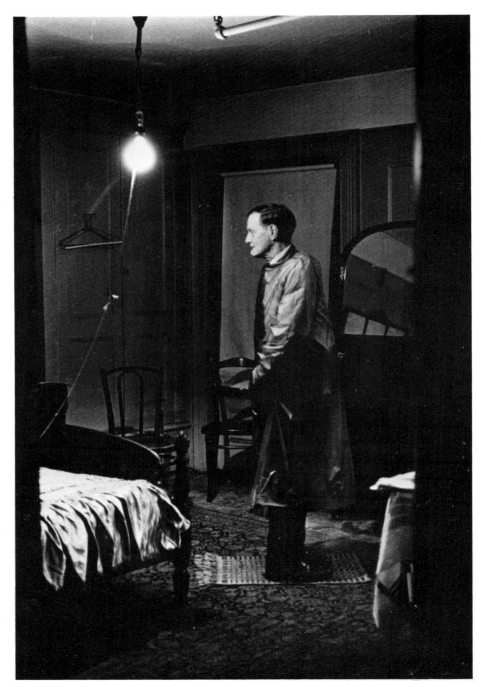

Backwards man in his hotel room, New York, 1961

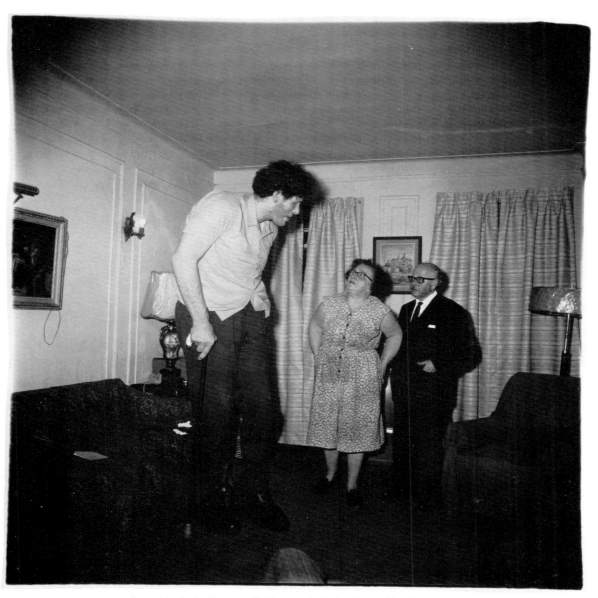

A Jewish giant at home with his parents in the Bronx, New York, 1970

342

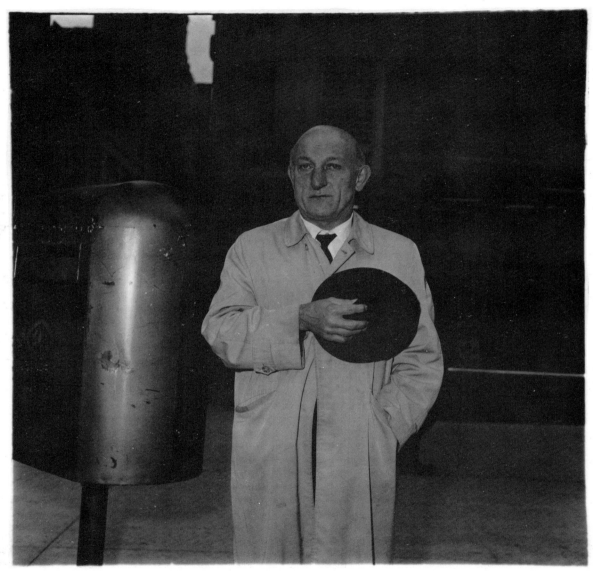

Man at a parade on Fifth Avenue, New York, 1969

Exploration of a Medium: the Polaroid Collection

Exploration of a Medium: the Polaroid Collection

It was not until the start of this century that a few men, amateur photographic historians, photographic scientists and educators began collecting photographs. They amassed images, regardless of subject or photographic system. By mid-century, or shortly after, these collectors either sold their collections to institutions, museums and universities or broke them up for sale piece by piece. We must not forget that these memorabilia included photographica as well as images and both had equal value to the collector. Most collectors were more involved with researching and discovering unknown areas in the brief history of this medium. Today, we acknowledge the importance of the Cromer and Sipley Collection at the International Museum of Photography at the George Eastman House, the Helmut Gernsheim Collection at Texas University at Austin and the Erich Stenger Collection at the Agfa Museum in Leverkusen.

There are others, those in the Royal Photographic Society in England and the Museum of Modern Art in New York, or the new form of Estate Collections, such as those in Arizona.

Unlike most contemporary collections, the Polaroid Collection starts from the inception of its invention—in the research stages back in the 1940's. Various contemporary photographers were invited to use and practice with new experimental films and equipment. Although not all research material was kept, a quality analysis of imagery was sought rather than the normal family or snap-shot variety. In 1973, the Clarence Kennedy Gallery was founded and named in tribute to Professor Clarence Kennedy of Smith College. This gallery offers the public the opportunity to study photographs from the Polaroid Collection as well as other images.

The Collection is administered by an all-volunteer committee comprised of Polaroid employees from various areas of the company. The committee encourages and assists photographers with the medium of Polaroid Land Photography and enables Polaroid Corporation to acquire exciting and diversified portfolios of original instant images. Work from the Polaroid Collection has appeared in a variety of photographic exhibits and publications around the world illustrating the growth of instant photography, both as a science and as an art form.

Other artistically-involved areas of the Corporation added to the Collection, by commissioning and assisting international photographic artists, both students and masters, to show the quality of one-step photography. From this vast array of material, a selection of photographs was made for this exhibition. This is the first time an exhibit of this expanse — reaching from the United States to Europe and Asia — has been assembled.

This exhibit contains four major sections: "The Beginnings", "Black and White", "Color" and "The Contemporaries." By devising the exhibit in this way, the viewer may understand and comprehend the young, yet important historical role, that Polaroid images have played in the 140-year history of photography.

Not surprisingly, we find older and younger masters of photography well represented and the extremes of classic and avantgarde are very apparent. The international character and photographic quality inherent in these images create a unique niche in photography's history.

The striking results achieved in these experiments with form, through this singularly rapid and impatient means, are although just as much however the fruit of meditated aesthetic research and constant expressive integrity, as is shown by all the photographers represented in this exhibition and, for example, in the catalogue, in the photographs by Marie Cosindas, Gary Denham, Erich Hartmann, Sam Haskins, Yousuf Karsh, Rita Kohmann, Ulrich Mack, Robert Mapplethorpe, Sarah Moon, Horst Munzig, Martha Pearson, Lucas Samaras, Charles A. Sieburth, Jeanloup Sieff, Volker Steinhau, Josef Sudek, Jane Tuckerman, Vincent Vallerino, Willard van Dyke, Christian Vogt, Minor White. Their rigorous committment and the results which they obtain are never in fact conditioned, but always stimulated, and at times even favoured, by the medium of Polaroid.

e "Polaroid Collection" brings together the ost significant work achieved since 1940 by der and younger masters in the field of stant photography.
e Venetian exhibition is subdivided into four ctions — "The beginnings", Black-and-white", "Colour", Contemporaries" — illustrating the various storical phases of technical research and vlistic experiment with this new medium of pression.

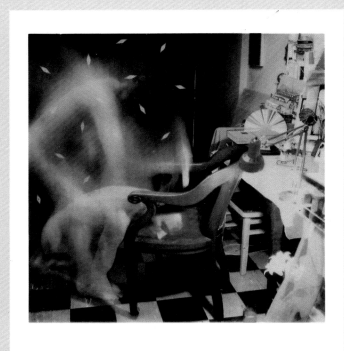

Lucas Samaras

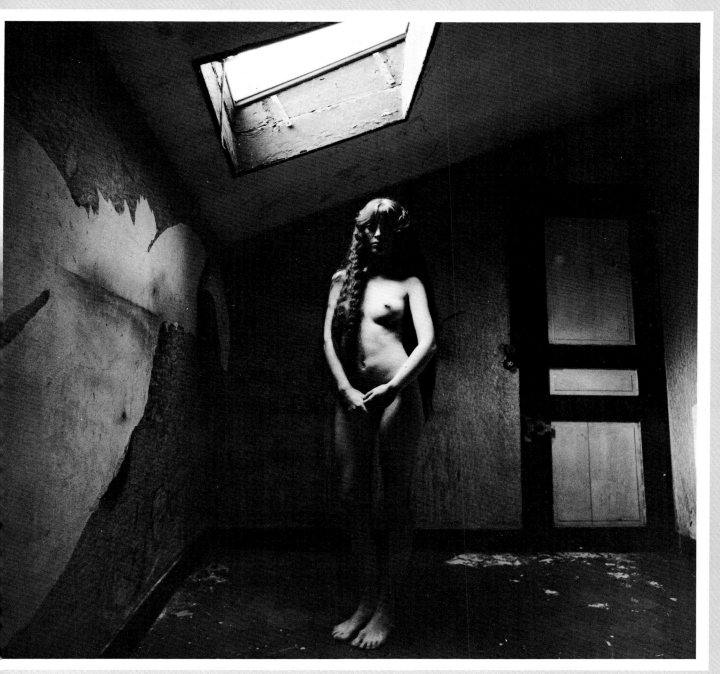

Jeanloup Sieff

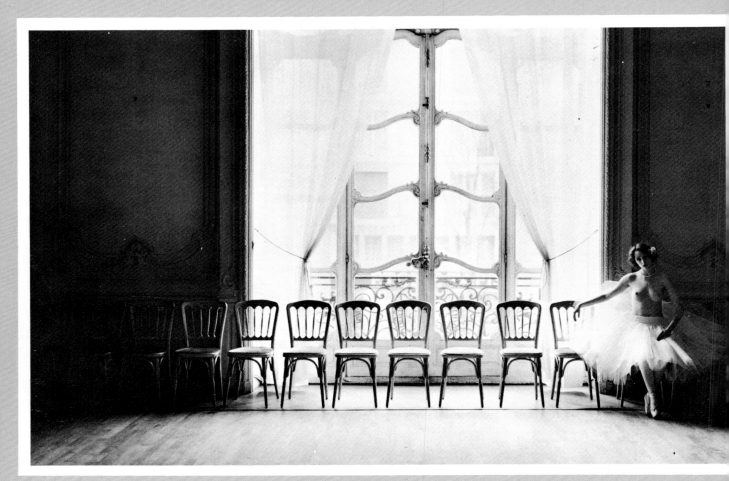

Sarah Moon

Robert Mapplethorpe

Sam Haskins

Horst Munzig

Ulrich Mack

Josef Sudek

Minor White

Yousuf Karsh

Marie Cosindas

Vincent Vallerino

Willard van Dyke

Jane Tuckerman

Martha Pearson

Volker Steinhau
Charles A. Sieburth

Erich Hartmann

Contemporary American Photographers

The past twenty-five years have produced the widest spectrum of photographic expression in the United States. The social and political struggles have aroused the concern of numerous documentary photographers. Concurrent with the uncertainty of the mass photographic magazines has been the growth of photographic books, providing financial encouragement and the possibility of visibility through publication. Paralleling this flourishing of the documentarians has been the dramatic acknowledgement by museums of photography as a legitimate art form, the emergence of galleries for showcase and for sales of photographic prints, and the availability of grants to fund photographic projects by corporations, foundations and government funding agencies. These have given impetus to the use of the medium as a vehicle for private, personal aesthetic expression by a new generation. During the same period, there has also developed a group of curators in art institutions across the country with the sensibility and desire to study the wide range of expression in this bustling medium. The methodology of this selection process results in an exhibition that not only reflects the diversity of the state of the art, but provides penetrating insight into contemporary American life and the creative interests and drive of twelve contemporary American photographers of note.

Curator's Choice: Cornell Capa

The post Second War decades provided various developmental opportunities to photographers interested in the social issues of their times. These were the years when the photographic magazines with large revenues and mass circulations provided financial support for extraordinary and ambitious projects on a scale never imagined before. It was the period that saw the flowering of the photographic essay by such masters as W. Eugene Smith. My three choices represent a young generation, all having learned from the photojournalists before them, all actively engaged in pursuing their chosen vehicle of expression. They share a keen sense of historical and local interests, and are motivated by youthful idealism and a sensibility to the yearnings of others.
Bruce Davidson goes on voyages of self-discovery while visiting the tenants who live on East 100th Street and the blacks down south fighting their own war for civil rights. His photographs are quiet, thoughtful, understated, reflecting the reality of the world and the photographer himself.
Earl Dotter is committed to doing a definitive portrait of the American worker. To date, he has done two major photographic essays, one on the southern textile workers and the other on the coal miners of Appalachia. His intent is clearly to improve their working conditions. The textile workers are America's lowest paid factory workers ($ 1.50 per hour less than the national average). His coal miners are involved in difficult, dangerous work, unrewarding but essential. Dotter's aim is not to make beautiful pictures, but to bring us to grips with the bitter realities of their lives.
Michael O'Brien is an involved news photographer who lives in an American community and does his work for its newspaper. He shows us the inhabitants of the local black ghetto, the sensitity of a retarded child as well as other images of our daily commonplace life. O'Brien is in the beginning of his career, a man who believes he can use his camera to change the world for the better by making others see things that they would rather not notice, if he did not show them.

Curator's Choice: Renato Danese

The work of Robert Adams, William Eggleston and Lee Friedlander has had

considerable impact on contemporary American photography. Their achievements and the contributions to this field are widely recognized and highly regarded. It is my pleasure to recommend the photography of these three gifted artists for presentation at Venezia '79.

Curator's Choice: James L. Enyeart

Curator's choice, collector's choice, or other similarly organized exhibitions, are generally based on the ''taste'' of the individuals selecting the work rather than their intellectual expertise or research. Subtitling an exhibition (''Contemporary American Photography'') may narrow the scope of concern but the fact remains that the goal of the exhibition is to provide differing viewpoints about a select group or groups of artists' works. How then can the choices for such an exhibition be anything but extremely personal on the part of the selectors?

My choices are therefore personal; made without reference to any of today's preponderance of art theories, and are based on the notion that America's most provocative artists since World War II have not and do not belong to any readily identifiable style, persuasion, or movement. In addition to preferring those artists who shy away from the mainstream, I am drawn emotionally, intellectually, and inextricably to beautiful objects which exude an appreciation of lush, sensual tactility. The works of Cosindas, Heinecken, and Uelsmann satisfy such criteria for me. In addition, each of these artists' works defy imitation of style or content. Their art is drawn from deep interior wells more than it is a reaction to observations of their environment and culture. Of course no artist is totally free from the social environment, but my interest leans towards those artists who explore, manifest, and offer alternatives to that environment rather than act within it.

367

Marie Cosindas first studied as a painter and, in her photographs, she creates as well as controls color. Her subjects, whether a person or still life, recall with confidence a sense of pictorial pleasure inherent to the history of art. She remains unafraid, unashamed, and unintimidated by the breast beatings of each year's avant-garde art theorists. In fact, in the face of those who battle new frontiers, Marie Cosindas quietly brought the medium of color Polaroid materials into aesthetic acceptance and credibility long before the current wave of interest and rediscovery of color photography.

Robert Heinecken does not make fine photographs. Rather, he uses a variety of media and skills to make his ideas photographic. Contradiction, humor, and satire are the philosophical umbrellas under which he externalizes those ideas while making evident the relationship of opposing forces both real and cognitive. He, more than any other artist in America concerned with photographic ideas, has influenced and inspired a new generation of ''makers'' rather than ''takers'' as Henry Holmes Smith has described the users of the medium.

Jerry Uelsmann's constructed images have damned pictorialism, romanticism, and surrealism by re-inventing each. His pictorial subjects are not drawn from some literary or allegorical reference but from a gestalt sense of one's (his own) conscious perception of an unconscious continuum. His romanticism (a love for light and its chiaroscuro effects) is an intellectual device rather than an emotional response and his so-called surrealism is in fact a super-realism in which the unbelievable is made believable and the inappropriate, appropriate. Uelsmann, like Cosindas and Heinecken, continues to refine a personal aesthetic and ideas which set him apart from the fashionable concerns of contemporary advocates of photography for photography's sake.

Curator's Choice: Anne Tucker

When Cornell Capa invited me to participate in the *Curator's Choice* exhibition "Contemporary American Photographers", he stipulated that I could include anyone who had come to prominence since World War II, but that each photographer should still be actively photographing. Given three choices and four decades to span, I selected photographers whose works had matured in the forties, sixties, and seventies respectively. While no one artist can carry the representative weight of an entire decade, my intention was for each selection to identify ideas which were first nurtured into maturity during a specific decade, ideas we tend to identify with that decade more than any other. However, I agreed with the artists that since they could exhibit only ten photographs, they should include only their most recent work. While I wanted the photographs included to reflect the temporal roots of their respective decade of maturation, I also wanted this selection of thirty photographs to at least allude to the rich diversity of ideas and distinctly different approaches currently coexisting in American photography. My choices were Helen Levitt, Ray K. Metzker, and MANUAL.

Levitt's particular territory was the streets of New York City. In the 1940s she made a series of black-and-white photographs while collaborating with writer James Agee and with Janice Loeb on a short documentary film set in Harlem, *In The Street*. In the early seventies, Levitt returned to a series of color photographs which were originally started in 1959-60. She photographs common occurences of the street with an uncommon eye. Like her friend and teacher Walker Evans, Levitt's photographs are rich with information, but they do not crusade. She does not traumatize the facts with heightened perspective or narrow depth of field, but stretches facts and form over the picture surface with the even tension of a good quilt design. We can accept her photographs as evidence, while agreeing with Garry Winogrand that "there is nothing as mysterious as a fact clearly described." Her subjects are tangible, while her photographs are elegant and lyrical.

In the 1960s, photographers concerns shifted from what the world looks like to what they wanted the world to mean, and from the exploration of place to the exploration of medium. They began to question what we have traditionally believed to be the "proper" concerns of the photographer. Like their colleagues in painting and sculpture, they were interested in defining and extending the properties of their medium. As a pivotal figure among these explorers, Ray Metzker has worked prodigiously for two decades. While Metzker, like Levitt, has photographed primarily in urban environments, he has not felt confined to faithful records of the subject. His interest is in pictorial innovation through the exploration of phenomena that are exclusively photographic, a search for definition. He asks questions which lead to more questions about the nature of the photographic image, and his success has been to retain heightened emotional control while closely approaching abstract imagery. His questions relate to what we expect a photograph to look like and how those expectations effect its meaning. What is photographic black, and what are its aesthetic powers? How do black forms — without rational detail — affect the picture? Metzker has placed black lines in the center of the picture and in a grid; he has placed amorphous black shapes in one corner and also from edge to opposite edge. The audiences responses depend in large measure on what they expected the photograph to look like. Metzker has also questioned the sanctity of the single negative (vs. a sequence), and sanctity of traditional photographic print sizes. Now he has begun to question our expectations regarding focus. In his new series, *Pictus Interruptus*, an out-of-focus form dominates the picture's foreground, obscuring the identity of the objects in focus behind it. The effect is

368

paradoxical, a concept which consistently reappears throughout his work. Though he makes straight photographs, the images appear at variance with our common experience. Their meanings are rooted not in habit, but in change and innovation. His photographs disturb and delight us simultaneously.

In the 1970s the lines between the arts have lost their distinctions. Museums are integrating paintings and photographs in exhibitions, historians are blending the previously segregated histories; painters and photographers are acknowledging the cross-pollination that has occurred between all the arts, painting and photography in particular. A case in point is MANUAL. In 1974, Edward Hill and Suzanne Bloom decided to challenge the conventional view of the artist as an alienated, romantic individual by formally establishing a collaborative identity: MANUAL. Both Hill and Bloom came to the collaboration with extensive training and experience in other media — Bloom primarily as a painter, Hill as printmaker, draftsman, and author of *The Language of Drawing*. For both, photography is a tool to be used singularly or in combination with language, video, painting or drawing. MANUAL refers to "touching," while it may also refer to "handbook"; the project nature of their work frequently alludes to both concepts. Their early, emblematic *Hand Series* (1974) asserted the experiential and reaffirming grasp they sought through living, and another series, *Woodland Rituals* (1975-76) metaphorically touches on the primacy of existance and its dual, gentle/hostile nature. The handbook concept applies to their critical "manual" on cultural phenomena such as the art object, primarily those which have achieved a "super star" status, such as Ingres' *Odalisque* and da Vinci's *Mona Lisa*. Ingres' *Odalisque* is displayed on television (an international cartel) and scrutinized above a table saw; da Vinci's *Mona Lisa* is also transformed and demythologized in a variety of ways. The photographs exhibited here are from the ongoing *Art In Context Series: Homage to Walter Benjamin*, a critical dialectic which sometimes operates through tongue and cheek and sometimes through poignant directness, but always reflects historical consciousness.

369

This exhibit organized by the "International Center of Photography" of New York, arranged by Cornell Capa, Renato Danese, James L. Enyeart and Anne Tucker, shows the work of 12 photographers who, though different in their approach to the art, have been regarded as the most significant in American photography today. The photographers, each presented by 10 pictures, are: Bruce Davidson, Earl Dotter, Michael O'Brien, Robert Adams, William Eggleston, Lee Friedlander, Marie Cosindas, Robert Heinecken, Jerry Uelsmann, Helen Levitt MANUAL, Ray Metzker.

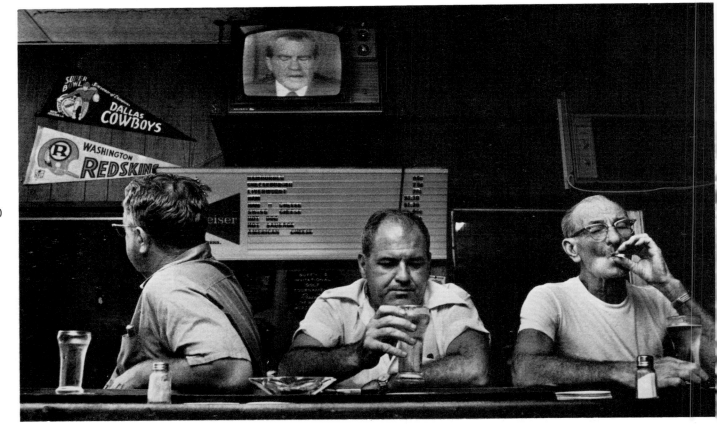

Michael O'Brien, Duffy's Bar, Miami, Florida, 1974

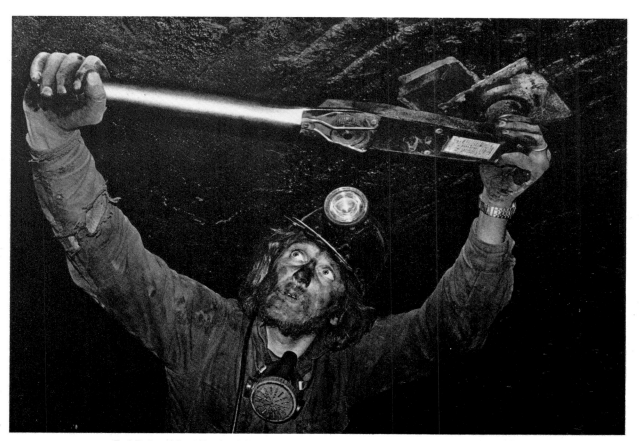

Earl Dotter, Miner Testing Mine Roof Support, Clearfield County, Pennsylvania, 1977

372

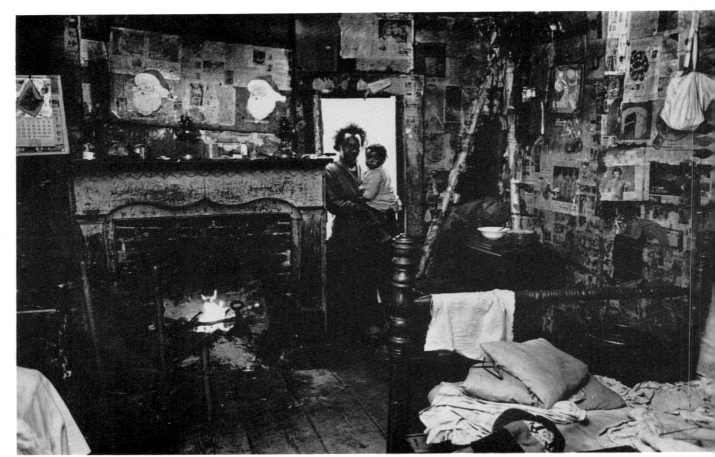

Bruce Davidson, Alabama, 1965

Robert Adams, Missouri River, Clay County, South Dakota, 1977

William Eggleston, Palms, Gulf Coast, Mississippi, 1977

Lee Friedlander, New York City, 1965

Marie Cosindas, Sailors, Key West, 1966

Robert Heinecken, TV Dinner / Shrimp, 1971

378

Jerry Uelsmann, Untitled, 1978

Helen Levitt, New York, c. 1972.

380

Ray K. Metzker, from Pictus Interruptus series, 1978

MANUAL, Lovis Corinth in Vermont,
from ''Art in Context - Homage to Walter Benjamin''

Contemporary European Photography

Contemporary European Photography

Sue Davis, directress of the Photographer's Gallery in London, has chosen: Joan Fontcuberta, Paul Hill and Andy Earl, with the following motivation:
I would like to say how pleased I am that at least one of the exhibitions at this Venice Exposition will be devoted to the younger and more experimental living photographers. The idea of asking various people in different parts of Europe to suggest exhibitiors should give a variety but it is clearly a good idea that the overall decisions are in the hands of one person, in this case Daniela Palazzoli, to ensure a good overall standard for the exhibition. Of the people suggested by us, the final selection of Paul Hill, Andy Earl and Joan Fontcuberta shows a good cross-section of experimental new work in various styles and techniques all of which I find interesting and exciting.
The most established, Paul Hill, will be giving a workshop himself in Venice in September and it is good that his students will have a chance to see his latest work as well as material he has already shown in London. Recently resigned from his position as Head of the Photography Department at Trent Polytechnic, Paul now runs a very good series of residential workshops at 'The Photographers' Place' in Derbyshire. Here students at various stages from beginners to advanced can come for short periods to work with local and visiting photographers. This also gives him a chance to continue with his own work which as you will see is growing and changing all the time.
Andy Earl is a former student of Paul's but his work is quite different and the juxtapposition well illustrates the freedom inherent in the best of British Education — leaving each student free to pursue his own interests once the basic groundwork has been given. Andy's interest in movement has led to his experiments with multiple flash in daylight and his early work with this technique at the fashionable meeting places of Henley and Ascot has led on to his recent work with the use of less manageable animals as subject matter. He has always been most interested in colour and this seems to me a very important break-through among the younger generation of European photographers as a whole.
Joan Fontcuberta is a young Spanish photographer interested primarily in spacial relationships. He sometimes explores these simply with light but often incorporates sections of movement and even montage to add depth to the pictures. Seemingly more concerned with the general problems of photography than many of the Spanish photographers, his images are not violent in any way but are in tune with the current interest among many young photographers in the basic aesthetics of the medium. His beautiful prints, often selenium toned to a rich brown, are of a quality which makes them difficult to reproduce and well worth seeing in an exhibition.

Jean Claude Lemagny, Curator of the Cabinet des Estampes de la Bibliothèque Nationale, Paris, has chosen John Batho, Aleksandras Macijauskas and Michel Szulc Krzyzanowski, with the following motivation:
To produce an exhibition is to invent the structure and atmosphere of a space, making use of works of art assembled in a certain order. I should have liked a few persons each to have been able to form an exhibition in the freest and most subjective possible way, within a given space. Through the domain of photography, the historical process of personal choices and sovereign decisions which has led to the kind of general consensus by now accorded to exhibitions of painting and sculpture and which we for this very reason now overlook, could thus have been reconstructed.
But as I have been given different conditions I felt I ought to choose, among so many others, three photographers whose work I have had the honour of studying attentively as part of my job at the Cabinet des Estampes. These three are about as different as they could be, and I feel attached to each of them by a special bond of personal sympathy.

John Batho wrestles with the question of colour in photography. He wanted to take up the challenge which it posed to him. Seeing that its rendering of reality is technically feasible, why shouldn't colour have access to a quality, to a nobility at least on a par with those of black and white? A craftsman by training, John Batho has all the craftsman's patience and he accepts from creation only what the excellence of his craft will allow. Not that he allows himself to be taken in by the myth of the artist-craftsman. His work is among the most lucidly developed that I know.

Aleksandras Macijauskas is a reporter who has come to make his report. He seeks to convey the rugged truth about things and people. Nothing is further from him than the contrived or the mannerism. But to state brutal reality correctly he knows that in the very interests of exactitude he must throw into his image the power of spaces, of foreshortening and of purely photographic perspectives; like the actor who, in order to be natural, has to talk louder and to exaggerate his gestures. The result is a realistic and at the same time an epic art. It has vast human warmth, which is very hard to find in western countries today.

Michel Szulc Krzyzanowski masterfully surmounts the idea of a distinction between "artist" and "photographer" which is, alas, still rife even since the advent of conceptual trends in art has made it utterly pointless. Szulc Krzyzanowski explores the meaning of photography in relation both to its exterior scale and to the photographee's body. His work is a magnificent feat of incarnation. Thought becomes space and presence, and matter allows itself to be inwardly governed by thought.

Daniela Palazzoli, professor of mass media at the Accademia di Brera in Milan, has chosen: Bernard Plossu, Heinrich Riebesehl and Marialba Russo, with the following motivation:

To coordinate an exhibition like "Contemporary European Photography" posed a twofold problem: information and formative choices. The four organizers responsible for selecting the photographers who represent younger European photography here, occupy positions in the photographic world which bring them into daily contact with an extremely large number of photographers and their works. Their posts furthermore enable them to present their choices to a wider public through distinguished outlets and thus to contribute towards the guidance of taste and styles in photography today. As far as my own personal choices as one of the organizers are concerned, the first question I asked myself was whether and how a new generation of photographers can be singled out, and on the basis of what criteria. In fact, the passage from one generation to the next is not only a chronological one, but occurs in connection with profound, comprehensive changes in the lifestyle of a society and in the internal structures of a medium. In the last decade photography has undergone a slow but radical change of status, making itself increasingly felt among cultural and art circles. The phenomenon, which has involved museums, publishing and private galleries, may perhaps have been more striking in the United States, but is slowly asserting itself in Europe too. The fact that the facilities through which the public came into contact with photography were changing has certainly influenced the formation of a new generation of photographers. Europe has seen a swarm of independent enterprises run by young photographers who become their own sponsors and patrons, and by their colleagues who set up publishing cooperatives and create new exhibition spaces. Moreover the creation of photographic circuits as alternatives to the mainstream press has meant that, without destroying the interest in photo-reporting and documentaries, many photographers turned their lenses towards facts, objects and events in which they felt a personal emotive involvement —

regardless of whether this might be of any interest to the general public. This independent outlook has helped to furnish an inedited and unofficial portrait of the period. The alternative visual material which it has engendered is often of considerable historical and social importance and always provides a significant aid in trying to read the underlying and inexpressed problems of the moment.

Sensitivity towards political and social events — both those shared by the masses and those of the outcaste minorities, does not exclude an interest in form or in more creative research. Quite the contrary. A characteristic of the new photographers is that they have gone past the fragmentary and unresolved framework of conceptualism while incorporating its results. The conceptualists (whether defined as painters or photographers) relied heavily on the photographic image in connection with texts and writings. They were in fact moved by a disgust in the consumer product and finished work in the art supermarket style. They have re-evaluated photography as an experience, as a mode of visualizing thought without reaching a compositive synthesis. Now that the polemical tone has been dropped, the equation between living and photography, thinking and visualizing, is put into effect without precluding an attention to forms, but rather, with a definite consciousness of photographic language.

These three points are exemplified here by Marialba Russo, a remarkable researcher into the anthropological realities of Campania — an Italian region that still has its mysterious and secret rites, with which she feels a profound psychological affinity;

Bernard Plossu, who in the recording of places close to him daily or far away and accessible only by travel, researches the formal and emotive constant, the poetry that forms the link between him and the world;

and Heinrich Riebesehl, who investigates the forms and social rituals of his country, giving a formal balance to the interior resonances and related refusals which he brings into his photography.

Allan Porter, Director of *Camera* review in Lucerne has chosen: Keith Collie, André Gelpke and Joseph Koudelka, with the following motivation:
To select a list of important younger european photographers is a complicated task. With the use of objective analysis of the stream of photography today my choices are determined by the social documentary thrust which each of the above photographers have displayed and exhibited in their continuing young career. They are not art photographers nor reportage agency photographers but self determined documentarians with definite socio-political commitments. They are outside the wave of most contemporary photographers and have chosen important aspects of our society to document and record in their quiet, sincere anonymous manner. Their photographs come before their style and their personality. They are unseen but their photographs capture a quizzicle perturbance of our world today.

This exhibition, coordinated by Daniela Palazzoli, presents the work of twelve photographers, chosen by four curators (Sue Davis, Jean-Claude Lemagny, Daniela Palazzoli, Allan Porter) and including some of the most representative figures of modern European photography.
They are: John Batho (France), Keith Collie (Great Britain), Andy Earl (Great Britain), Joan Fontcuberta (Spain), André Gelpke (Germany), Paul Hill (Great Britain), Joseph Koudelka (Czechoslovakia), Aleksandras Macijauskas (U.S.S.R.), Bernard Plossu (France), Heinrich Riebesehl (Germany), Marialba Russo (Italy), Michel Szulc Krzyzanowski (Holland).

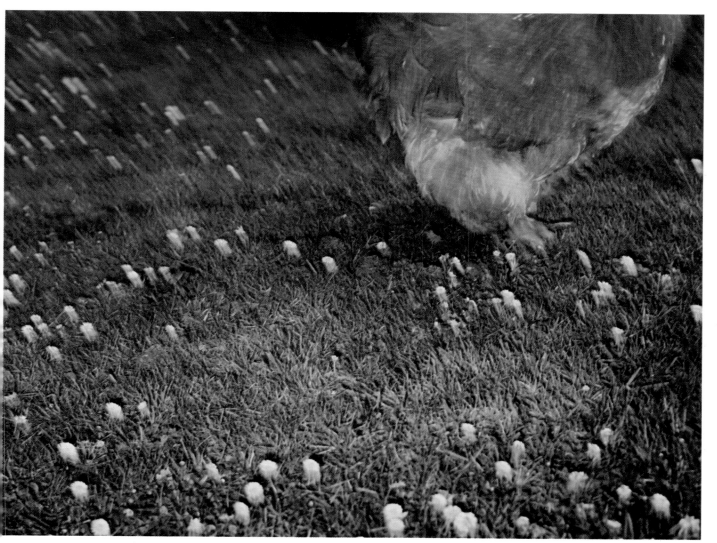

385

Andy Earl, Hen, 1979

386

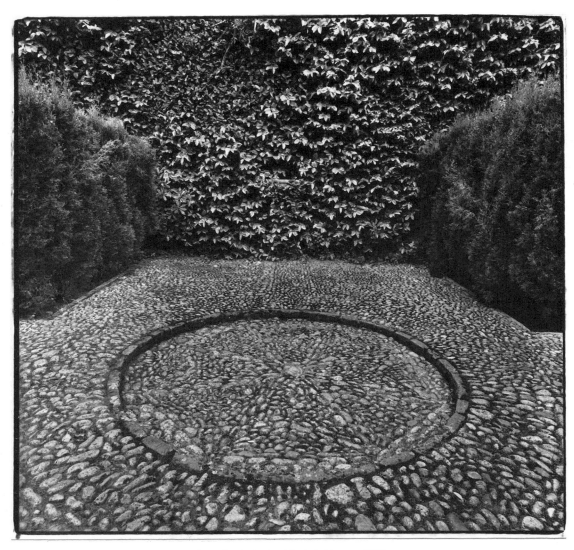

Joan Fontcuberta, Mont de Venus, 1979

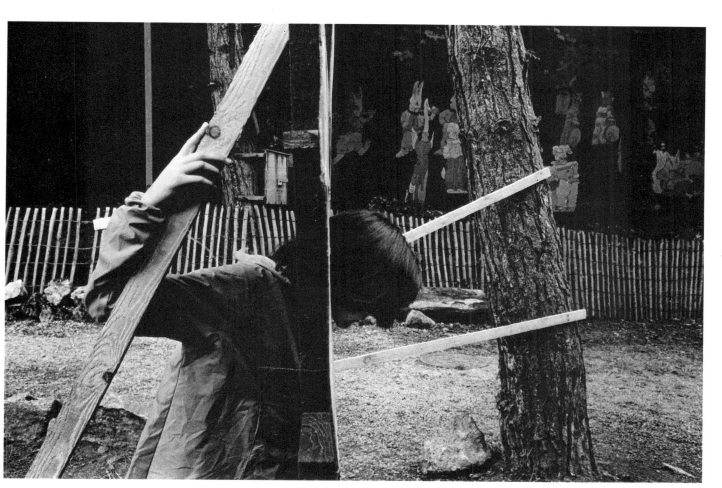

Paul Hill, Girl with Anorak, 1977

388

John Batho, Deauville, 1977

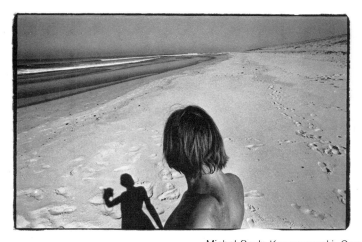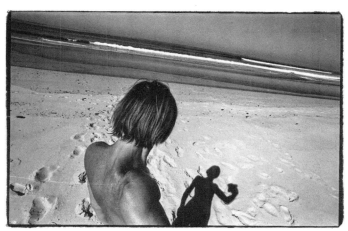

389

Michel Szulc Krzyzanowski, Carcans Plage, September 22, 1978

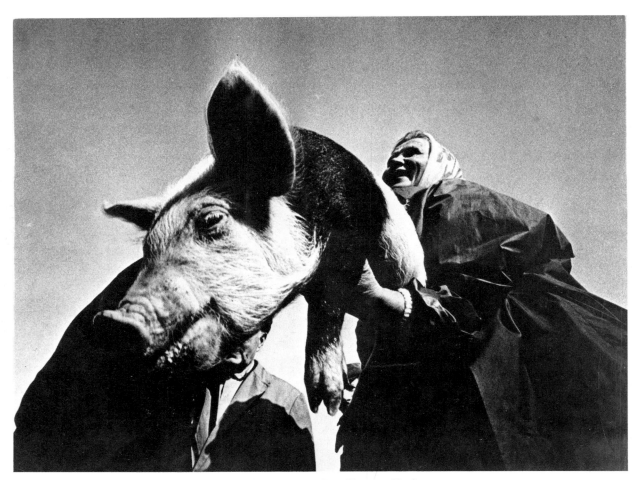

Aleksandras Macijauskas, Woman with pig

Heinrich Riebesehl, Greenhouse

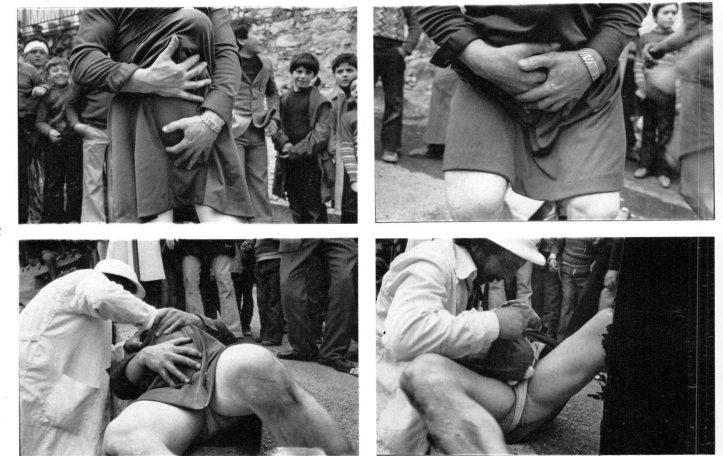

Marialba Russo, Childbirth, Cilento, photographed in b/w and in color, 1978

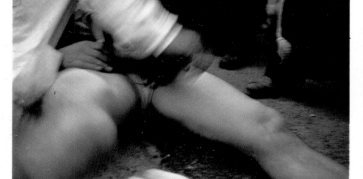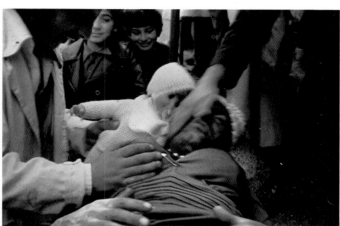

393

394

Bernard Plossu, Silence, Paris, 1973

André Gelpke, Plastic People, 1979

Keith Collie, Hotel Ritz

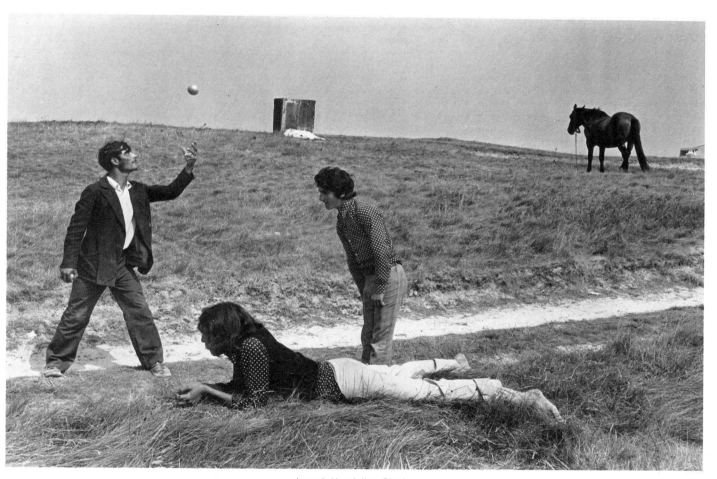

Joseph Koudelka, Gipsies

Acknowledgements

Photographs by Alfred Stieglitz p. 92, 94, 96 and 97 from *Camerawork*, vol. 36, 1911

Photograph by Alfred Stieglitz p. 93 from *Camerawork*, vol. 12, 1905

Photograph by Alfred Stieglitz p. 95 from *291*, vol. 7-8, 1915

Photograph by Eadweard Muybridge p. 218 courtesy of The International Museum of Photography at George Eastman House, Rochester, New York

Photograph by Nickolas Muray p. 222 courtesy of Mr. Sam Wagstaff, New York

Photographs by E.O. Hoppé p. 223 and 226 courtesy of The Mansell Collection, London

Photograph by Edward Steichen p. 223 courtesy of The Condé Nast Publications Inc.

Photograph by Hugo Erfurth p. 224 courtesy of The Condé Nast Publications Inc.

Photograph by Soichi sunami p. 226 courtesy of Mrs. Soichi Sunami

Photographs by Horst p. 227 courtesy of Horst and Sonnabend Gallery, New York

Photograph by James Van Der Zee p. 228 courtesy of Anthony Barboza

Photograph by Margaret Bourke-White p. 229 courtesy by The Condé Nast Publications Inc.

Photograph by MANUAL p. 380 courtesy of Cronin Gallery, Houston, Texas

The bio-bibliographical notes in the catalogue were prepared by Italo Zannier and Vittorio Sgarbi with the exception of that for Francesco Paolo Michetti prepared by Marina Miraglia and those for Count Primoli, Tina Modotti and Contemporary European Photography by Daniela Palazzoli.

Credits

Lewis W. Hine

Organized by The Brooklyn Museum, NYC
Curator: Barbara Head Millstein
Guest Curators: Walter and Naomi Rosenblum

Francesco Paolo Michetti

Curators: Marina Miraglia and Daniela Palazzoli

Eugène Atget

Organized and printed by Pictorial Services, Paris
Original plates courtesy of the Photothèque des Archives des Monuments Historiques, Paris
Curator: Pierre Gassmann

Count Primoli

Curator: Daniela Palazzoli
Permission to reproduce the negatives has been kindly granted by the Fondazione Primoli, Rome. The prints are by Oscar Savio.

The Alfred Stieglitz Collection

Curator: Weston Naef
Initially shown at the Metropolitan Museum of Art, New York City

Alfred Stieglitz

Courtesy of Zabriskie Gallery, New York and Paris

Edward Weston's Gifts to His Sister

Organized by The Dayton Art Institute, Dayton, Ohio
Curator: Kathy Kelsey Foley
Photographs courtesy of the family of Mary Weston Seaman

Tina Modotti

Curator: Megi Pepeu
Courtesy of Vittorio Vidali

A Private Collection: Sam Wagstaff

The Corcoran Gallery of Art, Washington, DC (Curator - Jane Livingston) and Sam Wagstaff have worked together in organizing this project

Robert Capa

Curator: Cornell Capa, Executive Director, the International Center of Photography
Associate Curator: Edith Capa
Director of Exhibitions: William A. Ewing
Preparation Supervisor: Ron Cayen

Installation Supervisor: Steve Rooney

Henri Cartier-Bresson

Produced by the International Center of Photography
Curator: Robert Delpire
Executive Director: Cornell Capa
Director of Exhibitions: William A. Ewing
Preparation Supervisor: Ron Cayen
Installation Supervisor: Steve Rooney

W. Eugene Smith

Exhibition selected and organized by W. Eugene Smith with the assistance of Sherry Suris
Exhibition circulated by the Estate of W. Eugene Smith; John G. Morris, executor
The W. Eugene Smith Archives are housed at the Center for Creative Photography; University of Arizona, Tucson

Images des Hommes

Organized by Groupement Images with the assistance of Ministère de la Culture Française de Belgique

The Land

Selection by Bill Brandt
Organized by The Victoria and Albert Museum, London
Curated by Mark Haworth-Booth, Assistant Keeper of Photographs

Fleeting Gestures: Treasures of Dance Photography

Organized by The International Center of Photography
Executive Director: Cornell Capa
Director of the Exhibition: William A. Ewing
Associate Curator: Ruth Silverman
Preparation Supervisor: Ron Cayen
Installation Supervisor: Steve Rooney

Eye of the Beholder: the World in Color

By courtesy of the National Retinitis Pigmentosa Foundation

Hecho en Latino America

Created by El Consejo de Fotografia mexicano and first exhibited at the Museum of Modern Art in Mexico City in 1978

Self-Portrait: Japan

Organized by: The International Center of Photography
Executive Director: Cornell Capa

Guest Curator: Shoji Yamagishi
Associate Curator: Kyoko Yamagishi
Director of Exhibitions: William A. Ewing
Exhibition Coordinator: Yurkio Kuchiki
Preparation Supervisor: Ron Cayen
Installation Supervisor: Steve Rooney

Contemporary Italian Photography

Curator: Italo Zannier

Weegee

Organized by The International Center of Photography
Guest Curator: John Coplans
Assistant Curator: Ron Cayen
Executive Director: Cornell Capa
Director of Exhibitions: William A. Ewing
Installation Supervisor: Steve Rooney

Robert Frank

Photographs lent by Lunn Gallery, Washington, DC
Curator: Paul Katz

Diane Arbus

Curators: Marvin Israel and Doon Arbus
Prints courtesy of the Estate of Diane Arbus and Graphics International, Washington, DC
Exhibition prepared by The International Center of Photography
Executive Director: Cornell Capa
Director of Exhibition: William A. Ewing
Installation Supervisor: Steve Rooney
Preparation Supervisor: Ron Cayen

Exploration of a Medium: the Polaroid Collection

Selection by Allan Porter

Contemporary American Photographers

Organized by the International Center of Photography
Curators: Cornell Capa, Executive Director ICP
Renato Danese, Assistant Director, Visual Arts Program, National Endowment of the Arts
James Enyeart, Director, Center for Creative Photography, University of Arizona, Tucson
Anne Tucker, Curator, Curator of Photography, Museum of Fine Arts, Houston, Texas
Director of Exhibition: William A. Ewing
Preparation Supervisor: Ron Cayen
Installation Supervisor: Steve Rooney

Contemporary European Photography

Curators: Sue Davis, Jean-Claude Lemagny, Daniela Palazzoli, Allan Porter, coordinated by Daniela Palazzoli

Index of Photographers

401

402

403

404

Printed for
Electa Editrice by Fantonigrafica, Venice

8544